Japanese Arts Library

General Editor
John Rosenfield

With the cooperation and under the editorial supervision of:

The Agency for Cultural Affairs of the Japanese Government
Tokyo National Museum
Kyoto National Museum
Nara National Museum

KODANSHA INTERNATIONAL LTD. AND SHIBUNDO
Tokyo, New York, and San Francisco

Kutani Ware

Sensaku Nakagawa

translated and adapted by

John Bester

Kutani Ware was originally published in Japanese by the Shibundo publishing company, Tokyo, in 1974, under the title *Kutani-yaki*, as volume 103 in the series *Nihon no bijutsu*. The English edition was prepared at Kodansha International, Tokyo, by Saburo Noeaki, Takako Suzuki, and Michael Brase.

The author gratefully acknowledges a debt to Mr. Shimazaki Susumu, Mr. Minami Toshihide, and other members of the staff of the Ishikawa Prefectural Art Museum for providing photographs.

Distributed in the United States by Kodansha International/USA Ltd., through Harper & Row Publishers, Inc., 10 East 53rd Street, New York, New York 10022; in Europe by Boxerbooks Inc., Limmatstrasse 111, 8031 Zurich; and in Japan by Kodansha International Ltd., 2–12–21 Otowa, Bunkyo-ku, Tokyo 112.

Published by Kodansha International Ltd., 2–12–21 Otowa, Bunkyo-ku, Tokyo 112 and Kodansha International/USA Ltd., 10 East 53rd Street, New York, New York 10022 and 44 Montgomery Street, San Francisco, California 94104. Copyright © 1979 by Kodansha International Ltd. and Shibundo. All rights reserved. Printed in Japan.

Library of Congress Cataloging in Publication Data
Nakagawa, Sensaku, 1910—
 Kutani ware.
 (Japanese arts library)
 Translation of Kutani-yaki.
 Bibliography: p.
 Includes index.
 1. Kutani porcelain. 2. Porcelain, Japanese.
3. Kutani pottery. I. Title. II. Series.
NK4399.K87N3413 738.2'7 77–86501
ISBN 0–87011–322–4

First edition, 1979 JBC 1372–786380–2361

CONTENTS

Japanese Art Periods

Prehistoric		–537
Asuka		538–644
Nara		645–781
Hakuhō	645–710	
Tempyō	711–81	
Heian		782–1184
Jōgan	782–897	
Fujiwara	898–1184	
Kamakura		1185–1332
Nambokuchō		1333–91
Muromachi		1392–1572
Momoyama		1573–99
*Edo		1600–1867
*Meiji		1868–1912
Taishō		1912–26
Shōwa		1926–

Note: This table, compiled by the Agency for Cultural Affairs of the Japanese Government for the arts and crafts, has been adopted for general use in this series. Periods marked with an asterisk are discussed in the Glossary.

A Note to the Reader

Japanese names are given in the customary Japanese order, surname preceding given name.

ILLUSTRATIONS

49–50. Footed bowl with polychrome overglaze bird-and-flower design (*iro-e kachō-zu daibachi*). Old Kutani.

51–52. Shallow bowl with polychrome overglaze design of drying nets and lotus petal motifs (*iro-e aboshi remben-mon hirabachi*). Old Kutani.

53. Shallow nonagonal bowl with polychrome overglaze bird-and-flower design and diamond-shaped patterns (*iro-e hishi-mon kachō-zu kukaku-hirabachi*). Old Kutani.

54. Shallow bowl with polychrome overglaze design of butterflies and peonies with linked hexagonal pattern (*iro-e chōbotan kikkō-mon hirabachi*). Old Kutani.

55–56. Shallow bowl with polychrome overglaze design of peonies and butterflies (*iro-e botanchō-zu hirabachi*). Old Kutani.

57. Shallow bowl with polychrome overglaze design of bamboo and tiger (*iro-e taketora-zu hirabachi*). Old Kutani.

58–59. Shallow bowl with polychrome overglaze design of tree (*iro-e jumoku-zu hirabachi*). Old Kutani.

60–62. Shallow bowl with hexagonal pattern and design of quails (*iro-e kikkō-mon uzura-zu hirabachi*). Old Kutani.

63. Shallow bowl with paving-stone pattern and double-phoenix motifs (*iro-e ishidatami sōhō-mon hirabachi*). Old Kutani.

64–65. Footed bowl with polychrome overglaze design of auspicious motifs (*iro-e kichijō-mon daibachi*). Old Kutani.

66–67. Footed bowl with polychrome overglaze design of bathing woman (*iro-e suiyoku-zu daibachi*). Old Kutani.

68. Shallow bowl with polychrome overglaze design of butterflies and geometrical patterns (*iro-e chōkika-moyō hirabachi*). Old Kutani.

69. Deep bowl with phoenix design and *fuyōde* decorations in polychrome overglaze (*iro-e hōō-mon fuyōde fukabachi*). Old Kutani.

70–71. Shallow bowl with polychrome overglaze design of melons in a bowl (*iro-e uridai-bachi-zu hirabachi*). Old Kutani.

72–74. Shallow bowl with polychrome overglaze landscape design and linked circular medallions (*iro-e marumontsunagi sansui-zu hirabachi*). Old Kutani.

75. Shallow bowl with polychrome overglaze design of bamboo and tiger (*iro-e taketora-zu hirabachi*). Old Kutani.

76–77. Shallow bowl with polychrome overglaze design of cranes and "spade" motifs (*iro-e tsuru-ni-supēdo-mon hirabachi*). Old Kutani.

78–79. Shallow bowl with polychrome overglaze design of eagle and monkey (*iro-e washi-saru-zu hirabachi*). Old Kutani.

80. Shallow bowl with polychrome overglaze bird-and-flower design (*iro-e kachō-zu hirabachi*). Old Kutani.

81–82. Shallow bowl with polychrome overglaze bird-and-flower design (*iro-e kachō-zu hirabachi*). Old Kutani.

83–84. Shallow nonagonal bowl with polychrome overglaze bird-and-flower design (*iro-e kachō-zu kukaku-hirabachi*). Old Kutani.

85–86. Shallow bowl with polychrome overglaze design of peonies (*iro-e botan-mon hirabachi*). Old Kutani.

87–88. Shallow bowl with polychrome overglaze geometrical design (*iro-e kika-moyō hirabachi*). Old Kutani.

89–90. Shallow bowl with polychrome overglaze design of leaves and bird (*iro-e konoha-shōkin-zu hirabachi*). Old Kutani.

91. Shallow bowl with jar-shaped design of bridge and human figure in overglaze colors (*iro-e tsubowari-hashijimbutsu-zu hirabachi*). Old Kutani.

92–93. Shallow bowl with polychrome overglaze design of melons (*iro-e uri-zu hirabachi*). Old Kutani.

94–95. Shallow bowl with polychrome overglaze design of human figures and scattered "military" fans (*iro-e gunsenchirashi jimbutsu-zu hirabachi*). Old Kutani.

96–97. Shallow bowl with polychrome overglaze design of aged tree and white clouds (*iro-e rōju-hakuun-zu hirabachi*). Old Kutani.

98. Shallow bowl with polychrome overglaze design of bamboo (*iro-e take-zu hirabachi*). Old Kutani.

99–100. Shallow bowl with polychrome overglaze design of melons (*iro-e uri-zu hirabachi*). Old Kutani.

101–2. Shallow bowl with polychrome overglaze design of oak branches (*iro-e kashiwa-zu hirabachi*). Old Kutani.

103–4. Shallow bowl with polychrome overglaze design of hawk (*iro-e taka-zu hirabachi*). Old Kutani.

105–6. Footed bowl with polychrome overglaze design on the "resting in the shade of a willow" theme (*iro-e ryūinshōkei-zu daibachi*). Old Kutani.

107. Shallow bowl with polychrome overglaze design of "hares breasting the waves" (*iro-e usagitokai-zu hirabachi*). Old Kutani.

108. Shallow bowl with polychrome overglaze design of butterfly and fans(*iro-e chō-ni-semmen-zu hirabachi*). Old Kutani.

109–10. Shallow bowl with polychrome overglaze design of bamboo and myna birds (*iro-e take-ni-hahachō-zu hirabachi*). Old Kutani.

111. Geometrical patterns used on Old Kutani.

112–31. Patterns on fragments excavated at the kiln sites.

132. Fragment with inscription unearthed at kiln sites.

133. Bowl with polychrome overglaze design of landscape with deer (*iro-e shikasansui-zu hachi*). Kasugayama kiln.

134. Bowl with polychrome overglaze design of Chinese figures (*iro-e tōjimbutsu-zu hachi*). Kasugayama kiln.

135. Pair of sake bottles with polychrome overglaze design of pine, bamboo, and flowering plum (*iro-e shōchikubai-mon heishi*). Kasugayama kiln.

136. Foliate-shaped bowl with polychrome overglaze landscape design (*iro-e sansui-zu rinka-bachi*). Minzan kiln.

137. Gourd-shaped sake bottle with polychrome overglaze design of gourds (*iro-e hisago-mon hisago-gata tokuri*). Minzan kiln.

138. Dish with underglaze-blue design of phoenixes (*sometsuke hōō-mon sara*). Wakasugi kiln.

139. Sake bottle with underglaze-blue landscape design (*sometsuke sansui-zu tokuri*). Waka-sugi kiln.

140. Spouted bottle with underglaze-blue design of peonies and butterflies (*sometsuke botan-chō-zu hei*). Wakasugi kiln.

141. Large dish with underglaze-blue design of mandarin duck (*sometsuke oshidori-zu ōzara*). Wakasugi kiln.

142. Square bottle with bright blue "lapis lazuli" glaze and underglaze-blue landscape design (*ruriyū sometsuke sansui-zu shihō-hei*). Wakasugi kiln.

143. Water ewer with polychrome overglaze floral scroll design (*iro-e hanakarakusa-mon sensan-hei*). Wakasugi kiln.

144–45. Jar with polychrome overglaze design of pomegranates (*iro-e zakuro-zu tsubo*). Wakasugi kiln.

146. Deep bowl with polychrome overglaze flower-and-grasses design (*iro-e sōka-mon fuka-bachi*). Kasugayama kiln.

147. Large dish with polychrome overglaze bird-and-flower design (*iro-e kachō-mon ōzara*). Wakasugi kiln.
148. Vase with polychrome overglaze floral design (*iro-e sōka-mon hei*). Wakasugi kiln.
149. Tea-leaf jar with design of human figures in polychrome overglaze with gold (*iro-e kinrande jimbutsu-mon sencha-tsubo*). Ono kiln.
150. Shallow bowl with polychrome overglaze design of *omoto* (*iro-e omoto-zu hirabachi*). Yoshidaya kiln.
151. Four-tiered hexagonal box with polychrome overglaze design of camellias (*iro-e tsubaki-mon rokkaku-yodanjū*). Yoshidaya kiln.
152. Square dish with polychrome overglaze design of melons (*iro-e itouri-mon kakuzara*). Yoshidaya kiln.
153. Shallow bowl with polychrome overglaze design of limestone rock and bird (*iro-e taikoseki-to-tori-zu hirabachi*). Yoshidaya kiln.
154. Shallow bowl with overglaze design of cranes (*iro-e tsuru-zu hirabachi*). Yoshidaya kiln.
155. Bowl with polychrome overglaze landscape design (*iro-e sansui-zu hachi*). Yoshidaya kiln.
156. Eating utensils (*shokki-rui*). Yoshidaya kiln.
157. Sake bottles with polychrome overglaze design of domestic fowl (*iro-e niwatori-zu tokuri*). Yoshidaya kiln.
158. Sake bottle with polychrome overglaze design of irises (*iro-e shōbu-zu tokuri*). Yoshidaya kiln.
159. Steamer with polychrome overglaze design of clematis flowers (*iro-e tessenka-mon mushi-wan*). Yoshidaya kiln.
160. General view of Yoshidaya kiln site.
161–63. Ceramic fragments unearthed at the site of the Yoshidaya kiln.
164. Incense burner with polychrome overglaze design of plants and water fowl (*iro-e sōka-mizudori-zu kōro*). Aoya kiln.
165. Four-handled bottle with polychrome overglaze peony-scroll design (*iro-e botankarakusa-mon shiji-hei*). Aoya kiln.
166. Large gourd-shaped sake bottle with decoration in overglaze colors and gold (*iro-e kinrande hisago-gata ōtokuri*). Miyamotoya kiln.
167. Hexagonal dish with design of boy on ox in overglaze colors and gold (*iro-e kinrande bokudō-zu rokkakuzara*). Miyamotoya kiln.
168. Shallow bowl with polychrome overglaze bird-and-flower design (*iro-e kachō-zu hirabachi*). Matsuyama kiln.
169. Shallow bowl with polychrome overglaze paving-stone pattern (*iro-e ishidatami-mon hirabachi*). Rendaiji kiln.
170. Two-tiered box with striped pattern (*iro-e shima-moyō nidanjū*). Aoya kiln.
171. Bowl with design of Chinese figures in overglaze colors with added gold (*iro-e kinrande tōjimbutsu-zu hachi*). Miyamotoya kiln.
172. Large dish with design of dragon in overglaze colors with added gold (*iro-e kinrande ryū-mon ōzara*), by Eiraku Wazen.
173. Two-tiered box with polychrome overglaze "court textile" pattern (*iro-e yūsoku-mon nidanjū*), by Eiraku Wazen.
174. Bowl with design of Chinese children at play in overglaze colors and gold (*iro-e kinrande karako-asobi-zu hachi*), by Eiraku Wazen.
175. Lidded bowl with polychrome underglaze design of twin dragons (*iro-e sōryū-mon gōsu*), by Eiraku Wazen.
176. Large incense burner with polychrome overglaze bird-and-flower design (*iro-e kachō-mon daikōro*), by Kutani Shōza.

INTRODUCTION

This translation of *Kutani Ware*, by the late Nakagawa Sensaku, will introduce an area of Japanese ceramics that is at once unknown and altogether too familiar to Western connoisseurs and students of Japanese culture. The gilt-and-polychrome export porcelains produced at the Kutani kilns in the late nineteenth century, to which Dr. Nakagawa refers at the conclusion of his text, are probably collecting dust on the back shelves of most American and European museum storerooms and in attic chests containing the souvenirs of a great-aunt's grand tour of the Orient. The benefactor of the Fogg Art Museum, Mrs. Elizabeth Fogg, for example, seeded the new museum's collection with a donation of her own Kutani mementos, including a number of bowls with the familiar "hundred ancients" motif.

Dr. Nakagawa's book, however, serves as a reminder that gilt monogrammed tea cups appeared only toward the end of a long and distinguished development of porcelain production in the Kaga area, and that the designation "Kutani" covered a wide range of wares produced at kilns scattered among the valleys that cut into the high ranges that supplied the fine porcelain clay. Some workshops enjoyed a long history while others were destined to a short life. Undoubtedly there are still other kilns not mentioned in this book that have escaped the notice of art historians. The energetic progress of salvage archeology during the past two decades has done much to draw attention to the history of Edo-period ceramics of which Kutani wares are representative. Excavation of both famous and forgotten kiln sites has challenged historians to correlate legend and tradition with excavated data. No excavation aroused more anticipation, however, than the digs in Kutani village in 1970 and 1971, occurring as they did just at the height of the debate concerning the relationship between Kutani and Arita. Rather than giving conclusive proof for one side or the other, however, the excavations only raised new questions, yielding shards of wares not previously associated with *either* kiln. The study of Kutani is still going on, and the "true story" will have to be the subject of a future publication.

In the meantime, however, quite a bit can be said. Documentary and archeological evidence gives a rich array of details concerning production of ceramics in Kaga. In most cases we know the actual names of the men who invested their wealth and hopes

11

in starting up new pottery workshops. Their activities in Kaga were typical of a "porcelain fever" that swept the country in the nineteenth century. Wide distribution of the ordinary porcelains produced in huge numbers in Seto, Kyoto, and Arita brought the gleaming white, glasslike vessels to the table of the ordinary householder for the first time, and small-scale workshops sprang up everywhere, backed by wealthy farmers or by entire villages dreaming of cashing in on the insatiable demand for porcelain. They relied on skilled potters trained at the major centers to produce the wares—unless they themselves underwent equivalent training—and Dr. Nakagawa's study makes clear the importance of Arita in particular as a fountainhead of technical instruction. A sojourn in Arita was a valuable credential for the provincial potter who aspired to a workshop and reputation of his own. In most cases, the willing support of the financial backer was returned with honest work on the part of the potter. Elderly craftsmen in the major porcelain centers, however, can still tell tales of the unscrupulous potters who "ate new kilns." Obliged for some reason (often heavy indebtedness) to leave their jobs and take to the road, they headed for the isolated villages deep in the mountains of central Japan, where they were certain of receiving a warm welcome from peasants seeking an alternative to the meager farming. The potter had only to locate acceptable clay, set up a workshop and build a kiln, and produce the first kiln-load of wares in order to receive full room and board from the excited villagers. While the wares were still cooling, however, he was already taking to the road again, cheerfully assuring the gullible villagers that they were now capable of operating the kiln themselves. Such tales account for many kilns with surprisingly short histories.

The production of pottery in Kaga, however, had a remarkably long history, as recent archeology has demonstrated. Not even ten years have passed since the first discovery of a group of medieval stoneware kilns in southern Ishikawa Prefecture, centering around the city of Komatsu. Operating since the twelfth century if not earlier, the so-called Kaga kilns were a major producer of stonewares on the north coast until the sixteenth century; in the seventeenth century, in response to new demands from clan leaders of sophisticated taste, stoneware gave way to the more fascinating and commercially valuable porcelain that was to be known under the name of Kutani.

Louise Allison Cort

1

OLD KUTANI

The term "Old Kutani" (*ko-Kutani*) refers to the body of porcelain, richly decorated with overglaze enamels in strong colors, that is believed to have been produced during the early and middle Edo period at Kutani, in what is now Enuma County, Ishikawa Prefecture. "Kutani" is used loosely to cover the products of the kilns that were established in various parts of present-day Ishikawa Prefecture toward the end of the Edo period and that are still operating today.

The study of Old Kutani is complex, and the exact provenance of the surviving pieces known under that name presents particularly knotty problems. Indeed, the fact that "Old Kutani" and "Kutani" have been treated together in this book is itself due in part to these difficulties. Any attempt to separate the two inevitably brings one up against this question of the origins of specific Old Kutani pieces; while Kutani ware, on the other hand, includes some pieces that came from kilns built on the site of the Old Kutani kilns and others that are deliberate imitations of Old Kutani.

The porcelain ware with polychrome overglaze decorations known as Old Kutani is noted for the brilliant yet massive effect achieved by a combination of body, colored glazes, and design; unique, it stands in the front rank of Japanese enameled ceramics alongside the Kakiemon and enameled Nabeshima porcelains and Ninsei wares.

Unfortunately, many aspects of its history remain unclear. As we have seen, the exact origins of the pieces to which the name is applied are often obscure. It has been suggested that many of them were in fact produced in Arita, or that Arita porcelain has been confused with them, or even—in recent years—that many of the pieces were produced at the end of the Edo period (1600–1867) or later. Either way, Old Kutani presents more problems than any other ware in the history of Japanese ceramics, and to ascertain the truth is one of the major tasks still facing the expert.

Various studies have been made of the historical aspects and on the works themselves with special reference to the Arita connection. As a result—although much still remains to be done—some points have emerged with relative clarity in recent years concerning the major problem of the nature of the connection with Arita ware.

In 1970 and 1971 large-scale excavations were carried out at the site of the old kilns by the Ishikawa Educational Committee, the Yamanaka-machi Educational Committee,

and a Kutani Old Kilns Commission specially formed for the purpose. The diggings were highly successful, furnishing knowledge of the nature, dates, and products of those kilns; I shall discuss these in detail later. However, although the fragments discovered have provided valuable information as to the kinds of ceramics turned out by the Old Kutani kilns—including some types not hitherto covered by the concept of Old Kutani—the data obtained are not sufficient to yield any immediate solution to the question of exactly when and where the surviving pieces known as Old Kutani were fired. This observation is based, of course, only on the very general preliminary reports of the excavation findings. As further detailed studies are issued, they may be expected to throw more light on the various questions involved.

Either way, it is safe to say that, for the moment at least, research and excavation are insufficient to provide clear-cut answers to the questions raised by the "Old Kutani" ware surviving today. To indulge in hypotheses would be pointless—nor is it the aim of this book, which seeks to present a general survey of Old Kutani as we know it. I shall confine myself, therefore, to discussing the history of Old Kutani and actual specimens with reference to the studies available at the moment, and to presenting a very broad survey of "old kiln" sites and the objects unearthed there on the basis of the preliminary reports of investigations of the Old Kutani kiln sites.

According to the generally held theory as to the beginnings of Old Kutani, clay suitable for making porcelain was discovered in the seventeenth century at a gold mine in the Daishōji fief in Kaga province, and the clan *daimyō*, Maeda Toshiharu, ordered a certain Gotō Saijirō to go to study ceramics at Arita, the foremost center of porcelain production, with the aim of setting up a kiln at Kutani within the clan's territory. This tradition, however, requires more detailed examination.

The Sites of the Kilns

It is said that Old Kutani was made in the village of Kutani, in what is now Enuma County, Ishikawa Prefecture, and the site of the kilns was already given in the *Jūshū Kaetsunō tairo suikei*—a document published in 1736 essential to any study of Old Kutani—and in the later *Bakkei kibun*, an account published in 1803 of famous scenic spots and historical sites seen by Tsukatani Sawaemon, district magistrate of the Daishōji fief, during a tour of inspection of the clan's territories. Later, during the Taishō era (1912–26)—probably in response to inquiries from visitors—a tablet was erected in Kutani village to the memory of "Gotō Saijirō," the supposed founder of the kilns, to be followed in the Shōwa era (1926–) by another tablet on the actual site of the old kilns. A number of surveys were carried out during the same period, but it was not until the large-scale excavations of recent years that the scale of the important kilns was discovered.

The site in question, which is known as Sanrin Ichigō, lies beyond the village of Kutani, 13.7 km. up the Daishōji River from Yamanaka Spa, a well-known hot-spring

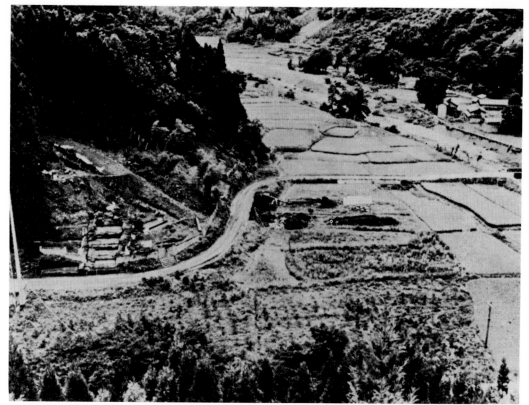

1. Overall view of the site of the Old Kutani kilns (from *Preliminary Findings of the First Series of Excavations at the Kutani Old Sites*).

The village of Kutani lies in a small basin where the valley widens somewhat at the confluence of the Daishōji River with its tributary the Sugino-mizu River, the former arising on Mount Dainichi and the latter flowing from the northwest of the same mountain. The site of the kilns lies in the hills on the far side of the river. The first full-scale excavations were carried out in 1970 and 1971.

resort. The village stands in a small basin formed where the valley opens up slightly due to the convergence of Daishōji River, arising on Mount Dainichi, with its tributary the Suginomizu River, which flows from the northwest slopes of Mount Ko-Dainichi. The kiln site is situated at the foot of the hills on the opposite side of the river from the village. Lying deep in the hills and buried by heavy snowfalls in winter, Kutani village has very few houses today. In the premodern age, moreover, roads within the fief were deliberately made steep or difficult to pass and bridges over rivers were kept as few as possible so as to protect it from the outside world. Thus Kutani was a remote backwood, accessible only by traversing difficult roads and fording countless swift-flowing currents; few places could have been more remote from the "civilization" of the big towns.

The Old Kiln Site

Two kilns were unearthed during the recent excavations (pls. 1–4). According to the general reports, kiln no. 1 was a linked-chamber climbing kiln (*rembō-shiki noborigama*) built by constructing terraces in a clearing on a northwest slope of the hills. It consisted of a firebox and thirteen ascending firing chambers, with a flue at the top; the stokehole has not survived. The distance, measured horizontally, from the lowest surviving part of the lower section to the flue is 33.4 m., the total restored length being more than 34 m. The height, from the surviving floor of the firebox to the floor of the flue, is 10.75 m.

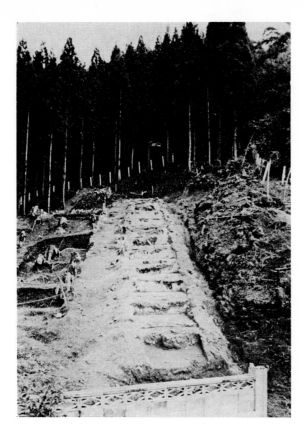

2. Overall view of kiln no. 1 (from *Preliminary Findings of the First Series of Excavations at the Kutani Old Sites*).

Kiln no. 1 was a linked-chamber climbing kiln constructed on a hillside facing northwest; thirteen firing chambers and the flue were excavated; the firebox has been lost. The total restored length exceeded thirty-four meters. Archeomagnetic findings put the estimated date at 1670 ± 30 years.

The dump—the area where fragments of pottery were thrown away—spread out on the left (north) side of the kiln proper; the site was originally a valley-shaped depression formed by a small landslide, and its suitability as a disposal area is believed to have been a factor determining the placement of the kiln itself.

Kiln no. 2 was built to the south of kiln no. 1, on a steep southwesterly slope. It was a linked-chamber climbing kiln consisting of a firebox and six chambers, the total sloping length being 13.7 m. and the horizontal length 13.02 m., the angle of the slope being an average 18.6°. It was roughly one-third the size of the no. 1 kiln, and the height, width, and depth of the chambers were all smaller. Structurally, it resembled kiln no. 1, but since it was built diagonally on a relatively steep slope, it has suffered severe damage. One part of the dump is found on the slope to the right of the kiln; the lower section, which lay in the path of a modern prefectural road, was pared away in the course of road construction, and the earth from it is believed to have been used in the bed of the road to the north of the bridge farther down the road.

A large quantity of varied shards of pottery were unearthed, principally from the no. 1 kiln dump: they include specimens of porcelain glazed with ivory white, bluish-white, celadon, iron, and cobalt blue glazes, as well as pieces decorated with underglaze cobalt, iron, and copper. A small number of fragments bore the polychrome overglaze decoration considered typical of Old Kutani, and one, a glaze test, bore the date 1656.[1] I shall discuss these valuable shards in greater detail later; as for the kilns themselves, their discovery has confirmed that ceramics were in fact produced on a considerable scale on the site at which the kilns are traditionally supposed to have existed.

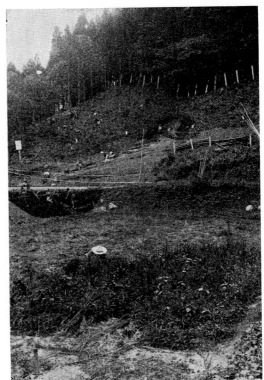

3. Overall view of kiln no. 2.
Built on a steep, west-facing slope to the south of kiln no. 1, this kiln consisted of a firebox and six chambers. Damage is severe, but the total length was 13.7 m., about one third that of kiln no. 1. Archeomagnetic findings set the date at which the kiln was abandoned at 1710 ± 40 years. It is believed to represent the final period of the Old Kutani kilns.

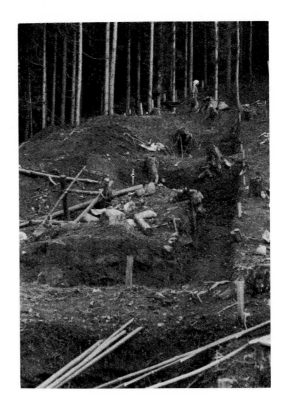

4. Site of kiln no. 2 during excavation.

The Dates of Production

The Founding of the Kilns

As for the date at which the kilns started production, let us first examine what old records have to say. The *Jūshū Kaetsunō tairo suikei* mentioned above, published in 1736, says, "This area in the hills is called Kutani. It was here that in the Meireki era [1655–58], Maeda Toshiharu [first lord of the Daishōji fief] commanded Mr. Gotō to start the production of pottery. There were other types of pottery too, similar to Nanking ware. At one stage production there was prohibited. Today the kilns are no longer in use."

The *Hiyō zasshū*, said to have been compiled in 1784, relates that in the time of Toshiaki, second lord of the Daishōji fief, Gotō Saijirō was sent to Karatsu in Hizen province to learn the art of making porcelain. Since they refused to teach the techniques to a man who had no wife or children, he married and established a family there, then, when he had mastered the art, abandoned them and fled back to his own home fief, where he made pottery at Kutani. It was in 1660 that Toshiaki became head of the fief, so this would mean that production must have started sometime in the Kambun era (1661–73), which began the following year. However, the work quoted was written fifty years later than the *Jūshū Kaetsunō tairo suikei*, and the story about a man's marrying a local woman in order to learn the secrets of pottery making is also told of, for example, the nineteenth-century potter Tamikichi of Seto. Again, the idea that Gotō Saijirō went to Hizen in the Manji era (1658–61) is contradicted by Miyamoto Kengo in *Kutani-yaki kenkyū* (A Study of Kutani Ware), which quotes the family history of the Nakazawa house to show that Saijirō was in Daishōji during that time.

The section on dates in the *Bakkei kibun*, which was written another twenty years later and which gives much information about Old Kutani, says that "Kutani ware is said to have been first produced, not by Gotō but by a man called Tamura Gonzaemon. In the shrine at Kutani there is a pair of vases with the inscription in cobalt blue under the glaze 'Tamura Gonzaemon, twenty-sixth of the sixth month, Meireki 1 [1655].' It is held that these vases were the first work that he produced and were presented by him to the shrine." There is a fragment of what seems to be a serving bottle for sacred wine which bears the same inscription, and it is believed to be related to the vases mentioned in the *Bakkei kibun*.[2]

Such questions apart, Edo-period (1600–1867) records seem to agree that production began either during the Meireki era (1655–58) or very slightly before that at the earliest. Works published after the Meiji Restoration of 1868 are less unanimous. The major work entitled *Kōgei shiryō* (Notes on the Applied Arts; Kurokawa Saneyori, 1878) puts the date in the Kan'ei era (1624–44), while *Hompō tōsetsu* (Description of Japanese Pottery and Porcelain; Imaizumi Yūsaku, 1891), *Nihon tōki zensho* (A Compendium of Japanese Ceramics; Ōnishi Ringorō, 1913), and others follow the same theory but assert that porcelain with colored overglaze decoration was not produced until the return

to the fief of Gotō Saijirō who went to Arita during the Manji era (1658–61) to learn the methods of its manufacture.[3]

On the other hand, a work called *Kutani tōyō enkaku-shi* (A History of the Kutani Kilns), written around 1877 by Asukai Kiyoshi, a former member of the Daishōji fief, claims that production began in 1651. This theory is followed by *Fuken tōki enkaku tōkōgei* (The Ceramic Applied Arts: A History of Ceramics in the Various Prefectures; Shioda Makoto, 1886), *Tōki shōshi* (Notes on Ceramics; Koga Seishū, 1890), and *Kōgei kagami* (A Mirror of the Applied Arts; Yokoi Tokifuyu, 1904), all of which accept the idea that colored porcelain began following Saijirō's return from his trip to Arita during the Manji era.[4]

Since then, and particularly since the end of the war, all kinds of theories have been put forward, but the one best supported by the evidence of old documents and pottery fragments is that Old Kutani began around the Meireki era (1655–58).

According to the reports on the recent excavations, the structure of kiln no. 1 conforms by and large to the oldest known form of early seventeenth-century Japanese porcelain kilns.[5] Again, archeomagnetic measurements—one of various scientific methods employed during the investigations—have given dates ranging within thirty years on either side of 1670.[6] In terms of Japanese era-names, this would mean that the works in question were produced over a period of years somewhere between Kan'ei 18 (1641) and Genroku 13 (1700), with Kambun 10 (1670) as the central point.

Another clue is afforded by the fragment of a glaze test unearthed from the dump of kiln no. 1 and bearing the inscription in underglaze cobalt blue "eighth month, Meireki 2 [1656], Kutani" (pl. 132). This seems almost certainly, judging from the impurity of the blue glaze, to date from the very earliest period of the kiln's activity. Thus it is fairly obvious not only that production had started by 1656 but that the establishment of the kiln itself probably occurred not long before this date. This date would also, of course, agree with the archeomagnetic findings.

These findings, where the second kiln is concerned, have yielded the date, with a wide margin for error, 1710±40—in terms of Japanese eras, from Kambun 10 to Kan'en 3, with Hōei 7 as the central year. This suggests—to consider only the earliest limit for the moment—that the kiln was built later than kiln no. 1.

What of the situation within the fief itself around the mid-1650s? Maeda Toshiharu, the first daimyo of the Daishōji fief, is known to have received the branch fief in 1639, at the age of twenty-one, so he would have been thirty-seven or thirty-eight by then. Although he was a man of action who liked trying his hand at all kinds of enterprises, to branch out into an entirely new industry such as ceramics—even granted the opportunity afforded by the discovery of suitable clay in the gold mine at Kutani—would surely have required a degree of knowledge and experience that he would be unlikely to have possessed before this age. Moreover, the unfamiliarity and the very nature of the undertaking would have necessitated a considerable period for preparation. Furthermore, as we shall see later, records show that the Gotō Saijirō who is believed to have

19

been associated with the enterprise was still doing work at the mine in the Shōhō (1644–48) and early Keian (1648–52) eras, which preceded Meireki.

On the other hand, financial difficulties necessitated an overhaul of fief affairs in 1653, and it seems eminently probable that a fief lord so interested in business and the promotion of industry would have launched into ceramics as one practical means of getting the fief's economy on its feet again.

The studies published in the late nineteenth and early twentieth centuries cited above, though placing establishment of the kiln as such in the Kan'ei (1624–44) or Keian (1648–52) era, all state that porcelain with polychrome overglaze decoration was not produced until the Manji era (1658–61), after Gotō Saijirō returned home from his studies in Arita. Again, the *Jūshū Kaetsunō tairo suikei* states that besides pottery something "similar to Nanking ware" was produced, but it is not known whether this refers to polychrome overglaze decoration or to blue underglaze decoration; either way, the precise circumstances under which the kiln started operations are still not clear.

The Abandoning of the Kilns

There are various theories, again, concerning the date when production ceased at the Kutani kilns. One view, which holds that this took place not later than 1695, derives from a passage in the memoirs of Maeda Sadachika which states that on the twenty-fifth day of the ninth month of that year, thirteen Omuro-ware incense burners ordered from the Kyoto kiln proved to be so poorly made as to be useless and that the order had to be remade. If Kutani ware had still been in production at the time—it is argued—there would have been no need to order ceramics from Kyoto.

A work entitled *Kaga ōrai*, an account of local products in the Kaga area published in 1672, though making no direct reference to the date at which the kilns were abandoned, lists "Daishōji-ware" tea bowls as a product of the area, along with textiles, metalwork, and foodstuffs, while another work of the late seventeenth or early eighteenth century, entitled *Sanshū meibutsu ōrai* and believed to be modeled on the work just mentioned, also refers to "Daishōji-ware" blue-and-white tea bowls, so it is believed that Kutani was still being produced in the last decade or two of the seventeenth century at least. Another theory holds that the kilns fell into disuse during the period from 1692 to 1704. This is based, first, on the death in 1692 of Toshiaki, second daimyo of the clan, who concerned himself with the industry in line with the last wishes of the first lord, Toshiharu; and, second, on the belief that Gotō Saijirō, thought to have been in direct charge of operations, also died in 1704. The disappearance of these two vital figures, it is argued, led to the abandoning of the kiln.

This theory is backed up by the fact of the fief's financial difficulties around the time. A period of misfortunes, including a very poor harvest in 1675 and the burning of the clan lord's residence in Edo in the twelfth month of 1682, had reduced the clan to penurious circumstances during the Jōkyō (1684–88) and ensuing Genroku (1688–1704)

eras. During the latter era in particular, it was not even possible to pay clan samurai serving in Edo their proper stipends.

It seems quite possible that such financial difficulties should have led to the abandoning of the Kutani operations, which involved high costs; and the death in rapid succession of two of the most important figures concerned would also have contributed to the kiln's demise.

Various other causes have been suggested, among them a shortage of the glazes that had to be brought in from outside and shogunate suspicions concerning the enterprise. Whatever the case, it has been generally accepted that the kilns were abandoned sometime in the Genroku era (1688–1704). Nor does this view seem to be contradicted by the archeomagnetic measurements already mentioned, which set the time limits for operations at 1641 to 1700 and for kiln no. 1 1670 to 1750 for kiln no. 2.

The one doubtful point here is posed by the findings at the second kiln. Even allowing for a wide margin of error, to accept the latest possible date of 1750 would put the abandoning of the kiln forty-six or forty-seven years after the end of the Genroku era (1688–1704). One wonders why no one so far has gone into the possibilities this suggests.

THE MEN RESPONSIBLE

Three names are usually cited as those of the men who played the most important roles in the Old Kutani ceramics industry: Maeda Toshiharu, first daimyo of the Daishōji fief, who was responsible for the original plan, and Gotō Saijirō and Tamura Gonzaemon, who assumed practical and technical responsibility.

Maeda Toshiharu

Toshiharu was born in Kanazawa in 1618, the third son of Maeda Toshitsune, third daimyo of the Kaga fief. In 1639, at the age of twenty-one, he was given a fief of his own and became first lord of the new Daishōji clan. Although his lands represented a yield of only 70,000 koku of rice,* he had the backing of the powerful Kaga fief, while his mother was a daughter of the Tokugawa shogun Hidetada, so that he seems to have lived a life of considerable luxury. He appears to have had a natural aptitude for business; he encouraged industry, concerned himself with the opening up of new paddy fields and mines, and even, it is said, personally took the lead in the work. At the same time, he was a cultured man, with a taste for the tea ceremony; he is said to have been a collector of the bowls and other utensils used in the tea ceremony, and to have been a connoisseur of raku tea ceramics in particular.

The chance discovery of porcelain clay at Kutani, where there was a gold mine, and the fact that there was no ceramics industry in the fief at the time are said to have

*One koku is equivalent to about 180 liters of rice, traditionally the average yearly consumption of one person. The Kaga fief had a revenue at this time of some 1,025,000 koku.

given Toshiharu the idea of founding the Kutani kilns. The Kaga fief, from which his own derived, frequently sent retainers to Hizen province, where the Arita kilns were located, and the specimens of textiles and ceramics which they brought back were quite possibly what gave the young Toshiharu his enthusiasm for pottery. He died in Edo in 1660 at the age of forty-two.

Gotō Saijirō

The name of Gotō Saijirō has long been cited in books and documents either as the man who studied and brought back to the fief the techniques of porcelain production or as the man chiefly responsible for the kilns when they started operations.

The popular tradition concerning Saijirō states that he originally lived in Kanazawa where he served the Kaga fief lord, enjoying a yearly stipend of 100 *koku* of rice and engaging in some aspect of metalwork. He later moved to the Daishōji fief. Here he was given a stipend of 150 *koku* and had a hand in the opening of the Kutani gold mine, where he was in charge of the operations involved in separating gold and silver from the ore, but with the discovery of good clay and the decision to start a ceramics workshop, he switched to porcelain production. On clan orders he went elsewhere to study the techniques of ceramic making, and on his return home started the Kutani kilns.

The place where he is said to have gone to study is generally thought to have been Arita, but because the Arita techniques were kept secret from outsiders, it is sometimes alleged that he went to Nagasaki and brought back with him a potter who had come from China. It has also been conjectured, from the fact that immediately following Kakiemon's success in producing polychrome porcelain, a certain Hanawa Ichirōbei (official purchaser to the Kaga fief) came to buy some of it, that Saijirō learned the techniques of the Kyushu potteries under cover of a job as clan purchaser, and that in the end he took a potter home with him.[7] The kilns as revealed by the recent excavations, and the shards found there, do indeed suggest that the methods of making porcelain were brought in from Arita, but no details are so far known about this.

There are all kinds of semianecdotal stories about Saijirō and pottery. There is the story already mentioned, for instance, that in order to gain access to the secrets of porcelain making in Arita he took a local wife and had a child by her, then later abandoned his family, returned to his fief and founded the Kutani kilns. Another says that by the time of his return the first fief lord was already dead and he himself had so far overstayed his leave of absence that he was dismissed from service; however, he was given a small allowance out of sympathy for what he had been through, which he used to start a kiln of his own. Yet another legend tells how the fief, fearing shogunate disapproval of the Kutani ceramics industry, passed all the responsibility for it onto Saijirō. The Kaga fief was a *tozama* fief (its daimyo was not a hereditary vassal of the shogunate) but it was one of the most powerful fiefs in the country, and the shogunate naturally kept a wary eye on its every move. Thus it is not inconceivable that all kinds

22

of rumors should have started circulating about the success of the Kutani wares, as a result of which an attempt was made—either by direct interference from the Kaga fief in the affairs of the branch fief of Daishōji, or by self-imposed restraints on the part of the Daishōji fief—to show that no disloyalty to the shogunate was being contemplated. It is possible, too, that in the process the hapless Saijirō was made a scapegoat, or even that the kilns themselves were abandoned.

The question is further complicated by the fact that there were at least two men called Gotō Saijirō, and there has been considerable argument as to which of them was involved in the Kutani kilns. Since this question, too, has a bearing on the study of Old Kutani, I will outline it briefly here.

The name Gotō Saijirō occurs in various documents and inscriptions, sometimes alone, sometimes with additional personal names: Yoshisada, Yoshitsugu, Sadatsugu, or Tadakiyo. The following are the main sources.

"Gotō Saijirō Yoshisada." A fitting on a long sword in the possession of Shirayama-hime Shrine in Ishikawa County bears the inscription "1628, Fujiwara Ason, an auspicious day of the eleventh month, Gotō Saijirō Yoshisada, resident in Kanazawa, Kaga province." The short sword from the pair also bears the same name. One should take into account here the family lineage records of Gotō house and of Gotō Shichibei (both compiled around 1680–90), which state that "Yoshisada" was a samurai with a stipend of one hundred *koku* of rice who was connected with metalwork in the Daishōji fief. He died in 1652, and according to his genealogy his descendants lived in Daishōji, working as potters.

"Gotō Saijirō Yoshitsugu." This name occurs in the inscription on one short sword in the possession of Shirayama-hime Shrine, and according to the Gotō family genealogy, was a name later taken by the Yoshisada already mentioned.

"Gotō Saijirō Sadatsugu." An inscription on the temple bell at Ganjō-ji in Daishōji reads, "Kan'ei 16 [1639], early winter. . . . Lord of Kaga Fujiwara Ason. Gotō Saijirō *fecit*. Sadatsugu [signature]," and another on a bell at the Honzen-ji temple reads, "Late Kan'ei 18 [1641]. . . . Fujiwara Ason, Lord of Kaga. Gotō Saijirō *fecit*. Sadatsugu [signature]."

"Gotō Saijirō Tadakiyo." In the Gotō genealogy already quoted, Tadakiyo is shown as the second head of the family begun by Gotō Saijirō Yoshisada. The second son of Ichiemon Kiyoshige, he left his own branch of the family in order to succeed to Gotō Saijirō Yoshisada; he was given five retainers, in his old age took the name Gen'i, and died on the twenty-fourth of the third month, 1704. This would be the man mentioned by the Gotō Shichibei genealogy as living in Daishōji and working as a potter.

"Gotō Saijirō" (no additional name). The *Jūshū Kaetsunō tairo suikei* and the other two early documents dealing with Old Kutani all refer either to "Gotō Saijirō" or simply to "Gotō." Again, in records of the Daishōji clan the entry "150 *koku*, Gotō Saijirō" occurs for the year 1642, and appears again in 1646, 1649, and 1652. The name Saijirō occurs in a letter addressed by the first clan lord, Toshiharu, to Tsuchida 23

Kiyoemon, who might be described as the shogunate's general overseer of the Kutani mines; this letter is believed to date from between 1644 and 1650, suggesting that Saijirō was engaged in work at the mines around that time.[8]

The Nakazawa genealogy records that in the fifth month of 1660, when Nakazawa Kyūbei committed suicide following the death of his master Toshiharu, a certain Gotō Saijirō was at the scene. The records of a temple called Jisshō-in—admittedly rewritten during the Tempō era (1830–44)—apparently record the death of Saijirō as having taken place on the fourth day of the third month, 1683.

Three theories have been advanced on the basis of these works: that Yoshisada and Yoshitsugu were the same man, and that Tadakiyo was his successor; that the Sadatsugu in the inscription on the bells was identical with the Saijirō described in documents simply as "Gotō Saijirō," and that he was the founder of the Kutani kilns; and that Yoshisada, Yoshitsugu, and Sadatsugu were all the same man, who had no connection with the Kutani kilns, the true founder being Tadakiyo.

In recent years, it has also been suggested that Yoshisada and Sadatsugu were the same man, a metalworker who worked at the furnaces; according to this theory, he was associated with the Kutani gold-mining operation as well as having a hand in the founding of the Kutani kilns, but the figure who contributed most to the technical and business side of the kilns was probably Tadakiyo.[9] Isono Fūsenshi, while following much the same theory, makes further deductions concerning the date of Tadakiyo's death and his social status.[10]

There are, thus, many differing pieces of evidence—and interpretations of them— where Saijirō is concerned, and nothing accurate is known as to just who was concerned and how in the Kutani kilns, but all in all it seems most reasonable to suppose that Yoshisada and Sadatsugu were one and the same person, and that he had a hand in the establishment of the Kutani kilns; also, that his successor Tadakiyo was associated with the technical aspect of production.

Tamura Gonzaemon

The *Bakkei kibun* mentions this Tamura Gonzaemon as responsible for producing Kutani ware, while a fragment of what appears to be a sake bottle has been found with an inscription in underglaze cobalt blue saying, "Twenty-sixth of the sixth month, Meireki 1 [1655], Tamura Gonzaemon." Some studies made in the late nineteenth century claim that Tamura founded the Old Kutani kilns in conjunction with Gotō Saijirō, or that Tamura alone was responsible.

Other scholars have claimed that the "Tamura Gonjūrō" named in the temple register of Jisshō-in, the site of the family tomb of the lords of the clan, refers to this Tamura Gonzaemon, while others assert that the samurai called Tamura Kurōsuke, named in the records of Yoshidaya Den'emon of the Yoshidaya kilns as a samurai with a stipend of fifty *koku* of rice, was a descendant of the same man. Another scholar, citing the fact that a Kambun-era (1661–73) map of Daishōji (existing as a Bunka-era

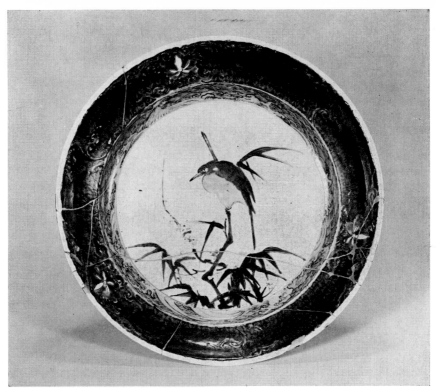

5. Shallow bowl with polychrome overglaze design of kingfisher. Old Kutani. H. 6.8 cm., d. 35 cm.

A picture of a kingfisher, done in green and yellow, perched among bamboo and red flowering plum is encircled by a wave pattern covered with yellow glaze, while the outer border has a floral pattern in deep blue against a green background. The kingfisher has a keen eye and is filled with a tense watchfulness that is skillfully set off by the half-open plum blossoms. Designs incorporating birds are common in Old Kutani, but this is a particularly powerful example. The underside of the bowl has floral scrolls in deep blue overglaze.

[1804–18] copy) shows the samurai-style residence of one Tamura Kurōsuke in a non-samurai residential section, suggests that this indicates that he was a workman who had been specially elevated to samurai status in recognition of his services to the Kutani kilns.[11]

In recent years Mr. Saitō Kikutarō, referring to the statements in the *Bakkei kibun* that the site of Gotō Saijirō's residence was in Kutani, and that Kutani ware was started not by Gotō but by Tamura Gonzaemon, has suggested that Saijirō was the man who looked for suitable clays and selected the site for the kilns, while the actual business of the kilns following their establishment was supervised by Tamura.[12]

Whatever may be the truth, it seems safe to assume that Tamura was closely associated in some way or other with the beginning of the ceramics industry in Kutani.

TYPES OF VESSEL

Types of Kutani ware surviving today include dishes (*sara*), bowls (*hachi*), footed bowls (*daibachi*), sake bottles (*tokuri*), vases (*hei*), lidded containers (*futamono*), and spouted sake servers (*chōshi*). Dishes and bowls are particularly common. The dishes range

in size from large specimens more than 30 cm. in diameter to medium and small sizes, and cover a variety of shapes including round, nonagonal, octagonal, hexagonal, square, foliate-rimmed, and gourd-shaped. The bowls, which include both shallow and deep bowls as well as others with stands or with handles, also include some over 30 cm. in diameter. A large number of the sake bottles are gourd-shaped, including some that are faceted or spiraled.

The large dishes and bowls are particularly notable for the general excellence of their large and freely drawn designs. Saitō Kikutarō, who has studied these pieces from a broad perspective and put forward a new approach in his *Ko-Kutani shinron* (A New View of Old Kutani), attributes this in part to the fact that the large "Swatow" dishes (called *gosude* in Japanese) of southern China and similar large dishes (Japanese *fuyōde*) from the porcelain center Ching-te-chen in Kiangsi province that had been imported in such great quantities since early Edo times came to be imitated at Kutani—partly to make up for the cessation of supplies of large dishes from Ching-te-chen in 1654. He similarly attributes the nine-sided dishes to the influence of Chinese design. In much the same way, he suggests, the fact that the Kaga fief is known to have ordered tall-footed Delft bowls from Holland has something to do with the frequent occurrence of footed bowls in Kutani ware, and he also sees the ring-shaped vases of Kutani ware as inspired by similarly shaped Delft pieces. Such adoption of new shapes derived from Chinese and Dutch ceramics constitutes, he asserts, a major feature of Old Kutani as a whole.

Most of the pieces just discussed are decorated with polychrome overglazes, though there are some, known as "Green Kutani" (*aode*), in which most of the surface is covered with a green glaze, as well as others in which a deep blue glaze is used in the same way.

TYPES OF BODY AND OVERGLAZE

The body normally employs a grayish, coarse-grained porcelain clay. Those pieces that have polychrome overglaze decorations are sometimes covered with an opaque, dull white glaze showing considerable variations in the thickness of the fired glaze, including places where it has cooled where it ran. On other pieces, the surface is covered with a smooth, even white glaze with a bluish tinge, and the firing has taken well, the glaze melting evenly to give a good shape. On still others the glaze, although the surface is even enough, has been applied thickly and is pitted with small holes that suggest the formation of bubbles as the glaze melted at a high temperature.[13]

The pieces with polychrome decorations may be divided into those that employ cobalt blue decoration under the glaze and those that employ only overglaze enamel decoration. In most cases where blue underglaze is used, it is confined to the sides of the stands of dishes and bowls, or to a line or two on the underside, but in certain cases it is used for the outlines of, or as an integral part of, the design. Its shade varies from a pale indigo to a sooty dark blue.

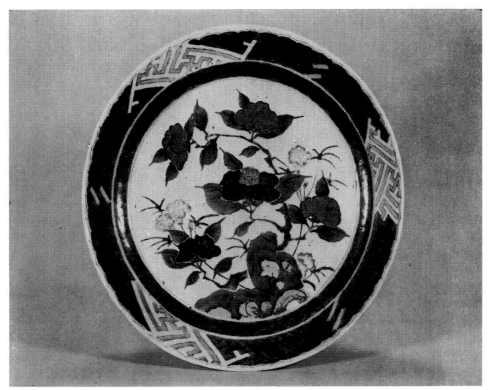

6. Shallow bowl with polychrome overglaze design of camellias. Old Kutani. H. app. 7 cm., d. app. 36 cm.

Camellia designs are rarely found on Old Kutani, though similar designs of peonies are common. The camellia blooms are done in deep blue and purple, the leaves and rocks in green, the stems in bluish-green, and the pinks in red. The design is encircled by a band of deep blue, the border outside being filled with a geometrical pattern in black covered in green glaze with a linked-swastika (*sayagata*) pattern in yellow glaze at three points. The whole effect is well integrated; the coloring, though rich, is consistently subdued, even the camellias using no bright color. The underside has simple floral scrolls in purple and dark blue.

The colors of the overglazes used in Old Kutani are for the most part dark and restrained; they include red, green, yellow, dark blue, and purple.

The red is somber, with a kind of quiet depth, and the layer of glaze is thick. Its effect is quite different from the bright red, close to vermilion, of Kakiemon and enameled Nabeshima, or the insistent reds of Imari.

The green used is clear, though heavier than the transparent green of Nabeshima or the fresh green of Kakiemon. The green of the pieces known as "Green Kutani" (*aode*) is clear and closer to blue. This Green Kutani ware has features not to be found in any other ware, ranging as it does from designs that are preponderantly green yet with one or two other colors such as yellow, purple, or dark blue added, to a layer of green applied uniformly over a design executed in black.

The purple, a paler shade than that of other wares, is transparent and subdued. The yellow, too, is subdued rather than bright.

These restrained yet satisfyingly deep hues obviously play an important part in creating the rich effect of Old Kutani. A great deal of care is also lavished on the ways in which they are combined. In Old Kutani, according to Mr. Saitō, green and yellow form the basic keynote, their combination being the pivot on which the design turns; the two colors are used to provide blocks of color depending on the requirements of the pattern, and are skillfully set against each other to achieve a unique effect. One notices, too, the extremely apposite use made of yellow, not only as a foil to the green but also as a means of emphasizing a focal point in a composition or in effectively knitting together a whole pattern of colors. Purple, too, is employed sometimes to provide a solid mass of color, and it has other uses as well; it is frequently used, for instance, for the trunks of trees. Red is usually applied very sparingly, though it occurs to some extent on pieces with complex designs; in the latter, the other colors sometimes seem brighter than usual, and sometimes the use of yellow, green, and purple differs from the cases already described.

On this question of colored glazes, Saitō Kikutarō has recently published the results of his latest studies in *Ko-Kutani shinron* (A New View of Old Kutani), in which, to summarize very briefly, he attributes the characteristic Old Kutani effect to a wide range of sources; thus he traces the typical Old Kutani combination of purple, dark blue, green, and yellow (unlike Imari where red predominates, Old Kutani uses very little red) to the color scheme of glazes used in the *kōchi* glazes of Kyoto or more directly to the three-color enamel *kōchi* wares (*kōchi sansai*) imported from coastal Chinese kilns. The dark blue that makes such a striking effect in Old Kutani as in other Japanese porcelains depended, he says, on *lājvard* glaze from Persia, and he discusses the areas where the ore was mined, the use of the glaze in Persian and Chinese ceramics, and the means whereby it was transported to Japan for use in Kutani. Old Kutani coloring, he asserts, was at its most powerful and most beautiful during the period when this blue glaze was most freely available.

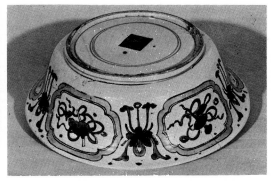

7–9. Deep bowl with polychrome overglaze design of snowy herons. Old Kutani. H. 11 cm., d. 37.3 cm.

An octagonal frame in yellow glaze encloses a design of herons left in white on a blue background with added lines in red. The surrounding space is entirely filled with a pattern of what seems to be either grassy undergrowth or waterweed, done in green, dark blue, yellow, and purple, with carp and catfish added here and there. The composition, though deriving from designs found on large dishes (called *fuyōde* in Japanese) from the Chinese porcelain center Ching-te-chen, is unusual, and trouble has been taken to achieve a decorative effect. The underside has five decorative frames in yellow glaze with "eight sacred treasure" motifs inside them and, between the frames, what look like modified *kabutobana* (wolfsbane) in dark blue and purple. The inscription consists of complex characters done in black and covered in green glaze. The same characters are found on many other pieces, such as the footed bowl with design of woman bathing (pls. 66–67) and pieces with the same kind of decorative composition as this bowl, but no one has succeeded in deciphering them.

10–12. Shallow bowl with polychrome over-glaze design of lotus flowers and kingfisher. Old Kutani. H. app. 6.3 cm., d. app. 33.1 cm. The lotus leaves have thickly applied green glaze; the flowers are done in purple and the bird in green and red, while the heads of the rushes are lightly touched with yellow. The border is filled with the "seven jewel" (*shippō-tsunagi*) motif in deep blue and yellow, with pine foliage in purple at intervals. The moment of the kingfisher's alighting on the rushes is well captured, and the whole is a highly successful example of a design adapted to Japanese tastes. The underside has alternating ivy scrolls and flowering plum motifs in dark blue. The inscription, the character *fuku* ("good fortune") in black within a double square, is covered with dark blue glaze.

Where green and yellow are concerned, he cites the existence of early *raku* ware made in Kyoto copying the yellow-and-green glazes of *kōchi* ware, and believes that the predominance of these colors in Old Kutani similarly derives from Kyoto ceramics or *kōchi* three-color ware; even the *aode* ware in which green predominates is, as he sees it, only a logical outcome of the *kōchi* approach to coloring.

To sum up, Saitō believes that green and yellow were the two pivotal colors around which Old Kutani polychrome decoration developed. The only three colors used at first were green, yellow, and red, purple being added later in imitation of *kōchi* three-color ware. Finally, materials brought from overseas by the Dutch trading house were used for a dark blue glaze, thus completing the complement of colors usually found in this ware. Mr. Saitō's theories concerning color are worthy of attention, particularly since they extend their field to take account of factors which hitherto have either not been noticed or have been left out of consideration.

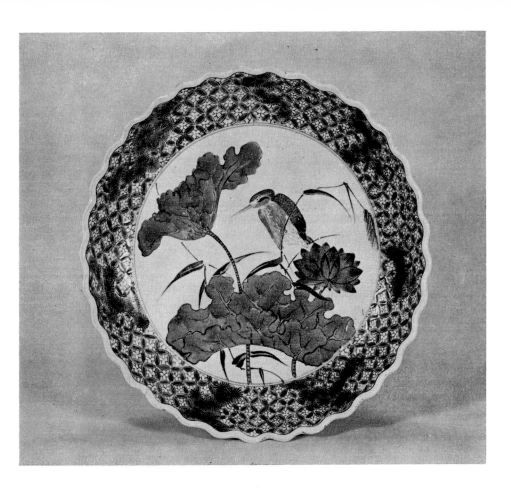

15-16. Square dish with polychrome overglaze design of paths through paddy fields. Old Kutani. H. 4.8 cm., l. 23.3 cm., w. 20.3 cm.

This has long been well-known among Old Kutani pieces for its unusual design. The central inner surface uses a broad stripe in dark blue to conceal a flaw that developed during making, and this is taken as the basis for a design suggesting the raised paths that separate paddy fields. The dark blue lines are edged with green, and the whole is divided into four sections bordered inside with yellow and deep blue, and containing plum blossoms in red. The interior of the sides of the dish is decorated with a diagonal lattice (*tasuki*) pattern in dark blue, while the rim has flower motifs in red. The outside of the foot is done in green with floral scrolls left in white, while the interior of the foot is filled with a complex geometrical pattern, each square containing a cross-shape in white with, inside it again, a swastika in red.

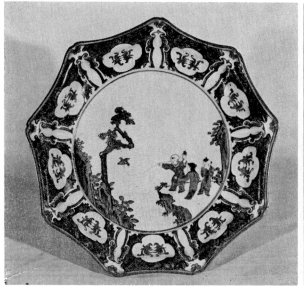

13-14. Shallow nonagonal bowl with polychrome overglaze design of Chinese children. Old Kutani. H. 5.7 cm., d. 33.6 cm.

Both the shape of this dish and the composition of the decoration are similar to those on the shallow nonagonal bowl with bird-and-flower design shown in plate 83. The border has nine four-lobed medallions left in white against a green background, each containing a *daki-myōga* motif in red with paired motifs in dark blue between the medallions. The circular central surface has a picture of Chinese children playing with a bird on a string, done in various colors and executed in a conscientious manner reminiscent of the Kanō school. The sensitive handling of the colors enhances the work's air of classical refinement. The underside, again as in the bowl in plate 83, is circled by stylized peony scrolls in underglaze cobalt blue. The inscription is different, but equally undecipherable.

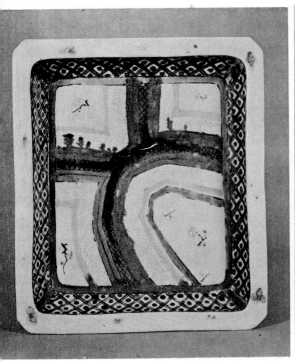

17. Footed bowl with the polychrome overglaze design "resting in the shade of willows." Old Kutani. Tokyo National Museum.

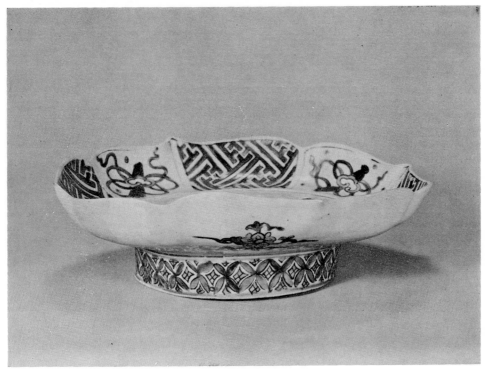

18. "Twisted gourd" sake bottles with polychrome overglaze flower-and-grasses design. Old Kutani. H. 20.1 cm. Tokyo National Museum.

Gourd-shaped pieces, as well as dishes and the like in "twisted-flower" shapes are common enough, but a twisted gourd shape such as this is rare. The *bishamon* and swastika patterns are done in red, while the flower-and-grass designs are painted in yellow with some green and red. The work shows grace and a loving care for detail.

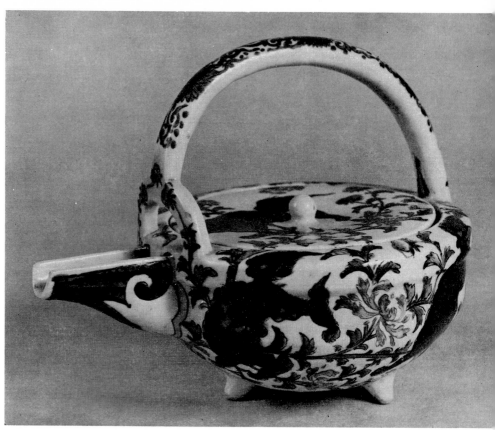

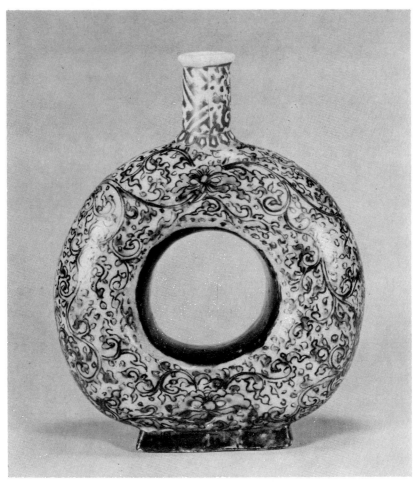

20. Ring-shaped vase with polychrome overglaze design of peony scrolls. Old Kutani. H. 21.5 cm.

This shape is extremely rare. A similar shape is found in the *sue* ware of ancient Japan, but the work shown here would seem to be a Japanese adaptation of Delft ware, first imported from Holland in the first half of the seventeenth century. The linked-swastika pattern on the neck is in red, while the peony scrolls on the body have green stems and purple flowers on a yellow base.

19. Sake server with polychrome overglaze peony-and-lion design. Old Kutani. H. 19.4 cm. Eisei Bunko.

The peony flowers and stems are done in red and purple respectively, the leaves and lions in deep blue and green. The spout has decoration in green glaze, with a band of yellow at the base; the handle has chrysanthemum scrolls done in underglaze blue. The design of lions and peonies is flowing and full of life, and the decoration of the spout is stylish. A peony leaf painted in the center of the base was probably added as an afterthought.

21–24. Fragments of bowls unearthed at the kiln sites (from *Preliminary Findings of the First Series of Excavations at the Kutani Old Sites*).

The shards unearthed, almost all of them at the site of the dumps, are covered with celadon, bluish-white, white, iron, ash, and bright blue "lapis lazuli" glazes. Some decoration in underglaze cobalt and iron occurs, and a very few have polychrome overglaze decoration. The most common shapes are *wan* (small food and tea bowls), dishes, and bowls (*hachi*), though there are a few tea caddies, vases, large jars, and special shapes. The bowls, which are of both pottery and porcelain, come in a wide range of sizes and depths, and the glazes include celadon, blue-toned white, white, and iron. Much of the porcelain is thin and of excellent quality.

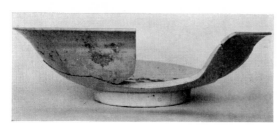
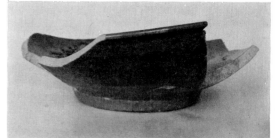

Types of Ware Excavated

Let us next survey briefly the findings of the preliminary reports concerning the types of wares uncovered by the excavations of recent years.

Although few specimens have been discovered intact, the fragments found have pointed to a large number of bowls (*hachi*), dishes, and *wan* (food and tea bowls, smaller than *hachi*), together with some tea caddies (*chaire*) and incense burners (*kōro*), and a few vases, large jars (*tsubo*), and special items such as inkstones and ornamental objects (*okimono*) in the shape of birds. Incidentally, the large bowls generally classified today as Old Kutani are, very roughly speaking, around 47.8 cm. in diameter and 13 cm. in height at the most, the average diameter and height being 35.6 cm. and 7.8 cm. respectively.

The excavated bowls include both porcelain and pottery and occur in a range of sizes (pls. 21–26). The glazes used are celadon, bluish-white, ivory white, and iron. The large bowls range from 31 cm. in diameter and 10 cm. in height to as much as 53 cm. in diameter and 11 cm. in height. Some are deeply curved while others are flat with an angled rim. The clay of the body is sometimes a white, fine, good quality clay, sometimes a somewhat coarser yellowish clay, and sometimes a rather coarse grayish-white clay. The medium-sized bowls resemble the larger bowls in the glazes and types of clay used,

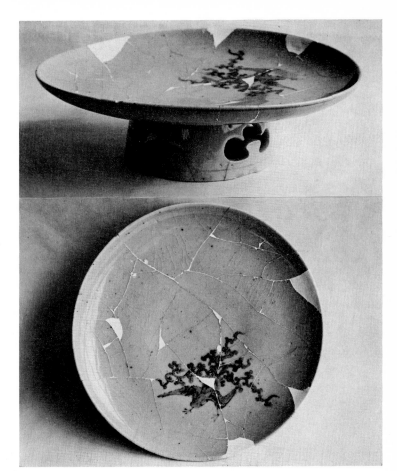

25–26. Footed bowl unearthed at kiln site (from *Preliminary Findings of the Second Series of Excavations at the Kutani Old Sites*). H. 6.9 cm., d. 22.5 cm.

This is one of three bowls that were found in whole or fragmentary form at the site of the no. 1 kiln dump. A high-quality body is covered with a slightly grayish-white glaze with a cobalt underglaze picture of a phoenix on the surface and openwork decoration in the foot. It is interesting to note that the works known today as Old Kutani include a footed bowl (pls. 64–65) that resembles this.

their size ranging from 18 cm. in diameter and 7.5 cm. in height to 28 cm. in diameter and 11 cm. in height.

Variations on the bowl shape include some mortars (*suribachi*), but particularly interesting are the bowls with tall stands. Three were dug up from the site of the kiln, one consisting only of fragments of the stand, but all use white glaze on a high-quality body, the color of which is somewhat grayish. Another, 21.8 cm. in diameter and 6.5 cm. in height, has a high stand with "clover-shaped" openwork decorations at two points. The remaining bowl is 22.5 cm. in diameter and 6.9 cm. in height (pls. 25–26). It has a design of a phoenix in blue underglaze placed slightly off-center on the interior surface and openwork decoration at four points on its stand. Specimens of similar design and roughly the same size occur among surviving Old Kutani dishes with stands.

The dishes also come in both pottery and porcelain (pls. 27–30). Their diameters range from 13 cm. to 30 cm., and the body and glazes used are much the same as in the bowls just discussed. There is a considerable variety of shapes: some are shallow, almost like plates, some rise steeply from the main body to the rim, and some have a flat rim turned up at the edge. Some medium-sized dishes have the rim folded back in four places to create a square shape; others have openwork decoration, and others again are foliate-rimmed. Some are decorated around the rim with a line of reddish-brown

37

31–34. *Wan* unearthed from kiln sites (from *Preliminary Findings of the First Series of Excavations at the Kutani Old Sites*).

Excavated *wan* (small food and tea bowls) include some that are everted diagonally from the waist, some which rise vertically to the rim, and others that turn outward broadly from the waist to the rim, while others again are in the shape of the Chinese *temmoku* tea bowls. Glazes include bluish-white, ivory white, milky white, and iron; along with pieces decorated with underglaze cobalt, specimens of so-called *suisaka* ware, in which brown iron glaze is applied to a porcelain base, have also been found.

27–30. Dishes unearthed at kiln sites (from *Preliminary Findings of the First Series of Excavations at the Kutani Old Sites*).

Excavated dishes include both pottery and porcelain, the diameters ranging from thirteen to thirty centimeters. Some are shallow, some rise toward the rim, either straight or in a slight curve, while some have been molded. The glazes include white, bluish-white, celadon, and iron, and there are also some blue-and-white fragments, some with a line of reddish-brown iron glaze around the rim, and some with bright blue "lapis lazuli" glaze.

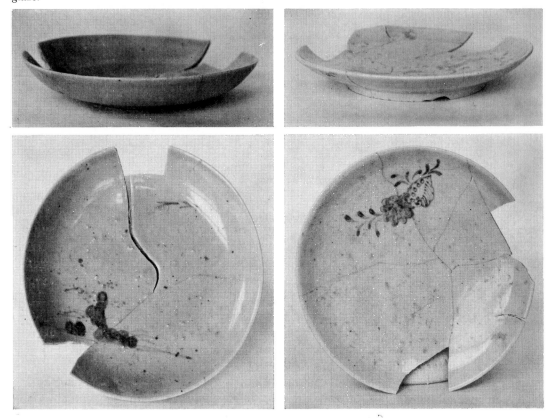

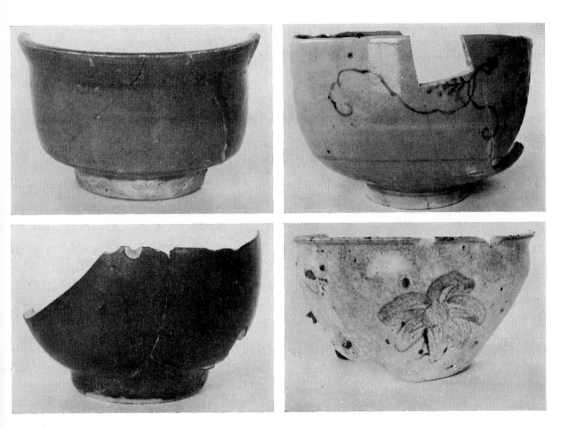

iron glaze (*kuchibeni*). Fragments of a small dish covered with a bright blue "lapis lazuli" glaze have also been uncovered.

Four distinct types of *wan* have been discerned (pls. 31–34), including some that are similar in shape to the well-known *temmoku* tea bowls based on the Chinese prototype from kilns in Fukien province and used as the classic bowl in the Japanese tea ceremony. The glazes used are also varied, including bluish-white, ivory white, milk-white, reddish-brown iron glaze, and gray. They also include some of the kind known in extant Old Kutani as *suisaka* type, with a warm brown iron glaze on a white porcelain body.

There are few large jars and vases. The tea caddies, of which a considerable number seem to have been produced, are in the square-shouldered (*katatsuki*) shape with iron glaze. The incense burners include some in celadon and also a few with bright blue "lapis lazuli" glaze on a thin white porcelain body. Other pieces found include part of the head of a bird-shaped ornamental object and an inkstone.[14]

Blue underglaze decoration is common on the tea bowls. It is used to paint fine lines and designs of trees and flowers on the outside of the vessel, but is not used on the inside or the underside of the stand. It is fairly common, next, on medium- and small-sized dishes, the design invariably being applied to the inside of the dishes only. Finally, it is found on a few bowls (*hachi*), sometimes on either the interior or the exterior, sometimes

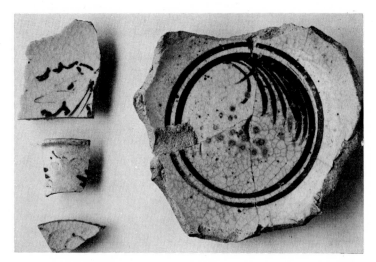

35. Fragments with polychrome overglaze unearthed from kiln site (from *Preliminary Findings of the Second Series of Excavations at the Kutani Old Sites*).

The dump on the level ground to the left of and above kiln no. 1 yielded a few shards with polychrome overglaze decoration. One of them, a fragment of the lower half of a tea bowl, bears two concentric red circles on a white glaze base, and a design of what seem to be rice ears in blue also over the glaze; the outside also seems to have borne a picture in red and blue.

on both. The cobalt (*gosu*) pigment used varies from a comparatively high quality to a type with many impurities. Where the quality is good and the firing has gone well, a deep blue is produced in a characteristic shade of darkish indigo.[15]

A very few fragments have been unearthed with multicolor overglaze decoration. One, a fragment of the base of what appears to be a tea bowl, has a rather coarse yellow body covered with white glaze on which a pattern of rice-ear shapes within a double ring has been executed in red and blue (pl. 35). The remains of a design in red and green are also discernible on the outside, and there is also a red line outside the foot rim. Another fragment is part of a small dish; the coarse, yellowish body is covered with white glaze, and the interior has a flower-and-grasses pattern in purple and two other colors (yellow or red, and green). There is also a small fragment of a small dish with a pattern of overlapping curves like scales done in red or green.[16]

During the investigations, part of a stretch of paddy fields known locally as Shuda ("Cinnabar Field")—an area of fields approximately 170 meters square on either side of the prefectural road about 40 meters in the direction of the village from the site of kiln no. 2— was dug up. It is believed to correspond to the place referred to by Tsuka-tani Sawaemon, district magistrate for the Daishōji fief, in his 1803 *Bakkei kibun*, in which he says: "In this neighborhood is the place where they pulverize cinnabar ore.

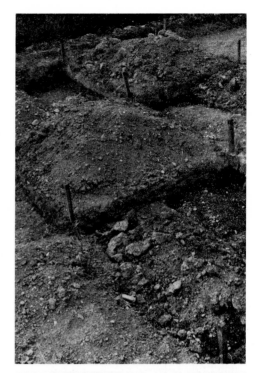

36–38. Shuda and fragment with polychrome over-glaze decoration unearthed there (from *Preliminary Findings of the Second Series of Excavations at the Kutani Old Sites*).

The spot described in the *Bakkei kibun* (1803) as "the place where they pulverize cinnabar ore" has been discovered in paddy fields forty meters to the south-west of kiln no. 2. Known locally as Shuda ("Cinnabar Field"), it yielded a fragment of a dish bearing an overglaze decoration in blue, apparently showing a turnip leaf, on its inner surface.

The ore is to be found there even now." A large number of these rocks were in fact discovered at the top of the layer of clay beneath the paddies; analysis showed them to be ferrous oxide with impurities, which is believed to have been the raw material for the red pigment used in overglaze decoration. At the same site, a fragment of a dish was discovered with an overglaze design of what seem to be turnip leaves in green on the inner surface (pls. 36–38).[17]

The recent surveys also extended to the condition of the pottery clays in the neighborhood of the old kilns. They revealed that there is a mine to the rear of the monument to Gotō Saijirō at the entrance to the Kutani basin, in which the quarry of the day is believed to have been situated. Much of the mine had caved in, however, and at the time of the survey it failed to yield any good-quality pottery clay.

On the other hand, clay suitable for pottery is to be found in the neighborhood of Suginomizu village—which lies across the bridge over the Suginomizu River from the kiln sites and up the prefectural road to the east. About eight kilometers up the Daishōji River from Kutani there is a village called Masago; a trail leads southwest from here, along the tributary of the Daishōji River for about two kilometers, to the Nakamata valley; large lumps of clay are dotted about in the bed of the stream around here, and if one climbs about fifty meters up a steep slope on the northwest side of the stream, one finds holes where the clay was apparently quarried.[18]

THE DECORATIONS

The most outstanding feature of Old Kutani is, without doubt, its decoration—which consists for the most part of designs and patterns done in colored overglazes. The striking and colorful effect created by a combination of bold composition, vigorous brushwork, and heavy application of the glazes is something not to be found in any other ware. The themes of the patterns, too, are unusually varied, drawing freely on a rich variety of sources ranging from the ceramics of late Ming and early Ch'ing China to painting, textiles, and designs found on decorative art objects imported into Japan.

Composition of the Decoration

Taking the bowls and dishes most typical of Old Kutani ware as a basis, types of composition can be classified roughly as follows: (1) pictures occupying the whole of the center, with no pattern on the rim; (2) a simple pattern of scrolls or the like on the rim, with a picture in the center; (3) a picture in the center surrounded by a number of segments filled with varying geometrical patterns; (4) geometrical patterns occupying the whole surface; (5) a picture in the center surrounded by a number of segments occupied by the so-called eight sacred treasures (*happō*) motifs and other patterns; and (6) a picture in the center surrounded by circular medallions enclosing geometrical patterns of the kind known as *shonzui* from their occurrence on late Ming porcelains known to the Japanese by that name.

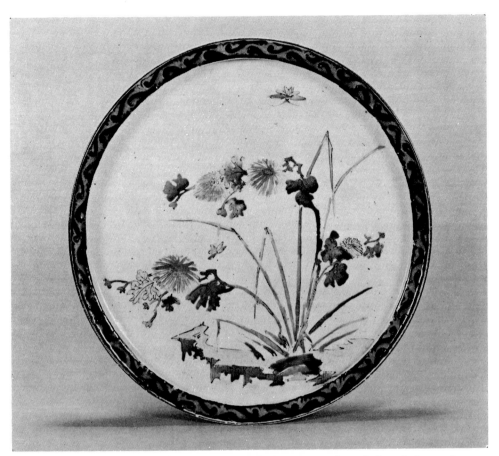

39. Shallow bowl with polychrome overglaze design of chrysanthemum and butterflies. Old Kutani. H. 3.9 cm., d. 28 cm.

The chrysanthemum flowers are done in red and yellow, the leaves in green, yellow, and dark blue, the bank in yellow, dark blue, and purple, the grass in green and yellow, and the butterflies in yellow, green, and dark blue. The color scheme is unusually careful for Old Kutani, and the overglazes are applied relatively lightly. The lines, too, are fine and sensitive, and the whole effect is unusually delicate. The rim is covered with a clear, somewhat bluish green. The underside is scattered with pine needles in red, and has the inscription *fuku* ("good fortune") within a square.

40–41. Shallow bowl with polychrome overglaze design of peacock. Old Kutani. H. 7.6 cm., d. 32.6 cm. Honzen-ji.

The picture as such is scarcely a masterpiece, yet it has a pleasing panache with its predominant purple set off with green, yellow, deep blue, and a touch of red, while the immaturity seen in, for example, the firing technique suggests that this is a work of Old Kutani's earliest period. The underside is encircled by six flower motifs, done in black lines covered with green glaze and linked together. Inside the foot there is a red inscription, unfortunately undecipherable, within a double square. Above and to the right of this inscription the figure of a Chinese child, possibly dancing, is drawn in red, while to the left and bottom left are seen the heads of two further figures; they convey a sense of fun, and were possibly added by the artist in an idle moment. The bowl has attracted attention for the light it throws on Old Kutani, since it is said for some centuries to have been in the possession of the temple Honzen-ji, which also owns a bell inscribed with the name Gotō Saijirō and the date 1641.

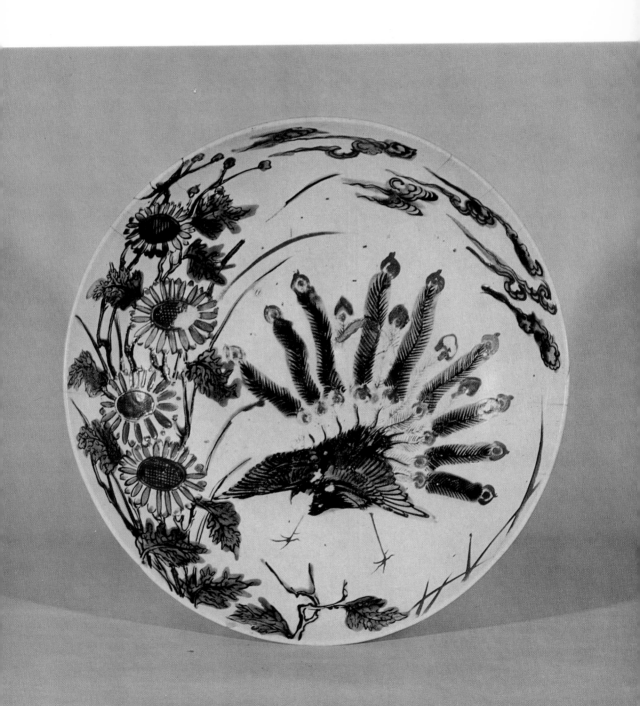

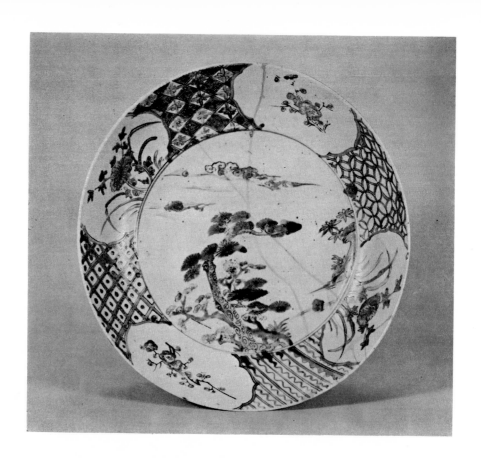

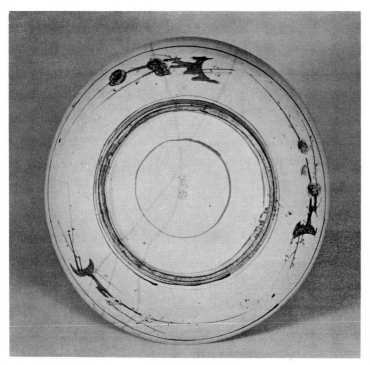

42–44. Shallow bowl with polychrome over-glaze design of pine tree. Old Kutani. H. 5.8 cm., d. 33.2 cm. Tokyo National Museum.

The porcelain body is thin, the shape severely distorted, and the glaze muddy. The central pattern is done in yellow, green, dark blue, and red; the basic geometric patterns of the border are done in green, while red predominates in the designs within the medallions. The color of the overglaze enamels, which are underfired, is poor. The underside has plum branch motifs in cobalt underglaze blue at three points, the buds being touched with red. The foot is encircled by a coarse comb-tooth pattern and bears inside it the inscription "Great Ming [Dynasty]," both done in cobalt blue under-glaze. The porcelain of the body, the tone of the glaze, and the picture are all similar in feeling to red-enamelled ware (*aka-e*) said to have been produced in late Ming China, and the piece does have a certain classical grace.

Of the above, the second and third types are believed to represent the influence of the ceramics of late Ming and early Ch'ing, in which similar schemes of decoration are common. The central picture in the third category comprises three subtypes in which (a) the surrounding geometrical patterns have a purely subordinate role, (b) the central picture and the surrounding patterns assume roughly the same importance in relation to the whole, and (c) the surrounding patterns occupy more space and are, if anything, more important than the central picture.

As Saitō Kikutarō has pointed out, the fifth type represents an imitation of early seventeenth-century porcelains from Ching-te-chen (called *fuyōde* in Japanese). The large dishes of this type decorated in blue-and-white have eight frames around the rim alternating with small oblong frames in between them, the eight larger frames containing, alternately, the "eight sacred treasures" motifs and a floral design of a type peculiar to the Chinese ware. There are some pieces that directly imitate this, others that substitute, for example, four-lobed medallions (*mokkō*) for the frames around the outside. Where the shape of the pieces is concerned, too—as, for example, in the nonagonal dishes—one frequently finds Old Kutani pieces that seem to be inspired by *fuyōde* designs.[19]

The sixth type of composition would seem to be have been imitated from the characteristic designs and patterns found on the blue-and-white tea bowls said to have been made at Ching-te-chen by one Go Shonzui in response to orders from seventeenth-century Japanese tea enthusiasts, in which there are spiral or swirling motifs and circular medallions filled with principally geometrical designs.

47

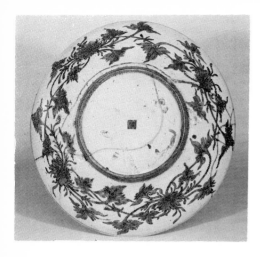

45–46. Shallow bowl with polychrome overglaze design of linked hexagons and chrysanthemums with flowing water. Old Kutani. H. app. 9.5 cm., d. 45 cm.

The unsophisticated simplicity seen in the central picture of chrysanthemums and water, the intricacy of the geometrical patterns, and the heavy coloring are skillfully integrated into a fine example of the boldly decorative design that characterizes Old Kutani. Surviving Old Kutani pieces include a number of other major works in which, as here, the surface is divided up into hexagons, diamond shapes, or squares, and each figure filled with further geometrical patterns, but this bowl is especially successful. The underside is encircled with a bold pattern of peony scrolls, the flowers done in purple and the leaves in deep blue. The area outside the foot is coated with green overglaze, and the inscription, the character *suke* (祐), is covered with deep blue.

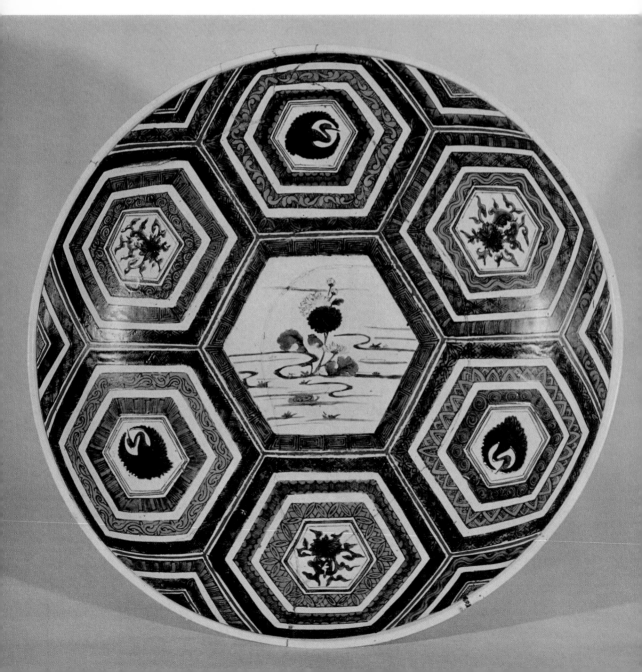

47–48. Shallow bowl with polychrome overglaze design of
lotus pond and kingfisher. Old Kutani. H. 6.3 cm., d. 36.3 cm.
Japan Folk Art Museum.

There is an interesting contrast here between the simple, some-
what stylized treatment of the pond and the realism of the
lotuses and birds. The work is among the best known of Old
Kutani pieces for the way in which restrained yet satisfying
colors are economically combined to create a mood that is rich
without being suffocating. The underside is decorated with
three narcissi outlined in black and filled in with deep blue.
The inside of the rim and the interior of the stand are circled
with lines in underglaze blue.

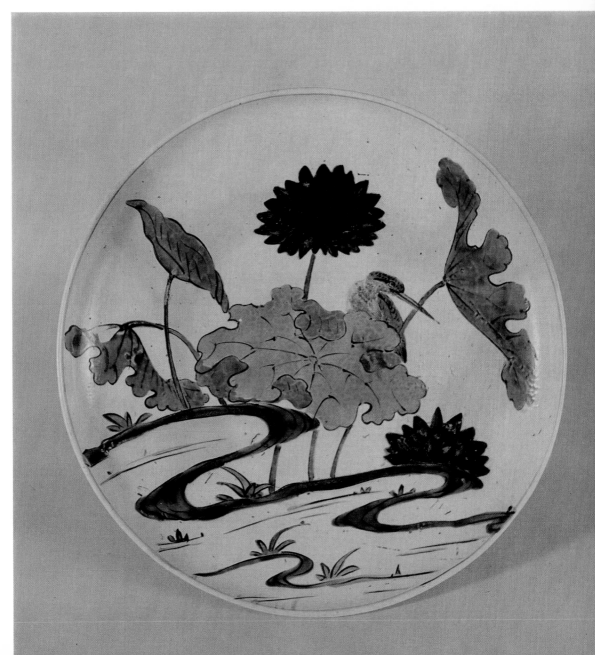

49–50. Footed bowl with polychrome over-glaze bird-and-flower design. Old Kutani. H. app. 10.6 cm., d. app. 29.1 cm. Ishikawa Prefecture Art Museum.

The central picture in this foliate-shaped, footed bowl colors the bird in purple, the flowers in red, the branches in purple, and the leaves in green touched with yellow. The fine black outlines are skilled and sensitive. The eight sections of the border are filled with waves, "seven jewel" (*shippō-tsunagi*) motifs, and wickerwork patterns done in black then thickly coated with yellow, green, purple, and dark blue glazes. The underside has a freely arranged pattern of peony scrolls in dark blue, while the side of the stand has wave patterns, diagonal lattice patterns with crosses inside, and bamboo-grass patterns done in striking tones of yellowish green, dark blue, and purple.

Principal Designs

The pictures used for the inner surface show an extremely complex variety of themes, styles, and brushwork, but they may be classified very roughly as follows: (1) pictures showing the influence of pictorial designs on Chinese ceramics, (2) pictures reminiscent of Kakiemon and Imari ware, (3) pictures with many elements taken over from painting, (4) pictures showing exotic influences, and (5) others.

1. Many of the pictorial designs on Old Kutani ware show stylistic influences from similar designs on the ceramics of late Ming and early Ch'ing China. For example, the dish with a design of pine, bamboo, and flowering plum, and the tall-footed bowl decorated with a landscape design (both now in the Tokyo National Museum) have much in common, in manner and execution alike, with the ceramics of late Ming China; while others, such as the dish with design of peach blossom and bird (private collection), suggest, in their organization and manner, a relationship to the pictorial decorations on ceramics of the K'ang-hsi era (1662–1722) of the Ch'ing dynasty. There are quite a number of works, also, in which certain parts of the picture, such as clouds or mountains, show the influence of these styles. The pieces that seem to be related to the colored porcelain of the K'ang-hsi era in China, whose style is said to have evolved in the late 1670s, may well, thus, have been produced at a later date.

2. Some pieces show a remarkable eclecticism—reminiscent of Kakiemon ware in the brushwork of the bamboo, of the blue-and-white dishes of late Ming and early Ch'ing in the treatment of perspective, and of Japanese Imari ware in the floral arabesques on the underside. Such designs showing diverse influences are very common.

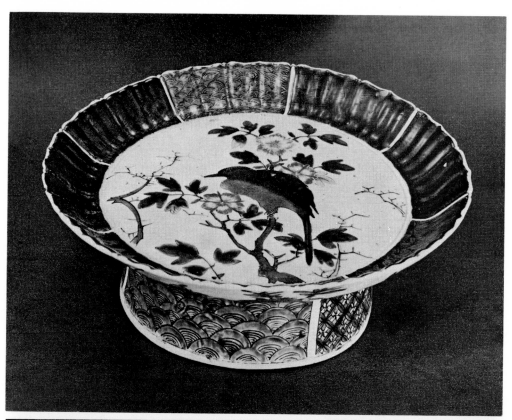

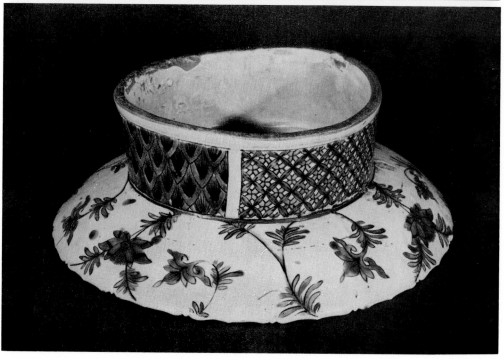

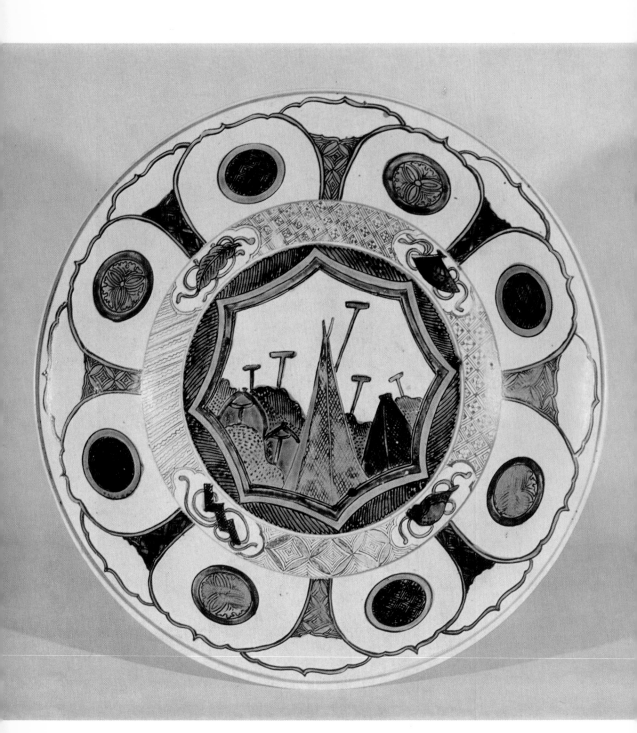

51–52. Shallow bowl with polychrome over-glaze design of drying nets and lotus petal motifs. Old Kutani. H. 10.4 cm., d. 47 cm.

This bowl, which turns outward toward the rim, is one of the most massive of surviving Old Kutani pieces. The composition of the design, with its central picture within an octagon surrounded by a double circle filled with geometrical patterns and bordered in its turn by lotus petal motifs, is inspired by the dishes produced at Ching-te-chen in late Ming and early Ch'ing China, but in the bold arrangement of the various elements it is typical of Old Kutani. The underside bears two leaf patterns in green, linked by freely flowing red lines. There is no inscription.

53

3. There are many Old Kutani pieces, again, that suggest a relationship to the painting of the day; some, for example, suggest the Kanō style, while others resemble a mixture of the Kanō and Tosa styles.

There are some pieces, even, whose preliminary designs are attributed to specific artists. One of these artists, Kusumi Morikage (active latter half of seventeenth century), was among the abler pupils of the well-known painter Kanō Tan'yū (1602–74); he was expelled from Tan'yū's school for failure to follow his master's style, and developed a unique manner of his own. The nineteenth-century treatises on painting *Koga bikō* and *Endai fuga* say that he lived in Kaga, while the *Honchō tōki taigaishō*, published in 1857, claims that he went to Kutani, where he painted pictures. The local customs recorded in his screens depicting rural life (*shikikōsaku-zu*; one of which is in the Ishikawa Prefecture Art Museum) do suggest that he lived for some time in the same general area. He enjoyed a long life, and there are paintings showing that he was still alive and active in 1698, around the age of ninety. There is no real evidence, however, to show that he was living in the area round the time that Kutani ware was being produced, much less that he had any connection with Old Kutani ware. It seems likely that the theory that he was responsible for doing the decorating on Old Kutani ware derives from the nineteenth-century documents cited above, together with the artistic excellence of so much Old Kutani decoration.

It was for long suggested, also, that there was some connection with the style of the Sōtatsu school of decorative painting. Sōtatsu himself never lived in Kanazawa, but Sōsetsu, variously described as Sōtatsu's pupil or his son, did live there; he also inherited from Sōtatsu the artistic pseudonym I'nen and the seal that went with it. This name I'nen was also passed on to his pupils, and there were, it seems, a considerable number of paintings, stamped with the seal "I'nen," that tried to pass as the work of Sōtatsu. Probably the belief that any work with the seal "I'nen" was by Sōtatsu, together with the fact that for a long period in the Kanazawa area it was the practice to include in a bride's trousseau a folding screen bearing a floral painting with the seal "I'nen," gave rise in time to a popular belief that Sōtatsu himself had lived in Kanazawa.[20] Concerning Sōsetsu, it is said that he was alive until sometime close to the Genroku era (1688–1704), and that although he painted pictures in the Sōtatsu style during his middle years, he later developed a more individual style of his own.[21] The question is also complicated by the existence of an artist called Sōsetsu (written with different characters), who some say was the same man as the Sōsetsu discussed so far; even if he was a different man, it seems that he was, at least, the first Sōsetsu's artistic heir. The existence in Ishikawa and Fukui prefectures of quite a number of pictures apparently by this second Sōsetsu has led some to conclude that he too lived in Kaga.[22] Nevertheless, there is nothing in the surviving works of these artists to link them directly with the ceramics known today as Old Kutani.

Recently, again, Mr. Saitō has made new discoveries concerning the decorations on Old Kutani. In a Chinese album of T'ang landscape paintings called *Gogen tōshi gafu* in

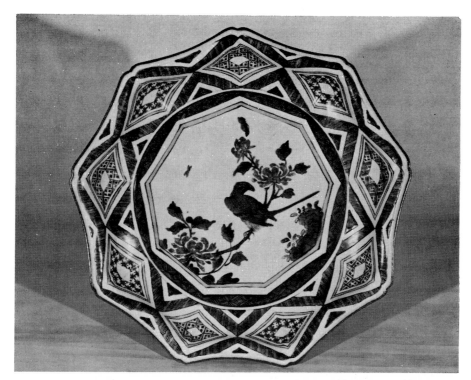

53. Shallow nonagonal bowl with polychrome overglaze bird-and-flower design and diamond-shaped patterns. Old Kutani. H. 5.5 cm., d. 32.5 cm. Kyoto National Museum.

It is unusual in Old Kutani for shallow nonagonal bowls of this type to have such large geometrical patterns surrounding the central design. The diamond shapes are placed within a framework of green bands, leaving a space in which the white ground is visible, and each has a narrow yellow border, the effect being both gay and stylish. The bird in the central picture is done in purple and yellow and the flowers in red; the leaves are green. The underside is encircled with stylized peony scrolls in cobalt blue underglaze, and the inscription, the character *fuku* ("good fortune") within a square, is covered with green glaze.

54. Shallow bowl with polychrome overglaze design of butterflies and peonies with linked hexagonal pattern. H. 8.6 cm., d. 41.2 cm. Umezawa Memorial Gallery.

On a heavily applied, rather dull white glaze, the peonies are done in thick purple glaze, while the leaves are green with a touch of yellow and the butterflies red. The whole effect is boldly striking. The border is filled with a continuous hexagonal pattern, the hexagons enclosing, alternately, "twin butterfly" and linked-swastika motifs. Various colors are used for these, the combinations being varied from place to place to enhance the richly colorful effect. The bowl is probably one of the most floridly decorative of all Old Kutani pieces. The underside has floral scrolls in dark blue; the base has the inscription *fuku* ("good fortune") within a square.

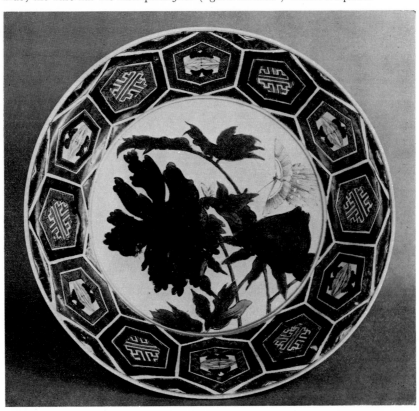

55–56. Shallow bowl with polychrome overglaze design of peonies and butterflies. Old Kutani. H. app. 3.9 cm., d. 34.7 cm. Tokyo National Museum.

This bowl, which is little deeper than a plate, has a line of reddish-brown iron glaze around the rim. The peony flowers are done in fine black lines and covered with purple glaze. The leaves are done in green with some deep blue and a few patches of yellow, while the mare's-tail is done in red. The butterfly sets these off with a gay combination of yellow, deep blue, and red. The underside has a complex pattern of peony scrolls carefully executed in underglaze cobalt blue, and there is a small "square *fuku*" inscription inside the foot.

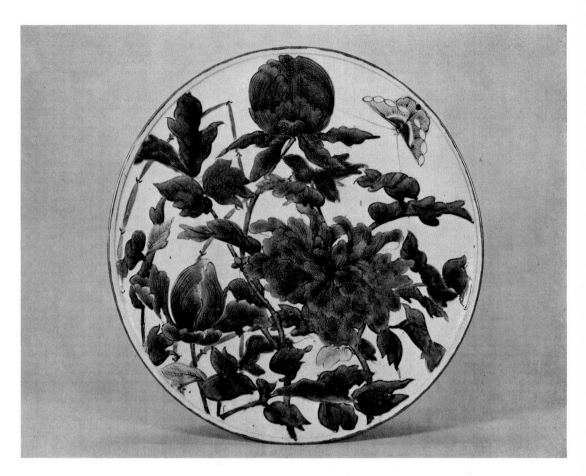

Japanese, one of the series *Hasshu gafu* which was printed from woodblocks in the Ming period as a manual for beginners and reprinted in Japan, he has discovered pictures similar to those on works such as the deep basin with landscape and human figures (Tokyo National Museum), the nonagonal dish with landscape and human figures, the four-lobed (*mokkō*-shaped) bowl with a design of a lone fisherman (both Umezawa Memorial Gallery), and the large shallow bowl with a design of fisherman returning home (Musée Guimet). He also sees another volume in the same series—*Sōhon kashifu* in Japanese—as the source of the outstandingly beautiful peony designs to be found on Old Kutani dishes in the Tokyo National Museum, Umezawa Memorial Gallery, and elsewhere (pls. 54–56), and which have hitherto been associated with the peony pictures so popular among the screen and sliding-door paintings on gold backgrounds of the Momoyama period. It seems likely, he says, that Kakiemon ware also derived its designs of these types from the same Chinese source; however, whereas the bird-and-flower designs of Kakiemon ware directly imitate the Chinese work in composition, Old Kutani is distinguished by the fact that it avoids direct copying, preferring to rearrange and regroup the elements to suit itself.

The *Hasshu gafu* in question was published in the first year of Tien-ch'i (1621), at the end of the Ming dynasty; it was subsequently brought to Japan, where a Kyoto bookstore published a facsimile edition in 1671. It is thus likely, says Mr. Saitō, that the Old Kutani pieces inspired by the Chinese work were produced after the book of reproductions had become generally available—at the earliest, in the 1670s. Mr. Saitō also believes that the dish with a design of myna birds and bamboo (pls. 109–10)—one of the most celebrated Old Kutani pieces—was inspired by the design of the trays traditional in the Noto area from olden times. Similarly, he sees a connection between the dish with a design of Hotei (Ishikawa Prefecture Art Museum) and the *tsuishu* (many-layered lacquerware carved in high relief) incense burners carved with figure of Hotei that were produced in the late Ming period.[23]

4. The pieces showing exotic influences include some that appear to have taken over patterns found on decorative art brought by sea from Holland and elsewhere, and even patterns from early Western-style painting in Japan. Examples include the strikingly unusual large shallow bowls with ship design and the floral scrolls on bowls with stand, while the *aode* dish with tree design (pls. 58–59) would seem to show the influence of copperplate etchings.

5. This category includes those works that seem to be in a different style from any of the preceding four. It includes, for example, works such as the large bowl with bamboo and tiger design (pl. 57), which has the boldness common to other Old Kutani yet, in the treatment of the tiger and the clay bank, seems to differ both from other Old Kutani and from the excavated shards. There is a suggestion of the style of the pictures found on Korean Yi-dynasty ceramics, and one wonders whether it could have been painted by a potter from Korea—or possibly a descendant of a Korean immigrant—but this raises in turn the question of why, if so, this style should be so rare.

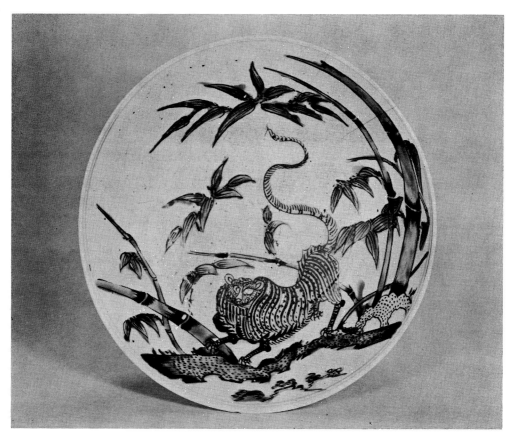

57. Shallow bowl with polychrome overglaze design of bamboo and tiger. Old Kutani. H. app. 9.4 cm., d. 33.4 cm.

This work is one of the most famous Old Kutani pieces on account of its daring composition. The tiger is done in yellow, the bamboo in green and purple on a coarse porcelain base, with powerful black lines. For all its suggestion of the crude and unsophisticated, the design also has something reminiscent of the blue-and-white ware of Yi-dynasty Korea. It seems likely that this is one of the earlier Old Kutani pieces. The underside has a simple cloud pattern in red.

59

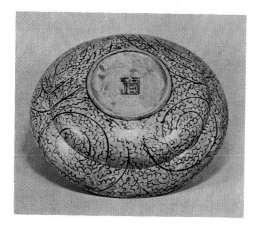

58–59. Shallow bowl with polychrome over-glaze design of tree. Old Kutani. H. 10.4 cm., d. 45 cm.

This bowl, one of the pieces known as Green Kutani (*aode*), seems to show influences of early Western-style painting techniques in the treatment of the tree. The contrast between the yellow and green glazes is an attractive feature peculiar to Old Kutani, and the decorative effect is greatly enhanced by the diamond-shaped "wood-grain" motifs done in strong black lines on the surrounding border and covered with green glaze. With its florid beauty and faintly exotic air, this bowl is among the most highly prized Old Kutani pieces. The underside has large chrysanthemum arabesques; the whole, including the inside of the stand, is covered with green glaze. The inscription is the character *fuku* ("good fortune") within a square.

60

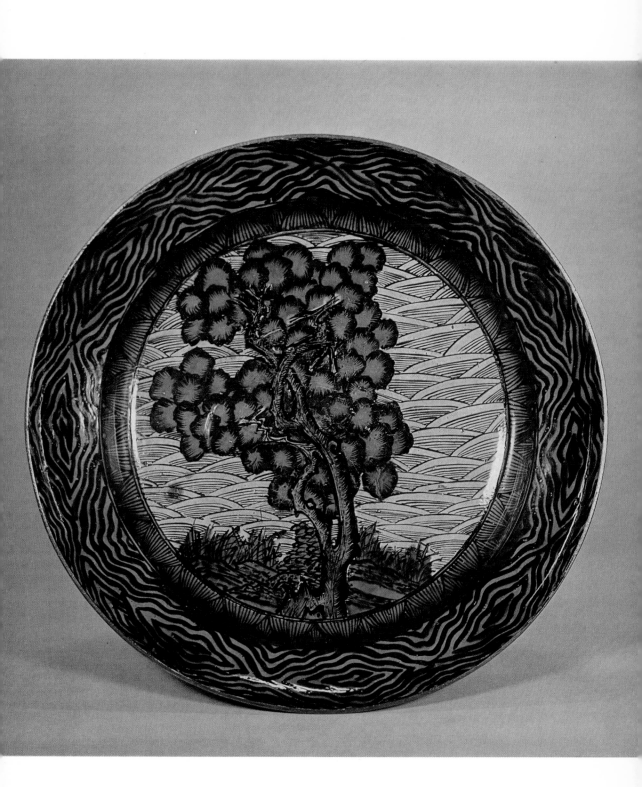

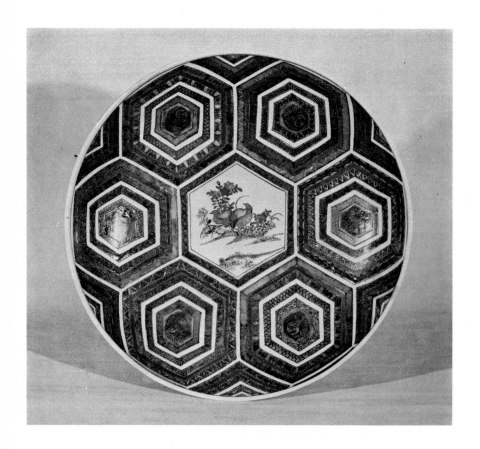

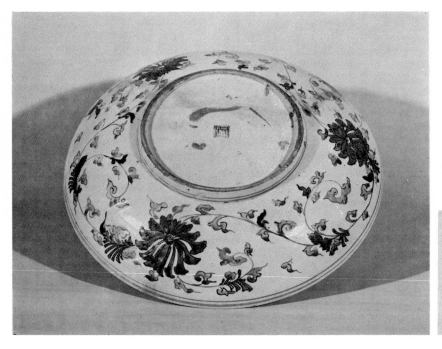

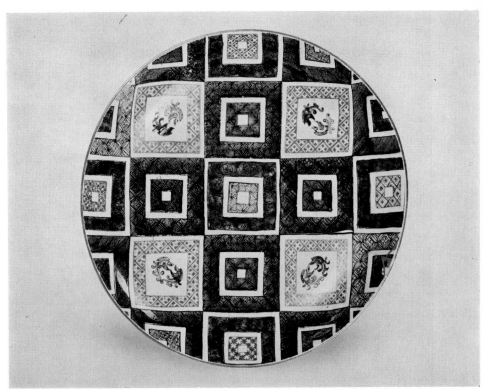

63. Shallow bowl with paving-stone pattern and double-phoenix motifs. Old Kutani. H. 7 cm., d. 34.6 cm. Ishikawa Prefecture Art Museum. The surface is divided up into a number of large "paving stone" squares, four of which enclose double-phoenix motifs in yellow and dark blue framed within a square diagonal-lattice pattern done in dark red. The other sections all consist of two square frames, one within the other, these frames being filled with geometrical patterns—square diagonal lattice, *shippō-tsunagi*, waves, and so forth—covered with skillfully disposed green. dark blue, yellow, or purple glaze. The piece is another example of the inventive use of geometrical patterns and colors; possibly there were influences from the textile patterns of the day. The underside has neatly ordered peony scrolls in blue underglaze. The inscription is undecipherable.

60–62. Shallow bowl with hexagonal pattern and design of quails. Old Kutani. H. 9.1 cm., d. 42.5 cm.
Each unit of the hexagonal pattern has a circular, stylized crane motif in the center, surrounded by many hexagonal frames each of which is occupied by one of a variety of different motifs such as "seven jewels" (*shippō-tsu-nagi*), swastikas, waves, swirls, and basketwork. The coloring also is skill-fully varied, and the hexagonal patterns are arranged so that identical patterns stand opposite each other in pairs. The central picture of quails is done in a naturalistic style, purple predominating among various other colors. The underside is encircled with peony scrolls in cobalt blue under-glaze, with purple and yellow applied to the flowers and, in places, green to the leaves. The inscription is the character *fuku* ("good fortune") within a square.

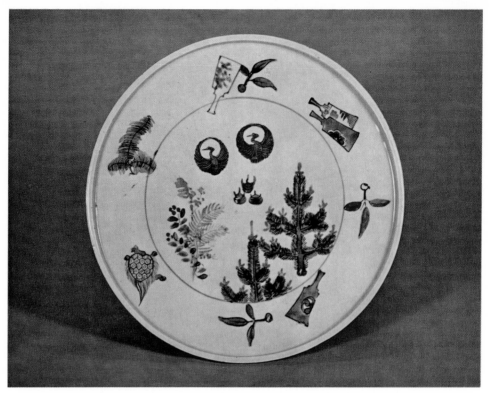

64–65. Footed bowl with polychrome overglaze design of auspicious motifs. Old Kutani. H. 6.2 cm., d. 24.8 cm.

The scattered arrangement of motifs associated with the New Year suggests that this bowl may have been intended for use at that season. The treatment of the motifs has an elegance unusual in Old Kutani. Another interesting feature is that underglaze blue is used—in addition to the circle on the upper surface—for the outline of one of the battledores. During the 1970–71 excavations, remains of a footed bowl resembling this piece, but with a phoenix design in underglaze blue, were discovered at the no. 1 kiln dump (pls. 25–26). The graceful treatment of the patterns on the fragments of porcelain retrieved also seems to have something in common with this work, which has accordingly attracted much attention.

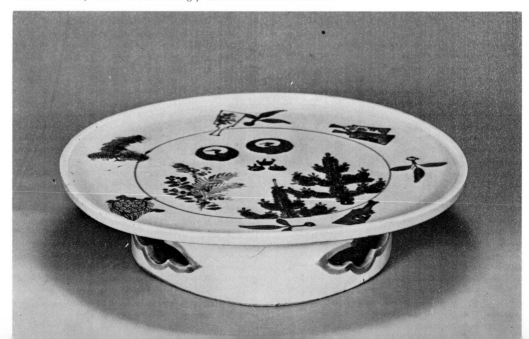

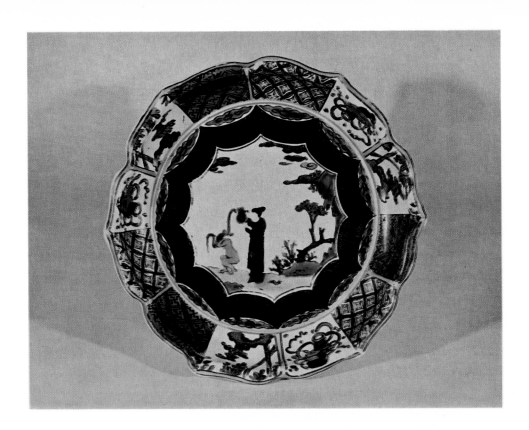

66–67. Footed bowl with polychrome overglaze design of bathing woman. Old Kutani. H. app. 8 cm., d. 25.6 cm.

The six-lobed rim of this bowl with stand is turned back on itself to form a kind of lip. The design is inspired by early seventeenth-century Chinese porcelains from Ching-te-chen (called *fuyōde* ware in Japanese), but the central picture of a naked woman bathing —probably based on some ancient Chinese story—is unusual. The underside is decorated with peony scrolls in purple, green, and yellow. The side of the stand is encircled with the "seven jewel" motif (*shippō-tsunagi*; a pattern of interlocking circles) in deep blue and yellow, and the base has an undecipherable character inscribed in black and covered with green glaze.

68. Shallow bowl with polychrome overglaze design of butterflies and geometrical patterns. Old Kutani. H. 5.8 cm., d. 34 cm. Idemitsu Art Gallery.

The central octagonal shape is divided into four sections, each of which contains several layers of geometrical patterns, all different colors. The four sections form two identically patterned pairs. The border outside the octagon is filled with many-layered lotus-petal shapes, each layer filled in turn with varied geometrical patterns in different colors. The concentrated use of geometrical patterns and the great care expended on the color scheme go to make a work of great brilliance. The underside has peony scrolls, the flowers in purple and the tendrils in deep blue. The inscription, which is covered with deep blue glaze, is undecipherable.

69. Deep bowl with phoenix design and *fuyōde* decorations in polychrome overglaze. Old Kutani. H. 9 cm., d. app. 39 cm.

The eight-pointed shape in the center is bordered by lotus-petal frames containing, alternately, "eight sacred treasure" and plant motifs and separated by small rectangles, the whole design closely echoing that of the blue-and-white dishes produced at the Ching-te-chen kilns during the late Ming and early Ch'ing periods and known in Japan as *fuyōde*. The predominant color is deep blue with added green and purple. The underside has a design of flowering plants and flying birds done in the Japanese manner. The inscription is the character *fuku* ("good fortune") within a square and covered with green glaze.

67

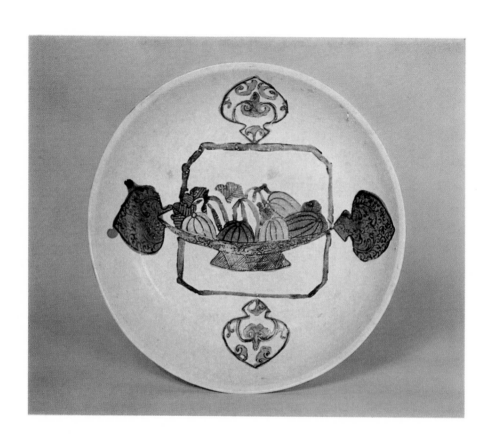

70–71. Shallow bowl with polychrome overglaze design of melons in a bowl. Old Kutani. H. 5.8 cm., d. 26.3 cm. Idemitsu Art Gallery.

The picture of melons in a bowl, though crude in its brushwork and coloring, has an unsophisticated charm, and the square with notched edges that so artlessly encloses it is a masterly touch. The spade-shaped decorations outside this frame are a surprisingly Western element, but the effect is stimulating rather than incongruous. The piece is unique among Old Kutani for its combination of novel design with a sense of assurance. The underside has an extremely free pattern, done in black lines and green glaze, of what seem to be variations on the scudding-cloud motif.

72–74. Shallow bowl with polychrome overglaze landscape design and linked circular medallions. Old Kutani. H. 6.8 cm., d. 32.4 cm. Nakamura Memorial Art Museum.

The central landscape design is in some ways reminiscent of those found on the ceramics of late Ming and early Ch'ing China, but the coloring is more gentle and sensitive. The so-called *shonzui* medallions around the circumference are done in underglaze blue, then decorated with overglazes in many colors, great care being expended on the color schemes. The rim is decorated with a line of reddish-brown iron glaze, and the underside has flowering-plum motifs in underglaze cobalt blue with touches of red and green.

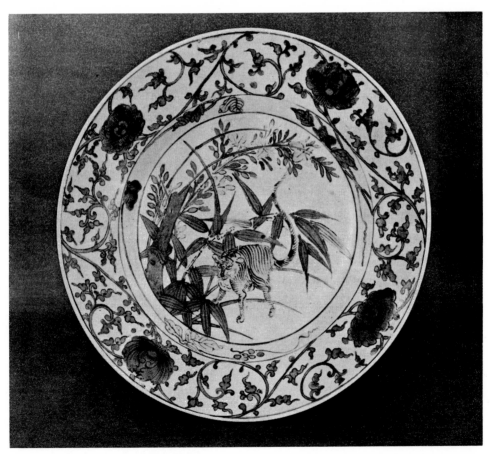

75. Shallow bowl with polychrome overglaze design of bamboo and tiger. Old Kutani. H. app. 8 cm., d. 35.7 cm. Ishikawa Prefecture Art Museum. There is an interesting contrast between the freedom of the bamboo, tiger, and flowering grasses of the central picture and the formality of the peony scrolls that surround it. The predominating color is green, with some yellow, effectively set off by the purple of the peony blooms. The underside has stylized flower motifs in yellow at three points, joined by tendrillike lines in green. The inscription, the character *fuku* ("good fortune") within a square, is covered with purple glaze.

71

76–77. Shallow bowl with polychrome overglaze design of cranes and "spade" motifs. Old Kutani. H. 9.8 cm., d. 42.7 cm. Ishikawa Prefecture Art Museum.

Once again, the design is a novel combination of the Japanese (the cranes) and the exotic (the "spade" motifs). The spade shapes, done in purple, are dotted with small heart-shapes left in white, while the cranes are in yellow and black with the heads and bodies similarly left in white; the green, purple, yellow, and white combine splendidly to create a boldly decorative mood. The underside is filled with a pattern of floral scrolls in green, yellow, and purple. The inscription, which consists of the four characters of the name "Goro Daiu" (五郎太夫) within a double square, was presumably suggested by the name commonly found on so-called *shonzui* ware from seventeenth-century Chinese kilns.

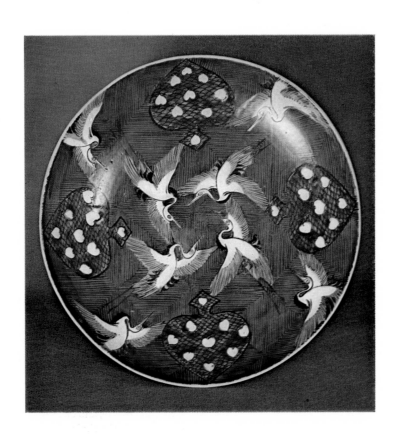

78–79. Shallow bowl with polychrome over-glaze design of eagle and monkey. Old Kutani. H. 6.3 cm., d. 31.8 cm.

This bowl has a shallow interior with a broad rim. The unusual design, depicting a great eagle holding down a monkey with its sharp claws, exhibits a harshness of execution uncommon even in Old Kutani. There can be few examples anywhere else in Japanese decorative art of such a brutal theme, and one suspects that some story lies behind the choice of subject. The underside bears what seems to be a variation on the peony-scroll pattern done in black, purple, and green, and the inscription consists of the character *fuku* ("good fortune") within a square done in black and covered with green glaze.

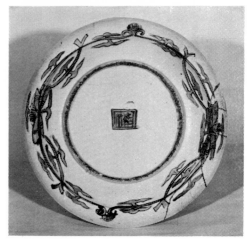

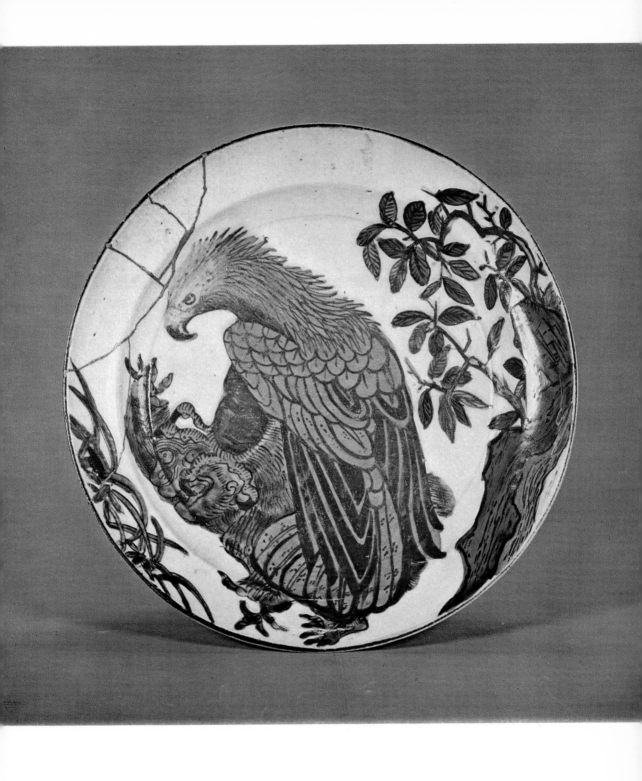

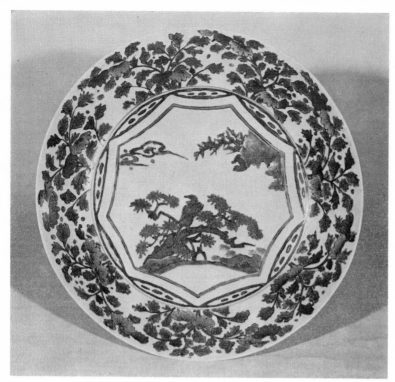

80. Shallow bowl with polychrome overglaze bird-and-flower design. Old Kutani. H. app. 7.5 cm., d. 38.3 cm. The nine-sided figure enclosing the central design is done in yellow and purple. The bird in the central picture is done in deep blue and the tree trunk in purple, the whole of the rest being done in green and deep blue with a few touches of red. The border is filled with seven chrysanthemum plants with a skillfully arranged color scheme of deep blue, green, yellow, and purple. The underside has five "eight treasure" motifs in deep blue, purple, and green. The inscription inside the stand is the character *fuku* ("good fortune") within a square.

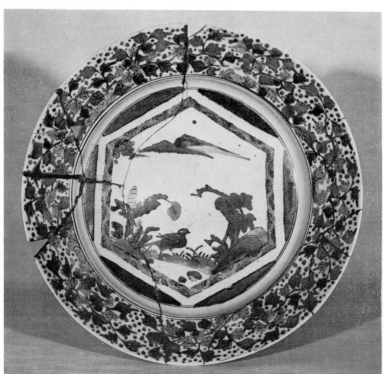

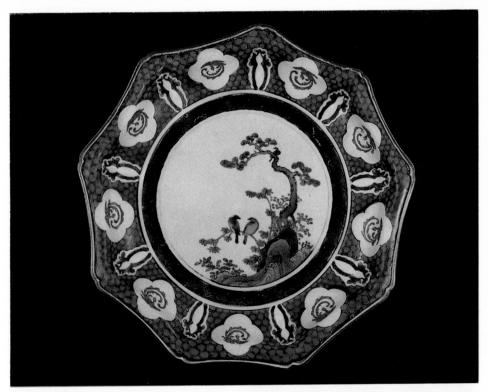

83–84. Shallow nonagonal bowl with polychrome overglaze bird-and-flower design. Old Kutani. H. 5 cm., d. 33.4 cm. Ishikawa Prefecture Art Museum.

Old Kutani includes a large number of shallow nonagonal bowls. Most of them have almost pure white bodies, with a line of reddish-brown glaze around the rim; the design includes a picture in the central circular space—small-scale and in the Kanō style—surrounded by a band of geometrical patterns and, on the border outside this, a fine geometrical pattern forming the background for four-lobed medallions containing pictures of phoenixes, cranes, and the like, alternating with twin leaflike shapes. The underside usually bears more or less the same peony scrolls in underglaze blue, but the inscriptions differ. This shallow bowl is a typical example, carefully made, with good colors and an air of elegance. The inscription has complex, undecipherable characters inside a double square.

81–82 (left). Shallow bowl with polychrome overglaze bird-and-flower design. Old Kutani. H. 7.7 cm., d. 37.6 cm. Terai-machi Town Office, Ishikawa Prefecture.

The bird in the central pattern is done in purple, the rest of the picture in deep blue, green, yellow, and purple. The hexagonal frame, which has a fine pattern covered with yellow glaze, is surrounded by another hexagon which is left white, and the remaining spaces within the circular central section are filled with geometrical patterns covered with deep blue, purple, and green glaze. The outer border has a pattern consisting chiefly of peony sprays done in yellow, green, and deep blue. The underside has a kind of floral scroll pattern done in yellow and deep blue; the inscription is the character *fuku* ("good fortune") within a square, and is covered with deep blue glaze.

77

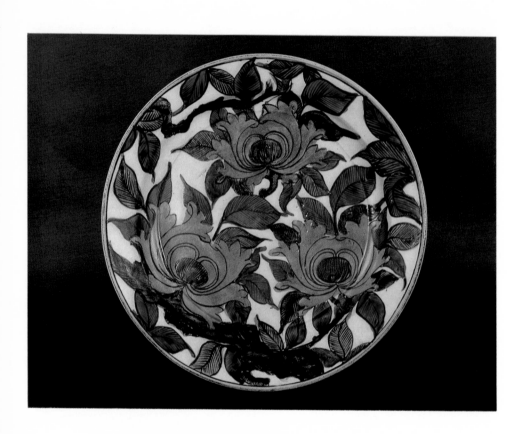

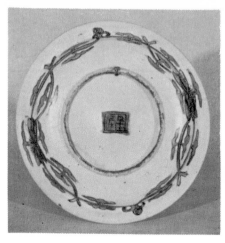

85–86. Shallow bowl with polychrome overglaze design of peonies. Old Kutani. H. 6.4 cm., d. 31 cm. Ishikawa Prefecture Art Museum.

It seems possible that this bowl was made by the same hand as that shown in plates 78–79, since the shape, size, coloring —a predominant yellow plus green and purple—and even the design on the underside and the inscription are almost identical. In its composition—the triangle of three great peonies—and use of yellow, green, and purple, it resembles the three-color (*san ts'ai*) ware of the K'ang-hsi era (1662–1722) of Ch'ing China. At the same time, as an example of Old Kutani that makes no use of either red or deep blue glaze, it may be seen as a precursor of so-called Green Kutani (*aode*).

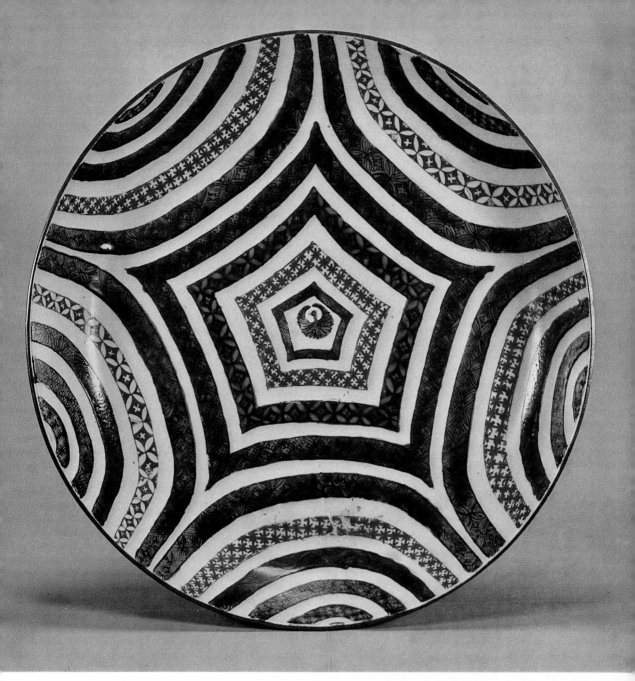

87–88. Shallow bowl with polychrome overglaze geometrical design. Old Kutani. H. app. 6.5 cm., d. 35.2 cm.

The quadruple pentagon in the center and the five quintuple arcs that surround it are filled with geometrical patterns, all carefully varied; the piece is an extreme example of the use of geometrical patterns for decoration that is one of the chief characteristics of Old Kutani. The underside has regular, stylized peony scrolls in underglaze blue. The stand has a comb-tooth pattern, while the inscription is the character *fuku* ("good fortune") within a double square; both are rendered in underglaze blue.

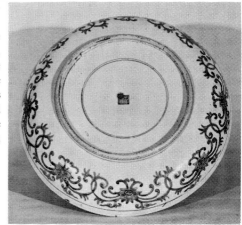

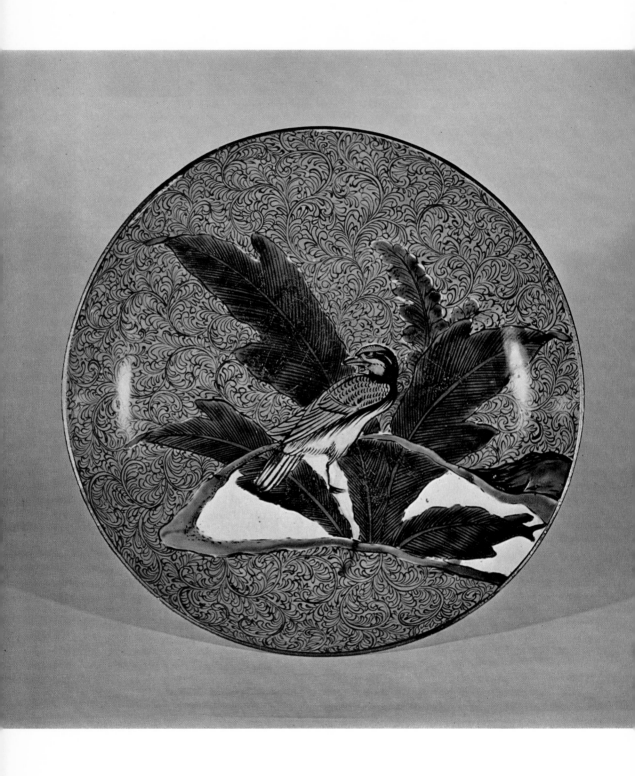

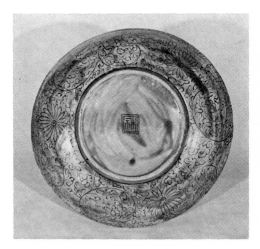

89–90. Shallow bowl with polychrome overglaze design of leaves and bird. Old Kutani. H. 6 cm., d. 33.7 cm.

The background is covered entirely with a kind of floral scroll pattern carefully executed in black and covered completely with yellow glaze, while the leaves and bird are done in green and light purple respectively, a most striking feature being the area of background left white and surrounded with a border of deep blue to represent what may be either a rock or water. The underside is filled with chrysanthemum scrolls in black, the whole—including the inside of the stand—being covered with green glaze. The inscription is the character *fuku* ("good fortune") within a square done in black.

81

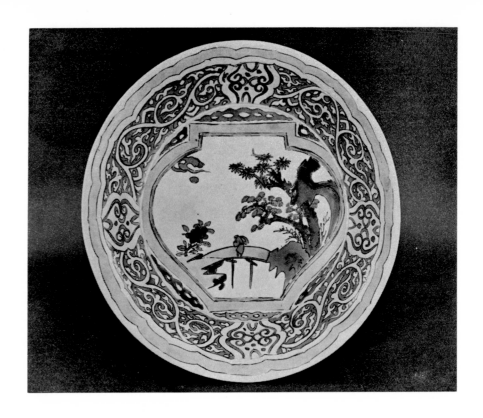

92–93. Shallow bowl with polychrome overglaze design of melons.
Old Kutani.

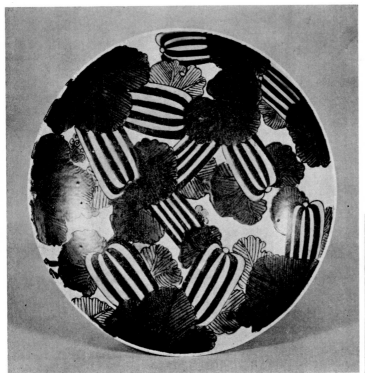

91 (left). Shallow bowl with jar-shaped design of bridge and human figure in overglaze colors. Old Kutani. H. 7 cm., d. 35 cm.

The central design is bordered with yellow and dark blue, while the picture itself is done in green, yellow, and purple. The border has floral scrolls formed by white left in reserve against a green ground, while the rim is bordered with a thirteen-pointed band, again in yellow and dark blue; this prominent use of yellow and dark blue is an interesting feature of the piece. The underside has five colorful "eight sacred treasure" motifs, while the inscription is the character *fuku* ("good fortune") within a square covered with greenish-blue glaze.

94–95. Shallow bowl with polychrome overglaze design of human figures and scattered "military" fans. Old Kutani. H. 7.2 cm., d. 38.8 cm. Ishikawa Prefecture Industrial High School.

The ground has square diagonal-lattice motifs enclosing swastikas, covered with green glaze, but with chrysanthemum sprays also here and there. The central medallion has classical Chinese figures, while the fans and the square and rectangular shapes about it contain bird-and-flower pictures. The pictures are done in various colors and bordered in each case with yellow. Although the effect may seem fussy in reproduction, the result in fact is a satisfying, restrained richness. The underside has large peony scrolls in purple, yellow, and green. The inscription, which is similar to that on the deep bowl shown in plates 7–9 and the footed bowl in plates 66–67, is undecipherable.

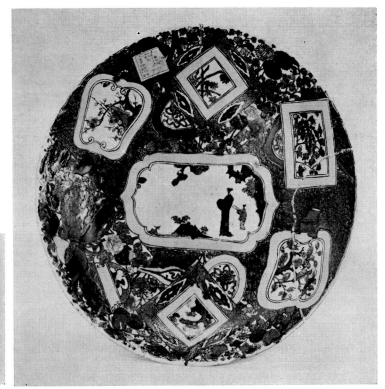

96–97. Shallow bowl with polychrome overglaze design of aged tree and white clouds. Old Kutani. H. 7.5 cm., d. 33.4 cm. Ishikawa Prefecture Art Museum.

The sky and clouds are left white, the leaves are green and yellow, the trunk is purple and the bird black. The inner band is deep blue; the outer border has black floral scrolls covered with yellow glaze. The underside is occupied entirely by black bamboo-grass motifs covered with green glaze. The inscription, the character *fuku* ("good fortune") within a square, is also covered with green glaze. The style of the floral scrolls on the border and the motifs on the underside is reminiscent of "Green" Old Kutani and is believed to indicate a stage in the development toward the latter.

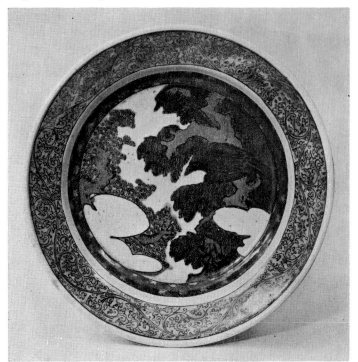

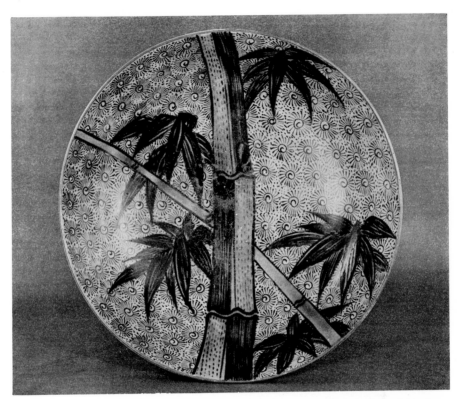

98. Shallow bowl with polychrome overglaze design of bamboo. Old Kutani. H. app. 8.5 cm., d. 33.6 cm. Ishikawa Prefecture Art Museum.

The bamboo is executed boldly in black lines and green on a greenish-yellow base completely filled with small floral motifs in black. The composition is at once bold and sensitive, with the thick trunk dividing the surface down the middle, one slender stem crossing it at an angle, and leaves arranged about them. The underside is entirely filled with swirl motifs covered with yellow glaze. The inscription, the character *fuku* ("good fortune") within a square covered with yellow, achieves a strikingly decorative effect, contrasting as it does with the white body inside the foot and the yellow of the bowl's underside.

101–2. Shallow bowl with polychrome overglaze design of oak branches. Old Kutani. H. app. 6.3 cm., d. 32.3 cm.
The oak branches—the branches in deep blue and the leaves in green—stand out boldly against the yellow background. The underside, which is filled with a pattern of chrysanthemum scrolls, is completely covered, including the inside of the foot, with a yellow glaze. The inscription is the character *fuku* ("good fortune") within a square.

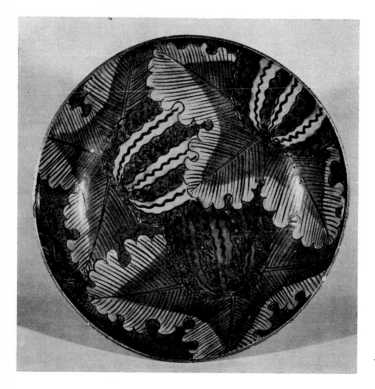

99–100. Shallow bowl with polychrome overglaze design of melons. Old Kutani. H. 6.7 cm., d. 33.5 cm.
The design contrives a deliberately bold effect. The colors used are green, yellow, and purple, each carrying its own weight while blending happily with the rest, and the black lines also contribute to the effect of the whole. The underside is surrounded with floral scrolls, the whole, including the inside of the foot, being covered with yellow glaze. The inscription, the character *fuku* ("good fortune") within a square, is larger than usual.

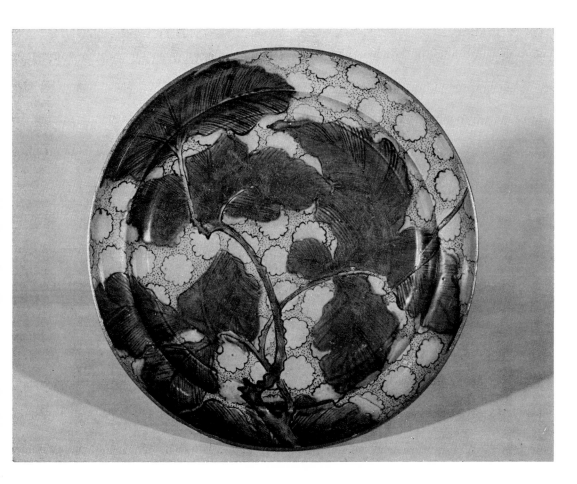

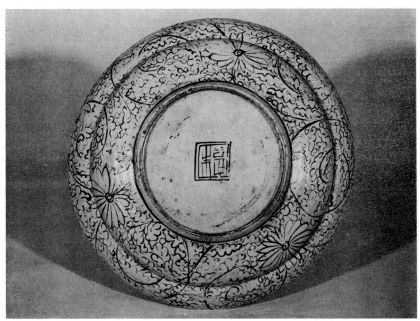

103–4. Shallow bowl with polychrome over-
glaze design of hawk. Old Kutani. H. app. 9 cm.,
d. 38 cm.

The ground is filled with small plum blossom
motifs covered with yellow glaze. The hawk is
done in strong black lines filled in with purple.
The leaves are mostly green, but purple is used
in some places on them and on the large flowers.
There is a sense of power reminiscent of the eagle-
and-monkey design of the shallow bowl shown
in plates 78–79. The underside is filled with swirl
motifs and entirely covered with green glaze.
There is an inscription, but it is undecipherable.

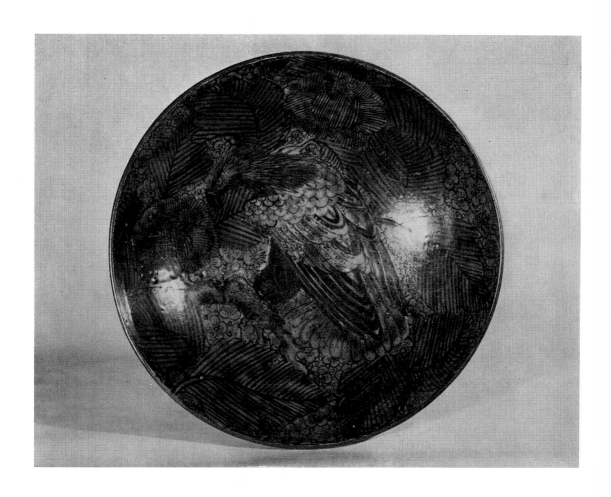

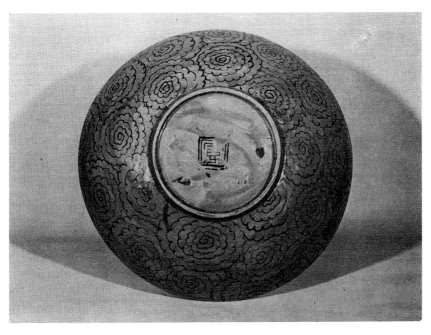

105–6. Footed bowl with polychrome over-glaze design on the "resting in the shade of a willow" theme. Old Kutani. H. 7.2 cm., d. 29.5 cm. Tokyo National Museum.

The four-petaled shape of this footed bowl is unusual. In the central picture of a human figure resting beneath a willow tree, the figure and the rocks in the background are purple and the willow and bank yellow, but some green and blue are also used. The brushwork is light yet with a certain classical elegance. The linked-swastika patterns of the border are done in green and the "eight treasure" motifs in blue, purple, and yellow. The underside has flower motifs in yellow and green at three points, and the side of the foot has a *shippō-tsunagi* pattern around it in the same colors. The inscription consists of the character *fuku* ("good fortune") within a double square, done in black and covered with green glaze.

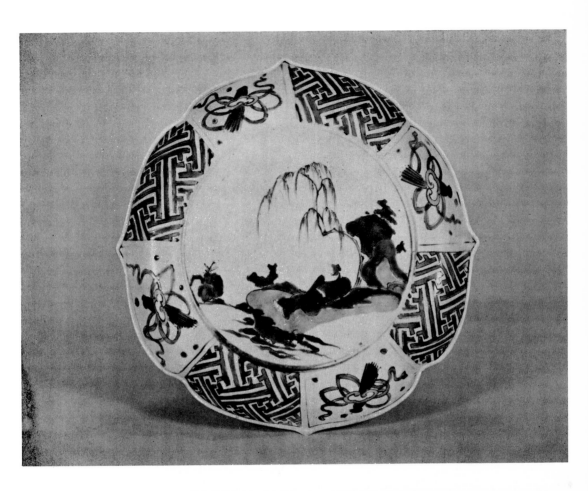

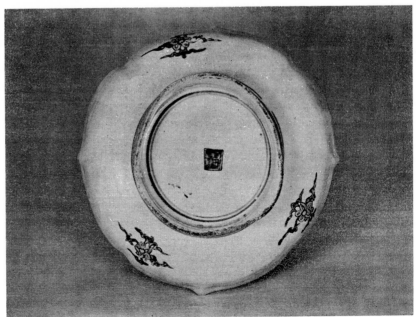

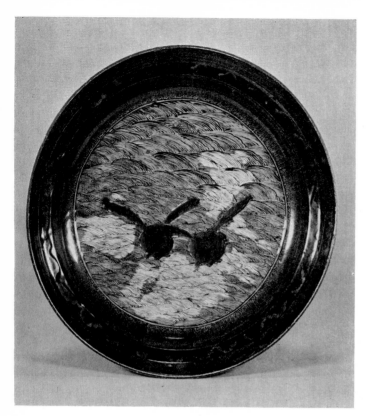

107. Shallow bowl with polychrome overglaze design of "hares breasting the waves." Old Kutani. H. 10.3 cm., d. 42.2 cm.

The sides and rim of this unusual bowl rise in two steps. The waves in the central picture—it is not clear in fact whether these represent the sea or a field of grain—are done in fine black lines covered with yellow glaze, while the hares are covered thickly with green glaze that almost obscures the details. The yellow glaze has come off in places, revealing the white base, but if anything this only enhances the decorative effect. The picture is bordered by a geometrical *bishamon* pattern, with a half-chrysanthemum pattern outside this and a band of wood-grain pattern on the rim; the whole is covered with a thick layer of green glaze. Although the work uses only two colors, green and yellow, it is remarkably successful. The underside has large chrysanthemum scrolls covered with yellow glaze while the inside of the foot is covered with green glaze.

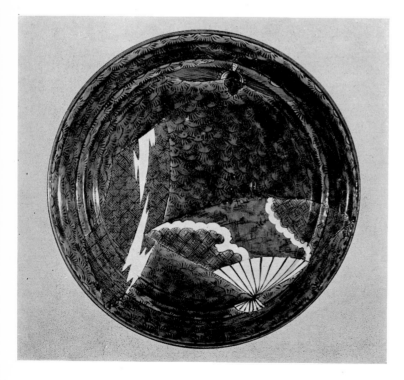

108. Shallow bowl with polychrome overglaze design of butterfly and fans. Old Kutani. H. 6.8 cm., d. 35 cm. Yamato Bunkakan.

On a green glaze base entirely covered with a pine-needle pattern are arranged two fans decorated with geometrical patterns on a yellow or purple base with areas of the white base left showing, while the butterfly is done in yellow with touches of purple. The design is one of the most Japanese in effect to be found in Old Kutani. The underside has chrysanthemum scrolls done in black and covered with yellow glaze, while the inside of the foot is done in green with the inscription *fuku* ("good fortune") within a square.

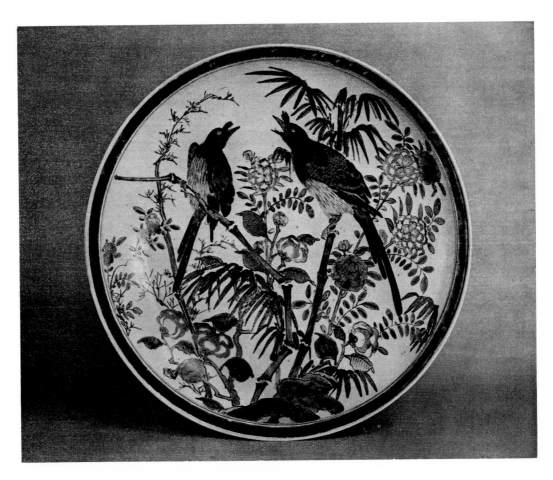

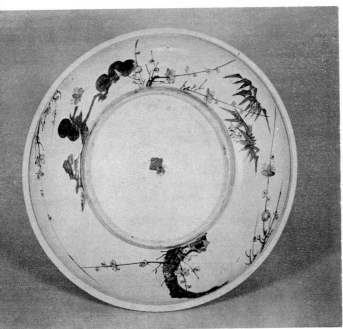

109–10. Shallow bowl with polychrome overglaze design of bamboo and myna birds. Old Kutani. H. 8.3 cm., d. 42.4 cm. Tokyo National Museum.

This work, one of the finest Old Kutani pieces, is justly celebrated. On a faintly bluish white glaze with a dull luster the two birds are done in black, green, and yellow and surrounded with bamboo, camellias, and other plants done in variegated colors. The line is skilled and sensitive. The rim has a wide band of deep blue. The piece shows at their best the boldness of composition, the rich though restrained coloring, and the vigorous execution that characterize Old Kutani. The underside has an equally dashing pine, bamboo, and flowering plum motif in various colors. There is an inscription, but it is covered with dark green glaze and is illegible.

111. Geometrical patterns used on Old Kutani.
Geometrical patterns play a large part in the decoration of Old Kutani ware, sometimes in a subsidiary, sometimes in a main role. It has been estimated that if carefully classified their number would run to more than three hundred kinds. Shown here is the merest sampling of some of the most important and frequently used patterns.

Geometrical Patterns

A very large number of Old Kutani pieces employ geometrical patterns alongside pictorial designs (pl. 111). In some cases, the geometrical pattern is subordinate to the picture; in others it claims equal or still more important rank, and in others again the design is exclusively geometrical. Either way, geometrical patterns play a vital part in the decoration of Old Kutani. These patterns take many forms, including some that seem to be related to the patterns on other ceramics, textiles, or other decorative art, but in the case of Old Kutani their number is extraordinarily large, since one basic pattern is subject to extremely small variations in each of its parts, which are then combined to build up larger patterns. In the relatively simple cases, one may find the same or similar patterns in Chinese ceramics of the late Ming and early Ch'ing periods, or in Japanese Imari ware. The more highly complex examples—and the means whereby the complexity is achieved—are almost without parallel in any other ceramics, so that this type of decoration stands out as a unique feature of the Old Kutani style.

As for the relationship between these geometrical patterns and the decorative style of Old Kutani bowls and dishes as a whole, one finds that, in pieces where the emphasis is on the central, pictorial design with only a minimum of pattern around the rim, the geometrical pattern itself is relatively simple. Where the bordering pattern is somewhat broader, the geometrical patterns include some that are more simple and some that are more complex. As the patterned border grows wider still, however, the geometrical designs become more and more complex, and the picture in the center is reduced to around one-half the diameter. On pieces where the central picture is extremely small or totally nonexistent, so that the surface becomes one large abstract pattern, the geometrical element achieves its highest degree of intricacy. Although the degree of complexity probably represents, very roughly, the direction in which decorative design was developing, it also seems that many different types were produced around the same time; thus complexity is not, in itself, a sure indicator of the period when the piece was produced, and must be considered in conjunction with other factors such as the nature of the picture and the materials and techniques employed.

The patterns on the underside of these bowls are done either in polychrome overglazes or in underglaze cobalt and are quite varied, including plum branch; lotus; peony, chrysanthemum, and other floral scrolls; "flying cloud" forms; flying phoenix and peonies; and "scattered treasures" and swirling motifs. There are any number of variations, moreover, on—for example—the peony-vine scroll pattern; and even on two dishes where the underside design is the same, the central patterns on the inside of the bowl differ both in style and manner. Incidentally, a large number of bodies for polychrome overglaze ware of the same type as Old Kutani have been unearthed at the Kuronda and Yambeta kiln sites in Arita; they include some fragments of bowls with what seem to be the same blue-and-white peony scrolls as occur on the underside of Old Kutani bowls—which raises yet another difficult problem.

In relation to this question of designs, Mr. Saitō has some interesting things to say concerning the changes in the use of colored overglazes, so I will summarize them here, even though it means duplicating to a certain extent what I have already written. He combines his discussion of the color glazes with a discussion of the inscriptions, but to avoid unnecessary complexity I have omitted the latter in what follows.

According to Mr. Saitō, the earliest Old Kutani made use of green, yellow, and deep red; first purple and then dark blue were added to round off Old Kutani's complement of five colors. In the second period, when much of the best work was produced, these same five colors were used, but the pale hues of the first period have become richer, and deep color glazes come to be applied so thickly that the underlying designs become almost invisible, perfecting the brilliant effect usually associated with Old Kutani. During the third and last period, the same five colors were used, but cobalt blue—which in the first two periods was limited to lines circling the underside of dishes—came to be used as an integral part of the design or even for the whole design on the underside, and an inscription was often added in cobalt. The use of *kuchibeni* (a border of reddish-brown iron glaze around the rim) also began at this stage. "Green Kutani" (*aode*), he says, scarcely existed as a type separate from ordinary polychrome decoration during the first period. In the second period green, yellow, purple, and indigo blue enamels came to be used in combination, in some cases white areas left in reserve also. In the last period green and yellow were used alone.[24]

Patterns on Recently Excavated Fragments

Let us now briefly survey the patterns found on the fragments of ceramics unearthed during the recent excavations as described in the preliminary reports (pls. 112–31).

The majority of patterns are done in underglaze cobalt. They are most common on fragments of tea bowls, followed by medium- and small-sized dishes, but they are also found on pieces of large dishes and bowls. On the tea bowls the designs are executed on the exterior of the body, and consist mostly of floral and plant patterns, bamboo, maples, grapevines, and daisies, as well as bellflowers (*kikyō*), flowering plum, wisteria, vines, and waterweeds. There are insects such as grasshoppers, and also patterns representing flowing water, or flowing water with *jakago* (baskets filled with pebbles, used to make embankments), drying fishing nets, or the like. The tea bowls in the *temmoku* style include some that have graceful floral scrolls around the rim and clematis flowers and vines around the body.

The floral and plant patterns, which are pictorial and realistic, are, so far as one can judge, tastefully executed with graceful brushwork. The patterns of flowing water with *jakago*, drying nets, and the like—which are also found in Oribe ware—are classical in their manner, and are reminiscent in feeling of the Kyoto style.

The designs of dishes, which are executed solely on the interior, range from bamboo, plum, grapevine, iris, and ivy patterns to landscapes, flowing water with water wheel.

and even—this on a very small fragment—the face of a child. In some cases the floral patterns are disposed appropriately about the surface of the dish, in others a single flowering plant is located at one point on the surface; some are considered particularly effective as pictorial compositions. The designs of flower petals include some in which the design is painted large in the very center, and others in which full-face plum-blossom motifs resembling the family crest of the Maeda family are scattered about the surface. The landscape designs appearing on what seem to be fragments of dishes show rocks with trees and Chinese-style pavilions; the brushwork is excellent, and the style appears to be that of the Kyoto-based branch of the Kanō school. The designs of flowing water with water wheel, like the flowing water patterns already mentioned, also seem to be in the Kyoto style.

There are three types of bowl: those in which the pattern is executed on either the exterior or interior alone, and those in which it appears on both. The floral, plant, and landscape designs seem to be similar to those on the dishes, and are skillful in their execution. They include a bowl with stand that has a phoenix design painted slightly off-center on the interior of the bowl (pls. 25–26), and a foliate-rimmed bowl with decoration reminiscent of *fuyōde* ware on its interior.

Decoration in colored overglazes, already discussed above, includes a pattern resembling rice-ears done in red and blue within two concentric red circles on a fragment of the lower half of a tea bowl (pl. 35); a pattern of flowers-and-grasses executed in purple and yellow (or red and green) on the fragment of a small dish; and a scalelike pattern in red or green on the fragment of another small dish. In addition, the fragment of the base of a dish unearthed from Shuda has a picture of what seems to be turnip leaves done in green (pls. 37–38).

Many of these types are not to be found among the pieces traditionally described as Old Kutani; they are different also from Imari, showing a characteristic style resembling, if anything, that of Kyoto ware.[25]

INSCRIPTIONS

The inscriptions are found on the bottom of the stand of bowls and dishes; most common is the character *fuku* (福; "good fortune"), or variations on it in which the number of strokes has been increased or decreased. Sometimes the inscription is written in black glaze covered with a thick layer of green or dark indigo glaze, and sometimes in cobalt blue. Some scholars would read what appear to be variations of the character *fuku* as the character *kaki* (柿; "persimmon"), and see it as the mark of Kakiemon ware.[26]*

One also comes across inscriptions resembling the characters *suke* (祐) and *homare*

* It should be noted that due to the multiple meanings and readings of Japanese characters, the romanizations and literal translations of some inscriptions are tentative.

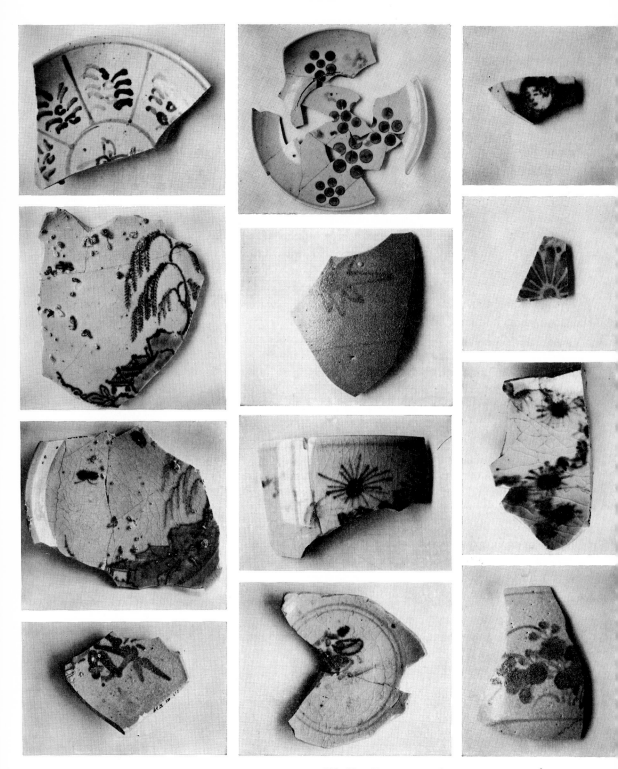

112–31. Patterns on fragments excavated at the kiln sites (from *Preliminary Findings of the First Series of Excavations at the Kutani Old Sites* and *Preliminary Findings of the Second Series of Excavations at the Kutani Old Sites*).

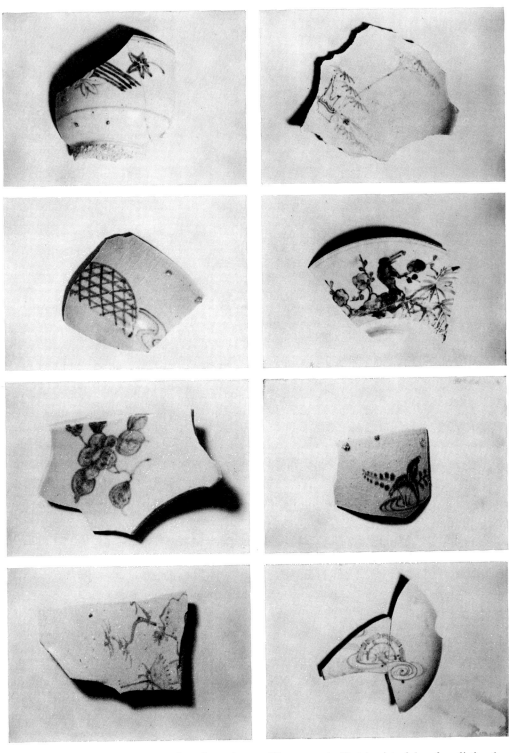

The patterns, for the most part done in underglaze cobalt blue, are mostly of flowers and plants, though there are some specimens of running water with wicker baskets (*jakago*), water wheels, and drying fishing nets among others. The general effect is pictorial and realistic; the execution is skillful and the mood graceful. One seems to detect a characteristic style and atmosphere different from Old Kutani, and also from early Imari.

132. Fragment with inscription unearthed at kiln sites (from *Preliminary Findings of the Second Series of Excavations at the Kutani Old Sites*).
A variety of shards bearing writing were discovered during the excavations. This fragment of a dish used as a glaze test bears, in underglaze cobalt blue, the two characters for "Kutani" (九谷) in the center and, on the right and left respectively, "the second year of Meireki [1656] . . ." and "eighth month, six . . ." in small characters. The reverse side has a picture suggesting a grapevine. The fragment is valuable as proof that the kiln was operating in 1656.

(誉); the fact that fragments bearing similar inscriptions have been unearthed at the site of the old Arita kilns has led some scholars to assume that these pieces were produced at Arita. There are various other inscriptions whose readings are doubtful; Mr. Saitō has made great efforts to decipher them, and has published his findings.[27] Some scholars, again, believe that these difficult to decipher inscriptions include some that represent the characters *chōju* (長寿; "long life"), *kiju* (貴寿; "venerable longevity"), and *fuju* (富寿; "affluent longevity"), and would attribute them to the hand of Kakiemon III.[28] There are other pieces inscribed with Chinese dynasty or era names—for example, "Great Ming [Dynasty]" (太明) or "Made in the Ch'eng-hua Era of the Great Ming [Dynasty]" (大明成化年製), some of which are written in a red iron-oxide glaze.

The recent excavations also uncovered some fragments of vessels or glaze tests on which various letters apart from the usual dates or formal inscriptions had been written. I will briefly enumerate them here as they are described in the preliminary reports.

A fragment of a large dish used as a glaze test has the characters for "Kutani" written large in the center in cobalt underglaze, with the characters for "second year of Meireki [1656] . . ." done small to the right and "eighth month, six . . ." on the left (pl. 132). A fragment of a small dish also used as a glaze test has the figures "26, 38" written near the rim of the interior. The fact that there is writing close to the rim suggests

that the interior surface also contained a lot of other writing. A piece of a medium-sized bowl used as a glaze test, bearing the characters "Chōkichi" (長吉; probably a person's name) done in thick strokes, has also been discovered.

Other finds include a fragment of a pottery dish with the character *shutsu* (出) in iron glaze, and part of what is believed to have been a jar-shaped pottery vessel, with, on the outer surface, a rectangle painted in white slip over iron glaze and, within the rectangle, the name "— — Tazaemon" (□□太左ェ門) done in cobalt blue. There is also a tea bowl with *hiragana* letters on the exterior—*kokoro . . . masuru*—that are believed to form part of a poem, and, on the interior of the stand, *mimo* in *katakana* letters.

There are two other pottery fragments, one bearing what appears to be a poem, the other the single *hiragana* letter *no*.[29]

FUTURE RESEARCH

Many years have passed since scholars first began to suggest that what was known as Old Kutani might in fact include some Arita porcelain, and a great deal of controversy, backed up by surveys and research of various kinds, has ensued in the intervening period. A particular stir was created nearly twenty years ago when Soame Jenyns, former curator of Asian Art at the British Museum, decided that a certain ewer hitherto known as Old Kutani had in fact been fired at Arita in response to an order from Dutch merchants. Jenyns published a report asserting that the early products of Arita ware were the so-called Old Kutani.[30] This report added further fuel to the controversy concerning the relationship between Old Kutani and Arita porcelain.

There is no space here to discuss the controversy in detail, but various theories have been propounded—for instance, that the influence of Arita porcelain is apparent in the shapes and designs of Old Kutani ware, or that Old Kutani represents a stage in the development of Arita ware. Some scholars pointed out, for example, that inscriptions identical to those on fragments unearthed at Arita are found among Old Kutani pieces. They have also pointed out that many fragments of pieces intended for overglaze decoration discovered at the Yambeta kiln site in Arita are similar to the body of enameled pieces called Old Kutani, and that these Arita shards include, moreover, blue-and-white floral arabesques also resembling those found on Old Kutani. Recently Mr. Saitō, after a thorough survey of surviving Old Kutani, has presented various new views of this complex problem from a broad perspective.[31]

Where the sites of the old kilns are concerned, there seem to have been some earlier investigations by individuals, but in 1959 the local Yamanaka-machi Cultural Properties Protection Committee undertook a broad general survey of its own. Then, ten years later, in the summer of 1970 and again in the summer of 1971, the first large-scale excavations were carried out by the education committees of Ishikawa Prefecture and Yamanaka-machi and a Kutani Old Kilns Commission set up specially for the purpose.

101

These most recent surveys involved elaborate studies from various perspectives, including the history of ceramics, archeology, and the use of scientific survey methods. At the time of this writing all that is available is the preliminary reports, but they show that the results achieved were impressive; information has been obtained as to the size, construction, and dates of the kilns, large numbers of ceramic fragments have been uncovered, and various hitherto unknown aspects of Old Kutani have become apparent.

The surveys have also raised new questions—for example, the question of the provenance of the techniques required to produce the celadon of which so many fragments were found, or of the relationship with the *suisaka* ware and the so-called Suisaka kiln. It is unfortunate, too, that no full-scale dump has been discovered.[32]

One of the greatest problems, of course, is the relationship of the excavated sites to the body of ceramics traditionally known as Old Kutani. The problem is discussed by Mikami Tsugio in the preliminary reports and by Fujioka Ryōichi in his *Iro-e jiki* (Enameled Porcelain), both of which point out that the presence of large numbers of fragments of undecorated white porcelain among the fragments unearthed may well mean that they were intended as the base for multicolor overglaze decoration. These same fragments include very few pieces of the large dishes and bowls that are common among the finer examples of Old Kutani. Moreover, such Old Kutani works, though including some that use only overglazes, also include quite a number that have one or two lines in underglaze cobalt around the underside, or scroll and other patterns, or inscriptions in cobalt on the underside—yet no examples of this seem to have been unearthed.

Where color overglazes are concerned, however, fragments with such decorations, though admittedly few, have in fact been unearthed, and large quantities of the iron-bearing rock believed to have been used as the raw material for the red pigment have been discovered, making it seem possible that porcelain with multicolor overglaze decoration was in fact produced at the excavated kiln. The fragments with overglaze decoration are unfortunately small, showing only small sections of the design, so that nothing can be said as to the style or the way in which the enamels were used.

By comparison, the excavation unearthed large numbers of fragments with pictorial designs in blue-and-white, particularly fragments of tea bowls and medium- or small-sized dishes. The execution of the designs is generally representational and realistic in layout and rendering; the effect is graceful, some of the pictures suggesting the Kyoto style, others of an excellence that makes one suspect the hand of a professional painter. If so, this poses various new questions, such as the identity of the men who had a hand in the designs.

These blue-and-white designs apparently differ considerably from the decoration on the works generally accepted as Old Kutani. Assuming that there was some relationship at the time between the underglaze cobalt patterns and overglaze enamel designs, one might cite the pedestal bowl with design of cranes and turtles with young

cryptomeria trees and battledores found among accepted Old Kutani ware (pls. 64–65), in which the outline of one of the battledores is done in cobalt and the whole has an elegance of mood that hints at some link between the two. This bowl with stand has come into the limelight because of the discovery, during the excavations, of fragments of a bowl very close in size and shape and with similar openwork on the stand (pls. 25–26). Nevertheless, such resemblances between excavated and extant wares are extremely rare.

In addition, fragments of vessels similar in shape to accepted Old Kutani ware have also been unearthed: a bowl, for example, with a very pronounced rim and a medium-sized dish in a distorted petal shape. Thus one of the most interesting tasks for scholars at the moment would be to select those pieces from among existing "Old Kutani" ware that can be identified more or less positively as products of the excavated Kutani kilns.

Further results can be expected in future from scientific studies of the materials used in the excavated fragments on the one hand and surviving Old Kutani works on the other. Further studies will also be necessary on early overglaze designs of Imari and other wares, as well as on decoration on Kyoto ware and the paintings of the Kyoto Kanō and other related schools.

2

KUTANI WARES

In the latter half of the Edo period, particularly from the early nineteenth century onward, official shogunate policies encouraging industry led to the establishment of local enterprises such as ceramics, dyeing and weaving, and lacquerware in various parts of Japan, and many distinctive local products began to appear. Ceramics in Kyoto, despite the brilliant developments of the early Edo period, had since seen something of a decline, but the growth of a new porcelain industry in the Kiyomizu area soon made Kiyomizu predominant among Kyoto wares. The emergence of a number of outstanding potters gave rise to a new golden age. In Arita the volume of production rose sharply, and at Seto too the establishment of a porcelain industry in the Bunka era (1804–18) brought a sudden new prosperity, while a whole succession of other new porcelain-producing kilns sprang up in various parts of the country. In fact, a majority of the ceramics known today by the names of their kilns came into being around this time.

In Kaga, in the meantime, no ceramics worthy of the name had been produced since the era of Old Kutani, but in the first decade of the nineteenth century a kiln was built at Kasugayama in Kanazawa with the idea of starting a ceramics industry and paving the way for a renaissance of Kaga ceramics. The Kasugayama kiln was succeeded by the Minzan kiln and others which gave rise in turn to branches including Wakasugi and Ono, while the Yoshidaya kiln was established in Kutani itself in an attempt to revive former glories, and was in turn succeeded by the Miyamotoya and Eiraku kilns. Thus the ceramics industry developed rapidly in Kaga, and the foundations of the contemporary "Kutani wares" were laid.

At this point, it would be ideal if one could divide the various kilns into two main traditions—that which derived from the Kasugayama kiln on the one hand, and the descendants of the Yoshidaya kiln on the other. In practice, however, though this might be possible at the first stages, the rapid increase in the number of kilns and the flourishing exchanges that took place among the potters themselves make the task nearly impossible, since there are great variations within the same style and, on the other hand, a great deal of intermingling with the styles of other kilns. Purely as a matter of convenience, therefore, I will discuss the various kilns here more or less in

the order in which they were established—though even these dates are not clear in some cases.[33]

The Kasugayama Kiln

The Kasugayama kiln paved the way for the development of the porcelain industry in Kaga toward the end of the Edo period, reviving ceramics in an area where they had been unknown ever since the abandoning of the Old Kutani kilns.

Since there was no porcelain in Kaga at the time, it was purchased as needed in Arita, Kyoto, and elsewhere. However, such places were far away, and prices were high, causing an enormous yearly drain on the clan's finances, so it was decided to encourage the manufacture of ceramics as a way of easing the strain and achieving self-sufficiency. It was decided that Kutani clay would be used, and in 1806 the well-known Kyoto potter Aoki Mokubei was invited to take the lead in establishing the new kiln.

Mokubei (1767–1833), who was also acquainted with leading literary figures of the time, was himself a man of some learning, and a skillful painter into the bargain. He had been drawn to pottery at the age of twenty-six or twenty-seven when he read *T'ao-shuo* ("Descriptions of Chinese Pottery and Porcelain"; *Tōsetsu* in Japanese), a specialist work on ceramics written in Ch'ing China. He showed a style and inventiveness above the run of ordinary potters, turning out celadon, blue-and-white ware, *kōchi*-style ware, pieces in the Ninsei style, works with polychrome overglaze decoration and gold-enameled ware (*kinrande*). At the time when he was first invited to Kanazawa he was already in the prime of life and well-known as a ceramics artist, but was attracted toward Kutani, and in the ninth month of 1806 he set off for Kanazawa. Once there, he turned out some trial work at Utatsuyama. Since the results were satisfactory, he went back to Kyoto and in the fourth month of the following year returned to Kanazawa bringing Honda Teikichi as his assistant. In the tenth month they built a kiln at a site on Kasugayama. The kiln was fired for the first time in the eleventh month, and quite an amount of porcelain was turned out, but the results do not seem to have met Mokubei's expectations.

Nevertheless, thanks partly to backing from the town, work seems to have proceeded on a considerable scale. Rejoicing that a ceramics industry had been revived after such a long period of neglect went with high hopes that the province would eventually be able to supply its own pottery and porcelain without having to buy from other provinces. Despite its auspicious beginning, however, the Kasugayama kiln was dealt a heavy blow by a fire at Kanazawa Castle at the New Year, 1808, which placed a great strain on finances and led to the cutting off of aid to the Kasugayama kiln. At the same time, Mokubei went home to Kyoto—possibly from displeasure at the way ceramics were treated chiefly as a promising industry rather than an art form. After this, Matsuda Heishirō continued to operate the kiln, employing the potters Honda Teikichi (or Sadakichi), Tōda Tokuemon, and Etchūya Heikichi as his assistants. 105

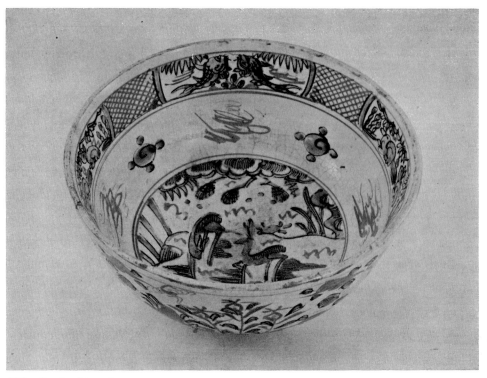

133. Bowl with polychrome overglaze design of landscape with deer. Kasugayama kiln. H. 8.3 cm., d. 18.5 cm. Ishikawa Prefecture Art Museum. This bowl, in the imitation red-enameled (*aka-e*) style common among the products of the Kasugayama kiln, has a soft body covered with a yellowish-white glaze. There is crackling. The characteristic *aka-e* design is done principally in red, in a relaxed manner. An inscription on the base reads *Kinjō-sei* ("Made in Kinjō [i.e., Kanazawa]").

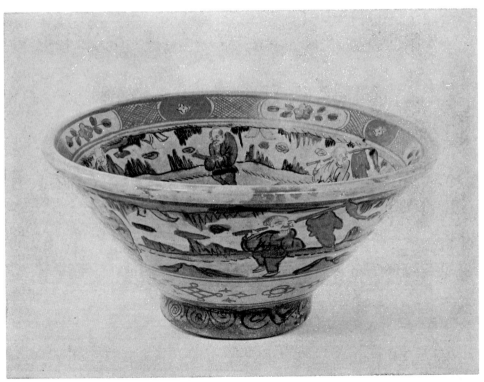

134. Bowl with polychrome overglaze design of Chinese figures. Kasuga-
yama kiln. H. 15 cm., d. 32.5 cm. Ishikawa Prefecture Art Museum.
The body uses coarse clay and is covered with a yellowish-white glaze with
a dingy appearance. Although the firing is technically inferior, the design
in this imitation red-enameled (aka-e) piece is skillfully executed and fits
convincingly into the surface available.

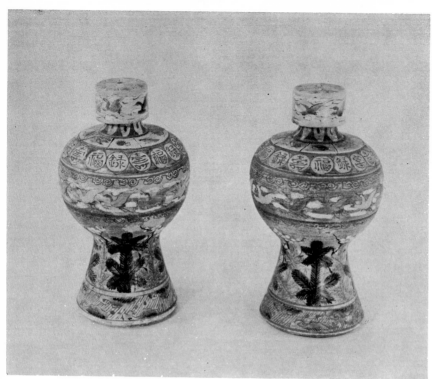

135. Pair of sake bottles (*heishi*) with polychrome overglaze design of pine, bamboo, and flowering plum. Kasugayama kiln. H. 16.5 cm.

These unusual pieces have unglazed bodies decorated directly with auspicious patterns done in enamels. It is apparently difficult to execute a design directly on an unglazed surface using colored glazes, but here it is achieved most successfully, with fine details. The inscriptions read *Kimpu-zō* ("Made in Kimpu [i.e., Kanazawa]").

Heishirō, who used the artistic name Basō (馬宋), came from a family of brush and ink merchants; he was something of a dilettante, and though he was officially manager of the kiln, he produced work that owed a good deal to stylistic elements personally inherited from Mokubei. Tokuemon had studied pottery decoration with Mokubei, whose style he is said to have carried on. But the Kasugayama kiln went into a progressive decline—accelerated by, among other things, Teikichi's moving to the Wakasugi kiln—and it seems to have been abandoned at the beginning of the Bunsei era (1818–30).

The wares themselves, which include celadon, blue-and-white, and copies of classic enameled *aka-e* ware, *kōchi* ware, and iron-decorated Korean ware, resemble the Kyoto ware of the day in general appearance—presumably because Mokubei guided the kiln in its first stages.

Among the celadon, which is comparatively common, one very occasionally finds pieces where the glaze has fired to a good color, but in most cases the green is dingy. The porcelain body of blue-and-white ware is not pure white, nor has the cobalt pigment fired to a very bright, clear color, but some of the pieces have a pleasing elegance. The overglaze-enamel pieces include many imitations of Chinese cobalt- and enamel-decorated wares (the so-called *gosu aka-e*), some of them very fine.

The inscriptions—sometimes stamped with a seal, sometimes incised, and sometimes written with a brush—include *Kimpu* (金府; i.e., Kanazawa), *Kinjō Higashiyama* (金城東山;

i.e., Higashiyama in Kanazawa), *Kasugayama* (春日山), *Kayō-sei* (加陽製), *Kinjō* (金城; i.e., Kanazawa), *Kinryōhen* (金陵辺; i.e., Kasugayama), *Kinjō Teikeizan* (金城帝慶山; Teikeizan is Kasugayama), *Kinjō Kasugayama-sei* (金城春日山製; "Made at Kasugayama in Kinjō [Kanazawa]"), and *Kinjō Bunka-nen-sei* (金城文化年製; "Made in Kinjō [Kanazawa] in the Bunka era [1804–18]"). The *Kinjō Higashiyama* mark is said to have been used by Heibei, a tile maker of Utatsuyama, on the pottery that he turned out as a sideline. It seems probable that the inscription *Kasugayama* was used even after the Kasugayama kiln had fallen into disuse. The works produced at the Kasugayama kiln and stamped with the seal "Mokubei" in addition to the mark of the kiln itself seem to include some that are the genuine work of Mokubei, but it is difficult to speak with any accuracy.

THE MINZAN KILN

This kiln was established during the Bunsei era (1818–30) by Takeda Shūhei, who regretted the demise of the Kasugayama kiln, and the name derives from the fact that its products are inscribed with the characters for "Minzan" (民山), which was Takeda's artistic name.

Takeda Shūhei, son of a samurai of the Himeji clan, went to Kanazawa at the end of the Bunka era (1804–18) and later entered the service of the clan. He is said to have worked in connection with the gold mines, but he was a man of many other talents as well. He is said to have been particularly skilled in making miniature objects, being known under the pseudonym of Yūgetsu, but he also did ink paintings and was the founder, under the name Keiundō, of a school of miniature landscape arrangements on trays.

Minzan set up his kiln at Kasugayama, where he made porcelain with the help of Mokubei's pupil Tōda Tokuemon and his son Tokuji, he himself supervising the design. At the same time, he set up an enameling kiln within the grounds of his own home, and invited Nabeya Kichibei, a ceramic painter from Komatsu, to do the overglaze decorations for the pieces he fired there. Kichibei was not only good at ceramic design but was also an expert sculptor and lacquer decorator. The Minzan kilns reached a peak of activity during the Tempō era (1830–44), but ceased production with Minzan's death in 1844.

Works produced by the kiln use porcelain clay for the bodies, but the low temperature of the firing gives them a pale pink color; the glaze, too, is not clear, but a distinctive feature of its decorations is the combination of fine lines in red glaze (*aka-e*) accented with added gold. This combination originated at the Minzan kiln, and although the wares were dull from underfiring, the format was significant as the precursor of the later "Hachirō" ware and as the ware from which red-enameled (*aka-e*) Kutani was to derive. There are some pieces which use yellow, green, purple, and blue in addition to the red.

109

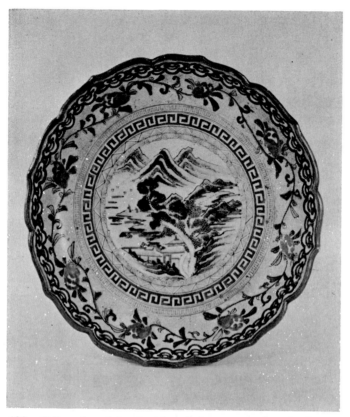

136. Foliate-shaped bowl with polychrome overglaze landscape design. Minzan kiln. H. 5 cm., d. 24.5 cm. Ishikawa Prefecture Art Museum.

The products of the Minzan kiln, which was established in the hope of reviving the success of the Kasugayama kiln, are characterized by designs done in fine red lines, and are forerunners of the later Kutani ware with decorations in overglaze red and other colors with gold. The body of this bowl, as often in Minzan pieces, was fired at too low a temperature to produce true porcelain. The central landscape is surrounded with geometrical patterns done in red, green, and deep blue, a unique effect being created by the juxtaposition around it of geometrical designs of varying degrees of boldness.

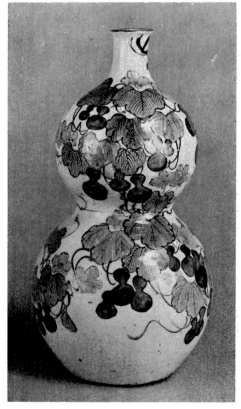

137. Gourd-shaped sake bottle with polychrome overglaze design of gourds. Minzan kiln. H. 28.5 cm. Tokyo National Museum.

A semiporcelaneous body with a yellowish-white glaze is covered with a proliferation of gourd vines, the outlines being done in black with the flowers, leaves, and gourds in red, yellow and green, and purple respectively. The piece is unusual among products of the Minzan kiln in that it is not in the fine-lined red-enameled (aka-e) style. The base has the "Minzan" inscription in red.

111

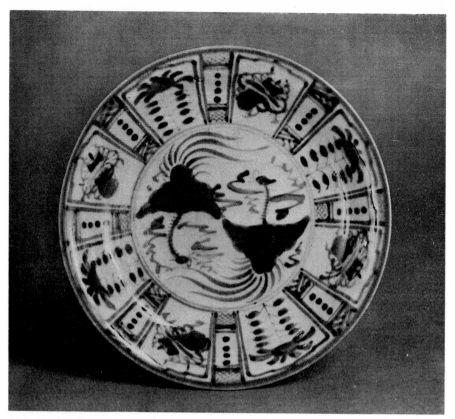

138. Dish with underglaze-blue design of phoenixes. Wakasugi kiln. H. 4.4 cm.,
d. 20.8 cm. Tokyo National Museum.

The patterns on the border represent a further simplification of those of the *fuyōde*
blue-and-white dishes produced at Ching-te-chen in late Ming and early Ch'ing China
and also imitated in Old Kutani, while the central design is a very free representation
of phoenixes. This attractive freedom of style was possible since most of the works
produced at Wakasugi were intended for everyday use.

THE WAKASUGI KILN

The Wakasugi kiln came into being when Honda Teikichi, who had come to the
Kasugayama kiln from Kyoto with Mokubei and had been working there as his
assistant, was invited by Wakasugi village in Nomi County to produce pottery there.
As the first pottery kiln in the Nomi area it is imporant as the forerunner of the Ono
and Rendaiji kilns and others.

Hayashi Hachibei, an important local official in the village of Wakasugi, was a tile
maker by family trade, but he was fond of the tea ceremony and *raku* ware and also
tried his hand at making pottery. It happened that Honda Teikichi visited him and
discovered good-quality clay at Rokubeiyama in nearby Hanazaka village, and in
1811 the two men joined forces, with the support of the clan, to found a new kiln. They
gathered a number of potters from Kyoto and Hirado and began operations on a large
scale, with Teikichi acting as chief potter. He was joined by Yūjirō, and the kiln's
fortunes steadily began to look up.

Teikichi was born in Hizen province and worked as a potter at various kilns until
1807, when he went with Mokubei to Kaga where he devoted the remaining dozen
years of his life to the revival of the Kaga ceramics industry. His work apparently

139. Sake bottle with underglaze-blue landscape design. Wakasugi kiln. H. 22 cm. Ishikawa Prefecture Industrial High School.
This piece has a degree of sophistication unusual in Wakasugi ware. The execution of the landscape design is skillful, and the decoration extending from the neck down onto the body shows an inventive variety.

140. Spouted bottle (*hei*) with underglaze-blue design of peonies and butterflies. Wakasugi kiln. H. 22.7 cm.

included blue-and-white of a classical elegance with excellent decorations; he died in 1819, but his achievements were to contribute greatly to the subsequent remarkable development of Kaga ceramics.

Yūjirō, who specialized in red-enameled (*aka-e*) ware, brought to Wakasugi ware a new style of decoration in which red predominated, with no added gold, and which combined robustness of execution with a certain originality of design. Some sources say that he was a decorator of ceramics from Hizen province, while others claim that he was born the son of a dyed-goods merchant with a shop called Akae-ya in Tokushima, and that he studied overglaze decoration in Wakasugi, evolving a new style of his own there.

Production continued to flourish until the kilns were put under the control of the district magistrate of the clan in 1816, and the name too was changed to Wakasugi Ceramics Center (*Wakasugi tōkisho*). Three years later, in 1819, the clan Bureau of Local Products issued a directive declaring that, since so much pottery and porcelain was being turned out at Wakasugi, Wakasugi ware would be used for official clan purposes from the beginning of the following year, and that purchases of ceramics from other provinces would be banned.

141. Large dish with underglaze-blue design of mandarin duck. Wakasugi kiln. H. 6 cm., d. 41.8 cm.
This is another example of a design inspired by the decoration on those Old Kutani shallow bowls that trace their origin to the *fuyōde* dishes from the porcelain center Ching-te-chen in China. The execution is careful, but the sense of freedom often found in Wakasugi ware is lacking.

Next, in 1820, thanks to protection and encouragement from the clan, responsibility for the Ceramics Center shifted from the district magistrate to the Bureau of Local Products, and the work was continued with Hayashi Hachibei as kiln head and Yūjirō as chief potter.

Things did not go as well as expected, however, so in 1822 the clan appointed a ceramics merchant, Hashimotoya Yasuemon, to the post of supervisor, and gave active aid and protection to the kiln, with the result that production began to revive. Again, a dozen or so years later fresh supplies of porcelain clay and good-quality pottery clay were found in Hanazaka and Yamaita respectively. Things were promising to go still better when a fire damaged the kiln and the site was shifted to the clay quarry at the neighboring village of Yahata. Although this new kiln was built on an impressive scale worthy of an official clan enterprise, the loss of Yūjirō and the appearance in rapid succession of the Ono and other kilns soon brought about a decline. Under the direction of Shōemon, Yasuemon's son, the kiln worked busily producing large quantities of blue-and-white ware for everyday use, but the quality deteriorated, and the cessation of clan patronage following the post-Restoration abolition of the clans finally led to the abandoning of the kiln in 1875.

Since the Wakasugi kiln was managed with the aim of promoting industry, the products naturally included a large number of articles for everyday use. The early

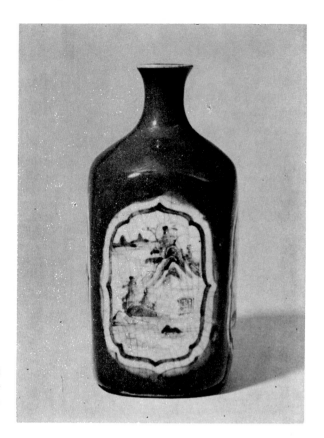

142. Square bottle (*hei*) with bright blue "lapis lazuli" glaze and underglaze-blue landscape design. Wakasugi kiln. H. 20.8 cm.

pieces have semiporcelaneous bodies that are frequently cracked and have an off-white glaze surface, even the blue-and-white ware having a dingy appearance, but great improvements were effected later. There are both blue-and-white and red-enameled (*aka-e*) wares, but various other types include some pieces in the Imari style and others with decoration imitating Old Kutani. Some pieces achieve style or impress with their freedom and freshness of approach, precisely because they were turned out, without a great deal of thought, for everyday use. There are some works, too, with pictures painted by known artists such as Yamaguchi Soken (1759–1818), who studied with the Kyoto painter Maruyama Ōkyo and specialized in human figures (especially figures of beautiful women), and Chinshū, a painter of the Mochizuki school who enjoyed a reputation in Kyoto artistic circles.

Excavations were carried out at the site of the kiln in the summer of 1972. No report has been issued at the time of this writing, but a considerable number of fragments have been unearthed, including cheerful blue-and-white wares with a well-fired porcelain base and other pieces with polychrome overglaze decoration, as well as some covered with bright blue "lapis lazuli" glaze. Quite a number of these are indistinguishable from similar pieces produced in Arita; it seems likely, in fact, that techniques were far more advanced than prevailing ideas of Wakasugi ware would suggest, and that the Imari influence was strong. One looks forward to the report for further details.

144–45. Jar with polychrome overglaze design of pomegranates. Wakasugi kiln. H. 19 cm., d. 33.8 cm.

The design is executed in black lines, the pomegranates being filled in with light red and the background done in green. An inscription on the base inside the foot reads "Bunsei 7 [1824], Craftsman Katō [three characters illegible] fired this at the Wakasugi Ceramics Center; polychrome ware, resident in Awa province Buichi Yūjirō; the year of the monkey, seventh month," together with a "painted seal" consisting of the character *yū* (勇; the same character as used in "Yūjirō") within a double square.

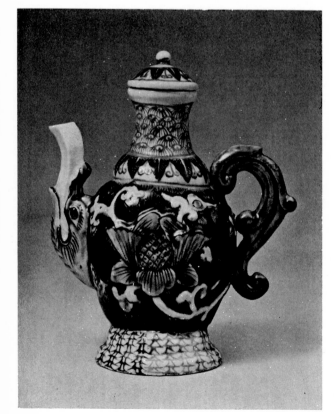

143. Water ewer with polychrome overglaze floral scroll design. Wakasugi kiln. H. 19.9 cm. The floral scroll design on the body of this piece, for which a mold was used, is raised in high relief. The decoration, particularly on the spout and handle, is rather overdone, but the coloring is interesting.

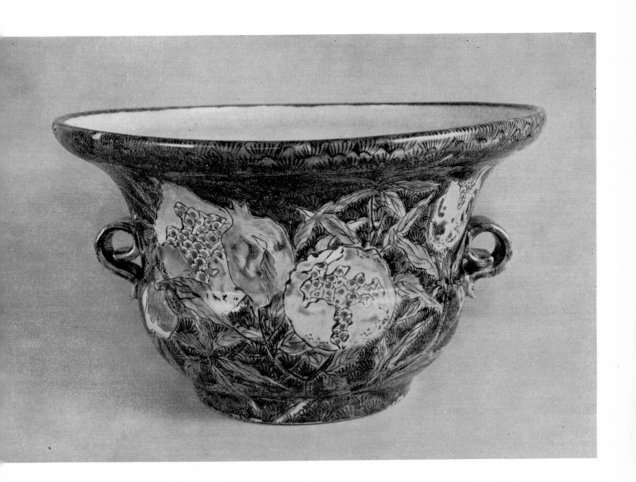

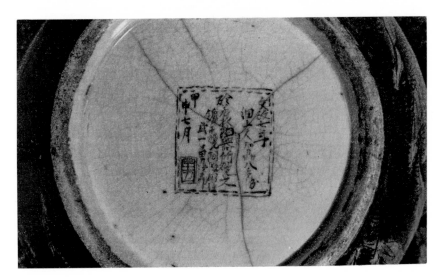

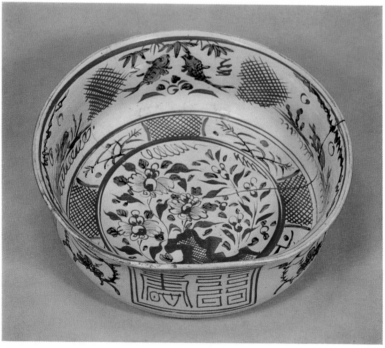

146. Deep bowl with polychrome overglaze flower-and-grasses design. Kasugayama kiln. H. 11 cm., d. 28.5 cm.

The Kasugayama kiln's period of activity was short, and revealed no special development, yet the kiln played a pioneering role in the revival of ceramics in Kaga, and was distinguished during its first stages—though for little over a year—by the presence of the celebrated Kyoto potter Aoki Mokubei, under whose guidance work was produced in the classic red-enameled (*aka-e*) and iron-decorated Korean styles as well as celadon. The work shown here, in the manner of *gosu aka-e* (Chinese enameled ware predominantly in red and green with occasional use of underglaze blue), successfully captures the latter's relaxed, charmingly unsophisticated style in design, coloring, and execution alike. The base bears the inscription "Kasugayama."

147. Large dish with polychrome over-glaze bird-and-flower design. Wakasugi kiln. H. 5.4 cm., d. 31.5 cm.

It was at the Wakasugi kiln that the Kaga clan first succeeded in the production of ceramics on an industrial scale, which the Kasugayama kiln had failed to do. Built in Wakasugi (present Komatsu City) in 1811, it attracted well-known potters such as Honda Teikichi and Yūjirō. A fire sub-sequently forced it to move to Yahata, where it survived until mid-nineteenth century. Most of its products were intended for daily use, and blue-and-white predominates, though there are some pieces in the style of red-enameled (*aka-e*) Imari and Old Kutani. The dish shown here combines the free, relaxed decoration characteristic of Waka-sugi with a sense of tight overall organiza-tion. The underside is encircled with floral scrolls. Inside the stand are inscribed, in the center, the words "Made in the Ch'eng-hua Era of the Great Ming [Dynasty]" and, around it, the words "Kaga Wakasugi kiln" and "Design by Soken in Komatsu." Soken refers to the painter Yamaguchi Soken (1759–1818) of the Maruyama school, who was well known for his paintings of beautiful women.

148. Vase with polychrome overglaze floral design. Wakasugi kiln. H. 24 cm. Ishikawa Prefecture Art Museum.

During its early years the Wakasugi kiln seems to have used off-white semiporce-laneous bases, but in its middle period it succeeded in producing a hard, almost pure white porcelain. The base of the bottle shown here is almost pure white; the Imari-style decoration, of a type often found on Wakasugi ware, is rather fussy, but is exe-cuted with loving care.

119

149. Tea-leaf jar with design of human figures in polychrome overglaze with gold. Ono kiln. H. 11.9 cm. Tokyo National Museum.

The Ono kiln was founded in 1819 by Yabu Rokuemon of Ono village in Nomi County, who had studied ceramics under Honda Teikichi at the Wakasugi kiln. At one stage, many outstanding potters were associated with the kiln and it produced good work, but later—partly because of a dearth of good decorators—the kiln began to concentrate on making undecorated porcelain. Its principal products were elaborately decorated pieces with fine red lines in the Minzan style; they are noteworthy as precursors, along with the Minzan ware, of the subsequent fashion for Kutani ware done in red and other colors with gold (*aka-e kinrande*). The decoration on this jar is quite finely worked and creates a kind of classical elegance, but the red is dingy and the work has not yet attained the refinement of *kinrande* during its best period.

THE ONO KILN

This kiln was founded by Yabu Rokuemon, a wealthy farmer of Ono village in Nomi County. He studied the making of pottery with Honda Teikichi of the Wakasugi kiln, then established his own kiln in Ono in 1819. The kiln seems to have been plagued at first by failures, but following the discovery of good-quality clay in Nabetani village in the Tempō era (1830–44), the standard of the ware improved, and in 1834 the kiln was given the protection of the district administrator. The scale of operations was expanded, and with the employment of outstanding potters such as Aoya Gen'emon and Matsuya Kikusaburō from Komatsu and Kutani Shōza from Terai, the kiln began to turn out distinguished work. The management of the kiln changed from time to time, and in the early Ansei era (1854–60), under the direction of Kichiemon, Rokuemon's adopted son, it began to devote itself to producing undecorated porcelain which it supplied to Nomi County, Kanazawa, and elsewhere as bases for overglaze enamel decoration.

Aside from undecorated porcelain, the kiln also produced decorated pieces with red-and-gold polychrome enameling. The red-and-gold pieces show particularly skillful drawing and can be seen, along with Minzan ware, as a precursor of the later "Hachi-rō" ware.

150 (page 122). Shallow bowl with polychrome overglaze design of *omoto* (*Rhodea japonica*). Yoshidaya kiln. H. 6 cm., d. 38.4 cm. Ishikawa Prefecture Art Museum.

The Yoshidaya kiln was built in 1823 on the site of the former Old Kutani kiln, but subsequently moved to Yamashiro. Its style seems to have been derived from the "green ware" (*aode*) of Old Kutani; in the early period the body was completely covered with colored glazes, and the colors included no red. The design on the bowl shown here is done in blue, purple, and green, the background being completely covered in yellow. The underside has floral scrolls covered with a thin green glaze; inside the foot rim the character *fuku* ("good fortune") appears within a square that has tree leaves disposed about it, the whole being covered with yellow glaze.

151 (page 123, top). Four-tiered hexagonal box with polychrome overglaze design of camellias. Yoshidaya kiln. H. 21.5 cm., d. 16 cm. Ishikawa Prefecture Art Museum.

Like the Wakasugi kiln, the Yoshidaya kiln was intended for the production of articles of everyday use; it turned out dishes, bowls, sake bottles, sake cups (*sakazuki*), *sencha* tea cups (*senchawan*), and candlesticks, and even such kitchen articles as mortars and earthenware cooking pots (*do-nabe*). This set of boxes was probably designed for serving food, or for holding meals taken on a journey. It is a pleasing work, with well-harmonized colors enhanced by skillful firing.

152 (page 123, bottom). Square dish with polychrome overglaze design of melons. Yoshidaya kiln. D. 21 cm. Ishikawa Prefecture Art Museum.

The melons in the central picture are done in fine lines; the rim has *kabutobana* (wolfsbane; *Aconitum japonicum*) blossoms and vine scrolls in green and blue with the base left uncolored. The underside has floral scroll motifs covered entirely with green glaze, but the inside of the foot is left unglazed. During the Yoshidaya kiln's early years, most pieces seem to have been covered entirely with colored glaze, since the body used was a kind of stoneware clay, but following the transfer to Yamashiro grayish-white porcelain bodies of relatively high quality were produced, and an increasing number of pieces came to make use of the white body as a background for the decoration. This dish is one example of the work produced after the shift to Yamashiro.

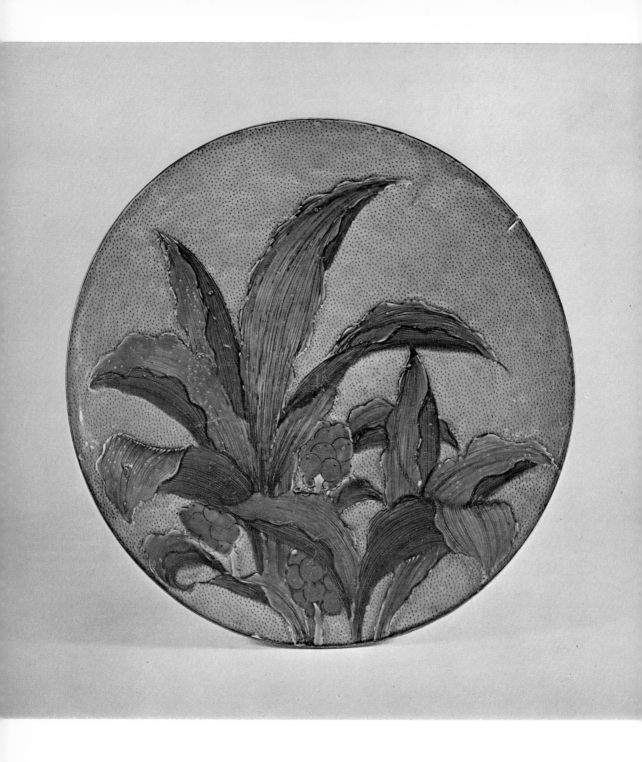

150–52. Captions on preceding page.

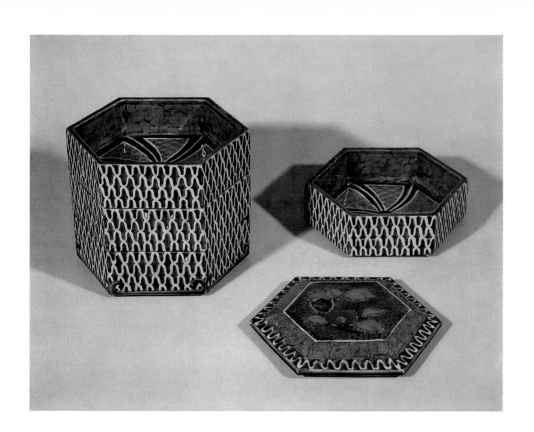

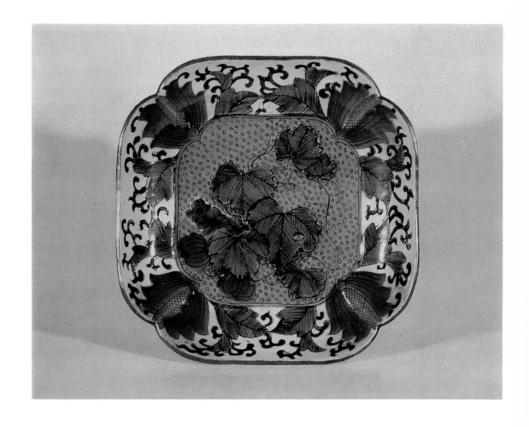

THE YOSHIDAYA KILN

This kiln was established around 1823 or 1824 by Den'emon, fourth head of the wealthy merchant house of Toyota in Daishōji, with the aim of reviving Old Kutani. Den'emon's family were sake brewers by trade, and it was the name of the business—Yoshidaya—that at some stage became the name of the kiln. Den'emon was a cultivated man, a scholar familiar with Chinese poetry and prose as well as Japanese verse and calligraphy, and a skilled painter into the bargain. In late life, conceiving the idea of reviving Kutani ware, he built his kiln on the site of the earlier Kutani kiln.

Kutani, however, situated deep in the hills, proved inconvenient in every way, and in 1825 or 1826 the kiln was moved to Etchūdani in Yamashiro after having been fired only five or six times.

Following this transfer to Yamashiro the kiln seems to have done well. Yoshidaya documents give the impression that the organization and technical level of the men employed were of no mean order: Aoya Gen'emon, for example, came from Wakasugi to the enameling kiln, while well-known Kaga potters of the day such as Nabeya Jōsuke, who was skilled at human figures and bird-and-flower pictures, and other artisans from kilns such as Shigaraki and various Kyoto workshops were brought in to do the decorating. The pieces produced were widely varied, ranging from shallow bowls that include some of the most outstanding examples of Yoshidaya ware to a considerable range of items of everyday use such as sake bottles, vases, deep bowls for food (*domburi*), pouring bowls (*kataguchi*), and mortars. The ordinary wares seem to have been marketed as far as Kanazawa and the Kansai area around Osaka and Kyoto.

Following the death of its founder Den'emon in 1827, however, the kiln began to deteriorate, and although at one stage it became the official kiln of the Kaga clan, firing was finally suspended in 1831 and the entire business was turned over to Miyamotoya Uemon, who had been the kiln manager.

Surviving examples of Yoshidaya ware include a large number of dishes and bowls produced from a kind of stoneware clay which is said to have been made with a mixture of porcelain clay from Kutani village and pottery clay from Suisaka village. The colored decoration—which uses yellow, green, dark blue, and other overglazes but no red—fills the whole surface (though some pieces make use of the white of the base in the composition). The decorations include bird-and-flower and landscape designs, as well as motifs that seem to be borrowed from the designs of blue-and-white wares. Some designs show the influence of the Old Kutani style, but they are vulgar and weak in execution. Nevertheless there are some fine large dishes, for example, which are worthy of the well-known potters who were assembled to produce them. The decorations on those pieces are superior to the general run of work from other kilns founded around the same time and have a characteristic elegance. Most of the inscriptions consist of the character *fuku* (福; "good fortune") within a square, done in black lines and covered with yellow or green glaze.

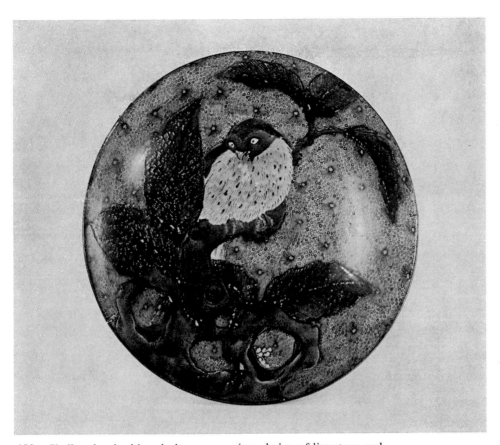

153. Shallow bowl with polychrome overglaze design of limestone rock
and bird. Yoshidaya kiln. H. 6.5 cm., d. 38 cm.
An oddly shaped piece of rock and a bird perching on a tree are skillfully
set against a yellow background covered with a "fish-egg" pattern and small
flower motifs. The firing is also good, and the whole effect is reminiscent of
the shallow bowl shown in plate 150.

125

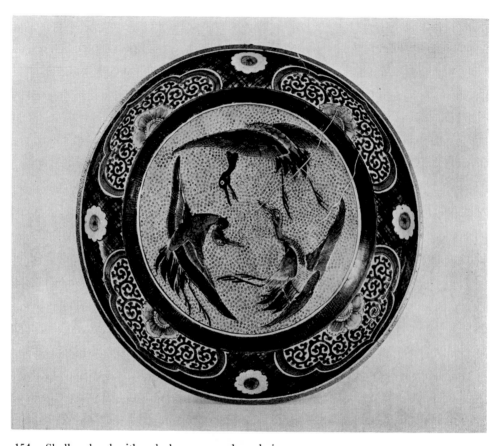

154. Shallow bowl with polychrome overglaze design of cranes. Yoshidaya kiln. H. 8.5 cm., d. 39 cm. Ishikawa Prefecture Art Museum.

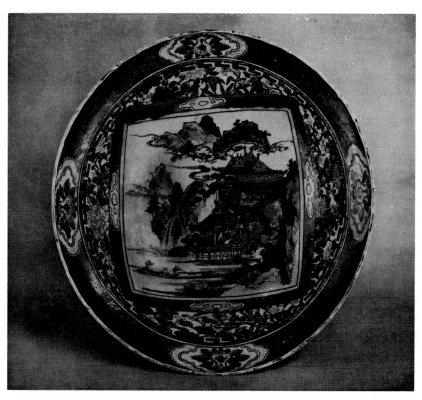

155. Bowl with polychrome overglaze landscape design.
Yoshidaya kiln. H. 13.9 cm., d. 47.8 cm. Tokyo National
Museum.

157. Sake bottles with polychrome over-glaze design of domestic fowl. Yoshidaya kiln. H. 18 cm.

Toyota, the name of the family that ran the kiln, appears again on these bottles together with the date "Bunsei 12 [1829], the year of the ox, ninth month." The kiln is said to have been abandoned in 1831, so these were produced two years earlier.

156. Eating utensils. Yoshidaya kiln. Ishikawa Prefecture Art Museum. A set of eating utensils, probably intended for use on some festive occasion. The underside of the dish bears the inscription "Bunsei 10 [1827], mid-seventh month, Toyota family." The Toyota family was responsible for the founding and running of the Yoshidaya kiln, so the set was probably made for the family's own use. The Yoshidaya kiln, first founded on the site of the old Kutani kilns, moved to Yamashiro after about two years, in 1825 or 1826, which means that this work was produced about one year after the move.

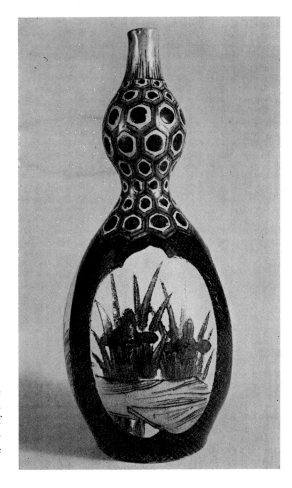

158. Sake bottle with polychrome overglaze design of irises. Yoshidaya kiln. H. 23.8 cm.
In this piece, which has a considerable sense of style, the pattern of hexagons at the top is done in green and purple while the lower half has a purple ground with three windows containing a design of irises and footbridge done in green, purple, and yellow.

159. Steamer with polychrome overglaze design of clematis flowers.
Yoshidaya kiln. H. 12 cm., d. 12.5 cm. Ishikawa Prefecture Art Museum.
The clematis flowers on the body and lid are done with a practiced hand.
The base has a hole so that the vessel can be placed over a source of steam
in order to cook whatever is inside it. The piece is strictly for practical use,
yet the decoration suggests a new graciousness in everyday life.

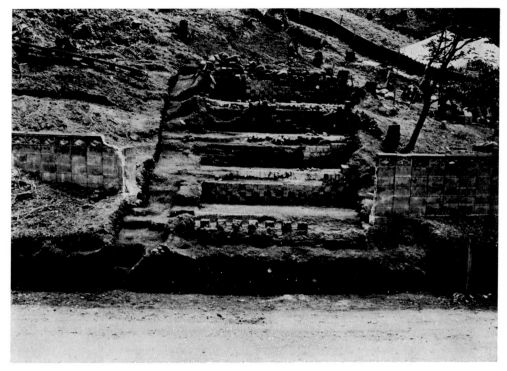

160. General view of Yoshidaya kiln site (from *Preliminary Findings of the Second Series of Excavations at the Kutani Old Sites*).
The site of the Yoshidaya kiln lies on a gentle slope to the right of the Old Kutani no. 1 kiln. A linked-chamber climbing kiln, it had four firing chambers and a flue at the top; the stokehole and firebox at the bottom have been lost as a result of road construction. The estimated total length was something over sixteen meters. The kiln was large, with brick walls, and high enough, it is believed, to permit a man to work upright inside.

The site of the Yoshidaya kiln in Kutani was excavated in the summer of 1972 as part of the same survey that included the Old Kutani kilns. A report on the results is included in the *Preliminary Findings of the Second Series of Excavations at the Kutani Old Sites*.

According to this report, the kiln was constructed on the gentle slope that was used as the dump for Old Kutani kiln no. 1. It was a linked-chamber climbing kiln consisting of a firebox and four chambers, together with a flue, the firebox having been lost due to construction of the prefectural road. The original length is estimated to have been over sixteen meters, and the height around five meters. The kiln seems to have been built on quite a large scale; the chambers, which were made of bricks, grow progressively larger toward the top of the kiln, and the ceilings—though these have of course collapsed—were high enough to permit a man to work standing. The interior of the kiln has yielded tools used for stacking, but extremely few shards. The remains of the dump have mostly been lost, the site having been intersected by the prefectural road, leaving only a very small area intact. As a result, few fragments have been found. Most of them represent bowls (*hachi*), dishes, and *wan* (food and tea bowls, smaller than *hachi*), with

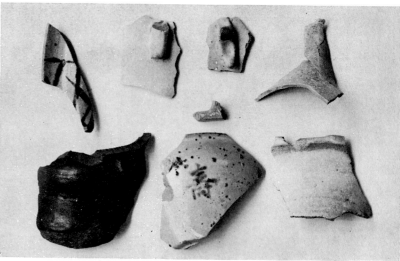

some large jars, sake bottles, and molded pieces. The glazes include celadon, white glaze, iron glaze, and ash glaze, the white being most common. A fair number of pieces, it seems, had a border of reddish-brown iron glaze (*kuchibeni*) around the rim. The bowls include many different types, with some whose stands were over twenty centimeters in diameter; the clay of the body was normally coarse with a high iron content, but a few pieces using high-quality clay were also found. The dishes occurred in a wide range of sizes, quite a few of them exceeding thirty centimeters in diameter. The great variety of shapes included nonagonal and foliate shapes, for which molds were used.

The few examples of decorated pieces include fragments of a tea bowl with floral scrolls in cobalt, and fragments of a white porcelain dish with a checkered pattern in iron. Only two fragments bearing inscriptions seem to have been found—a fragment of a *temmoku* tea bowl with the character for "long life" (寿) written on it in iron, and a fragment of a perforated circular plate with the incised character for "nine" (九; the "Ku" of "Kutani").[34]

161–63. Ceramic fragments unearthed at the site of the Yoshidaya kiln (from *Preliminary Findings of the Second Series of Excavations at the Kutani Old Sites*).

Almost all the fragments discovered at the site of the kiln and dump are of bowls, dishes, and *wan* (small food and tea bowls), with a few large jars, sake bottles, and molded pieces. Glazes used include celadon, white, iron, and ash glaze. White is the most frequent, and the use of *kuchibeni* (a line of reddish-brown iron glaze around the rim) is fairly common. Very few have patterns or inscriptions. The clay of the body is coarse with a high iron content, but some of the fragments use a better quality clay.

Aoya Gen'emon

Gen'emon, who was born in Komatsu, studied the techniques of pottery with Honda Teikichi at the Wakasugi kiln; he also had a hand in the Yoshidaya and Ono kilns, among others, contributing greatly to their development. His own pupils included such outstanding potters as Matsuya Kikusaburō, Itaya Jinzaburō, and Kutani Shōza. Aside from his activities at these various kilns, he also evolved an original type of ceramic in which white slip was applied over a fired base and decorated with colored pigments before being fired again. The kiln he founded also produced porcelain similar to that of the Yoshidaya kiln, but this special type of ceramics, which he is believed to have experimented with when he was already quite advanced in years, includes inkstone boxes, tiered boxes, cupboards, shelves, and other complex constructed objects. They are cleverly made, with a special charm of their own. There are also such ingenious objects—although they account for only a small proportion of his work—as an automatic fountain, a water clock, and other pieces applying the principles of physics. He is said to have learned about such things from a certain Nakamura Benkichi, who had

164. Incense burner with polychrome overglaze design of plants and water fowl. Aoya kiln. H. 10 cm., d. 11.5 cm. Ishikawa Prefecture Art Museum.

Although this piece does not emphasize the special skills of Aoya, his sensitive talent is apparent in both the shape and the design; it is understandable that he should have been considered one of the leading potters active at Wakasugi and other kilns.

165. Four-handled bottle (*hei*) with polychrome overglaze peony-scroll design. Aoya kiln. H. 32.3 cm. Tokyo National Museum.

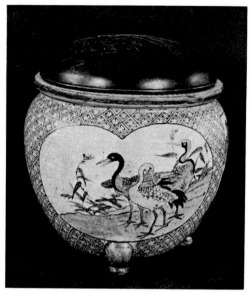

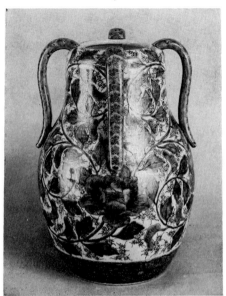

studied the new science in Edo and Nagasaki, was also talented as a painter and craftsman, and lived in Ōno village in Ishikawa County during the Tempō era (1830–44).

THE MIYAMOTOYA KILN

Following the end of production at the Yoshidaya kiln in 1831, the kiln was taken over by Miyamoto Uemon, who had been its manager, and production started again in 1835 under his name. From then on, decoration was the responsibility of Iidaya Hachirōemon, who had been trained as a painter of designs for dyed fabrics, and the Yoshidaya practice of using all enamel colors except red was replaced by a new emphasis on meticulously executed designs done almost exclusively in red and gold.

This technique of Hachirōemon's represented a synthesis of the red-enamel (*aka-e*) techniques begun by Minzan and those of the Ono kiln. For his designs he drew on a

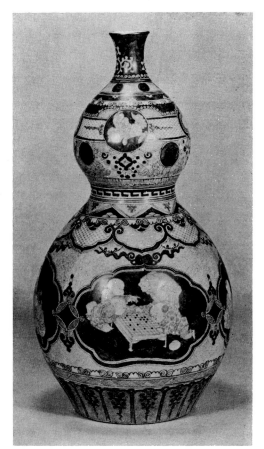

166. Large gourd-shaped sake bottle with decoration in overglaze colors and gold. Miyamotoya kiln. H. 36 cm. Ishikawa Prefecture Art Museum.

The design here may well have been inspired by the *Fang-shih Mo-p'u*, an album of pictures produced in Ming China. The color-scheme is finely worked out; the predominant hue is red, with green on the neck and at the base and blue in the *shippō-tsunagi* motifs of the body, with added gold. The effect is both colorful and dignified, and the piece represents one of the better products of this kiln.

wide range of classical Chinese subjects which he found in a work entitled *Fang-shih Mo-p'u* (The Fang Album of Ink Paintings; an album of pictures produced in Ming China in Wan-li 16 [1588] by Fang Kan-lu and in Japanese called *Hōshi bokufu*). His dignified, elaborately worked pieces represented a marked advance for the kiln; as their popularity grew, the kiln itself came to be called the Iidaya kiln, while the style of decoration came to be known as the Hachirō style (*Hachirōde*). The style was widely imitated and paved the way for the later vogue for red-and-gold ware (*kinrande*).

Against the background of Chinese geometrical patterns, the decorations depict scenes of "Chinese children at play," "the hundred ancients," landscapes with Chinese-style pavilions, birds and beasts and the like done with exquisite brushwork in quiet reds and richly gleaming gold on an unobtrusive yet satisfying white base, the whole combining to create an extremely dignified mood. The "square *fuku* [福; 'good fortune']" inscription is most common, but some pieces have "Kutani" (九谷) inscribed within a rectangle.

135

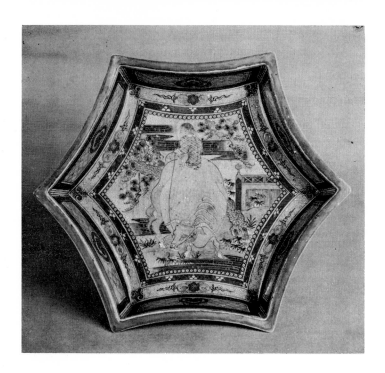

THE SANO KILN

This kiln was established by Okeya (or Saida) Isaburō, a wealthy farmer of Sano village, Nomi County. After studying enameling (*aka-e*) with Yūjirō at Wakasugi and blue-and-white at the Yoshidaya kilns, Isaburō had gone to Kyoto where he learned ceramic painting under Mizugoshi Yosobei at Kiyomizu. Next, he studied porcelain painting and carving in Arita. Following visits to Seto, Mino, and elsewhere, he returned home and in 1835 opened his own academy of porcelain painting.

The paintings on Sano wares used a number of techniques that were new to Kutani: introducing black into the red-and-gold color scheme, rendering a design in gold on a brownish-gold base, or double firing so as to give the gold a particularly cool, metallic sheen. Decorative themes such as the "hundred ancients," with its many classical Chinese figures, and the "seven sages of the bamboo grove" came to be closely associated with the Kutani ware from Terai (where the Sano kiln was located) and Kanazawa, for they were widely used on tea wares, tablewares, and later on articles for export as well.

Isaburō did not make the bases for his pieces himself, confining himself to painting on high-quality porcelain bases that he selected from various kilns, but he was also responsible for starting an enterprise manufacturing bodies. The considerable knowledge and expertise that he had amassed during his travels attracted many pupils who came to study with him and in their turn made varied contributions to the development of Kutani ware. Isaburō died in 1868 at the age of sixty-four, having explored new fields

167. Hexagonal dish with design of boy on ox in overglaze colors and gold. Miyamotoya kiln. H. 5.2 cm., d. 11.3 cm.
The design of this hexagonal dish with legs is done mostly in fine red lines interspersed with light green, blue, and yellow and with added gold. Here too the design, which suggests a taste for the Chinese classics, was probably inspired by the Ming album of pictures *Fang-shih Mo-p'u.* The general effect is restrained despite the predominance of red.

in the techniques and designs of porcelain painting and trained many others who were to carry on his work.

THE MATSUYAMA KILN

This kiln was established in Matsuyama village, Enuma County, at the beginning of the Kaei era (1848–54) by the villager Yamamoto Hikoemon in response to a command from the Daishōji clan. The kiln's main purpose was to make porcelain for use by the clan as gifts to other clans. The clays came from places such as Kutani and Suisaka, and the overglaze decorations covered the whole surface in the manner of the Yoshidaya kiln. Its products, however, were inferior to those of the latter kiln, the green having a marked yellow tinge and the purple being too reddish. The kiln lost the patronage of the clan toward the end of the Bunkyū era (1861–64), and thereafter went into a gradual decline.

THE RENDAIJI KILN

This kiln was founded in 1847 by Matsuya Kikusaburō of Komatsu with the cooperation of Aoya Gen'emon and others. Its earliest products were of poor quality, the body being of pottery-type clay with a yellowish-green color, but improvements were made later and pieces were produced in the red-enamel (*aka-e*) and Old Kutani manners. The kiln is believed to have continued production until around the Keiō era (1865–68). 137

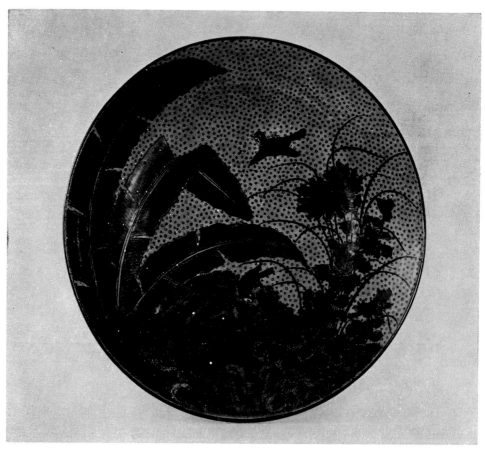

168. Shallow bowl with polychrome overglaze bird-
and-flower design. Matsuyama kiln. D. 40 cm. Ishikawa
Prefecture Art Museum.

The Matsuyama kiln was founded by Yamamoto Hikoe-
mon, under orders from the Daishōji clan, in Matsuyama
village, Enuma County, sometime around 1850. The aim
was to produce pieces for use as official clan gifts, but
since the bodies were a dingy white, overall decoration
in colored enamels was applied in the style of the Yoshi-
daya kiln. The glazes themselves—yellow, green, and
purple—cannot, generally speaking, compete with those
of the Yoshidaya kiln, but this piece shows a strength of
line and a skill in the firing that places it among the
better products of the Matsuyama kiln.

169. Shallow bowl with polychrome overglaze paving-stone pattern. Rendaiji kiln. D. 41 cm. Ishikawa Prefecture Art Museum.

The Rendaiji kiln, founded in 1847 by Matsuya Kikusaburō of Komatsu, lasted for sixteen or seventeen years in all. The bodies it used at first were closer to pottery, with a yellowish-green tinge, but later they improved, and the kiln began to produce porcelain with multicolor decoration. The work shown here, whose body suggests that it is an early piece, was obviously inspired by the kind of work covered entirely with geometrical patterns so frequently found in Old Kutani.

170. Two-tiered box with striped pattern. Aoya kiln. H. 19 cm., d. 15 cm. Ishikawa Prefecture Art Museum.

Aoya Gen'emon, one of the most celebrated potters in the Kutani revival, was associated with the kilns at Wakasugi, Yoshidaya, Ono, and Rendaiji, contributing greatly to their development. Noteworthy among his pieces are those employing an unusual technique in which he used low-fire clay of a kind similar to that used for *raku* tea ware, fashioning it intricately, almost as though it were wood, and covering it with enamel-type colored glazes. The box shown has definite character despite the simplicity of its shape; the apparently artless arrangement of colored lines is particularly effective.

171. Bowl with design of Chinese figures in overglaze colors with added gold (*kinrande*). Miyamotoya kiln. D. 25 cm. Ishikawa Prefecture Art Museum.

Although the Miyamotoya kiln was successor to the Yoshidaya kiln, the arrival of Iidaya Hachirōemon as chief potter in charge of decoration brought a change to an elaborate style employing chiefly red, with many fine lines, and accented with gold. Many of the pictures used to decorate the pieces are based on the *Fang-shih Mo-p'u* (The Fang Album of Ink Paintings), a work produced in Ming China in 1588, and show children and other Chinese figures. The decoration on this bowl, which seems to belong to the same category, is extremely elaborate, but its sumptuousness is tempered with a dignified restraint.

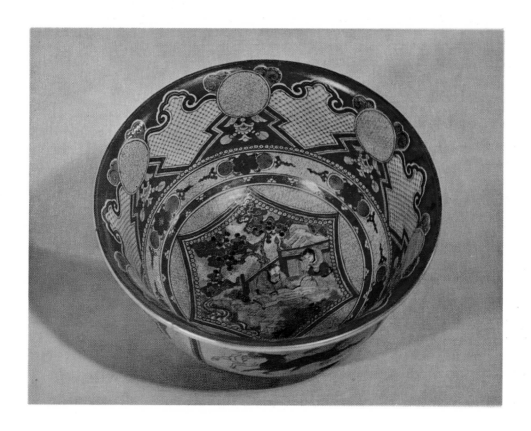

THE EIRAKU KILN

Following the decline of the Miyamotoya kiln, the Daishōji clan established a Bureau of Local Products and assisted Mifuji Bunjirō and Fujikake Yasoki in starting production of ceramics. Bunjirō, an innkeeper by trade, seems to have studied painting, while Yasoki is said to have been a scholar of the Japanese classics who was also well versed in industrial matters. In the 1860s, with the clan's aid, they decided to invite the famed Kyoto potters Eiraku Wazen and his brother-in-law Nishimura Sōsaburō (Kaizen), known for their work in the red-and-gold enamel (*kinrande*) format, to help improve the kiln's fortunes. Wazen seems to have been in his forties and at the height of his powers. Following his arrival in Yamashiro he apparently turned out various kinds of wares, discovered new materials, and improved the firing process. As might be expected, much of his best work used the *kinrande* style that was his specialty and included some large dishes of a brilliance outstanding among his surviving works.

Many of his pieces bear the written inscription "Made by Eiraku at Kutani" (於九谷永楽造) or the stamped inscription "Eiraku" (永楽) or *kahin shiryū* (河浜支流).

During his five years in Yamashiro, Wazen made great contributions to the improvement of Kutani ware, especially to the production of *kinrande*. He also trained outstanding pupils such as Kizaki Sen'uemon (artistic name Banki) and Ōkura Seishichi (artistic name Juraku).

Following Wazen's departure the kiln again went into a slump. Work was carried on by men including Ōkura Seishichi and Tsukatani Chikukan of the Local Products Bureau.

KUTANI SHŌZA

The son of a farmer, Kutani Shōza was born in 1816. While still a child he started studying porcelain painting with Kozakaya Magoji of Mikawa-machi, and he went on to study with Aoya Gen'emon of Komatsu and at the Miyamotoya kiln in Yamashiro. In the early 1840s he returned to Terai, where he made a living painting the designs for porcelain ware.

Skillfully assimilating the styles of Old Kutani, Yoshidaya, and Eiraku, he developed a finely wrought manner of his own. He also studied and improved the use of color overglazes, experimenting with the use of gold and silver alongside the other colors, producing a deep shade of red that had not hitherto been possible and even making use of pigments from the West that came into Japan following the Meiji Restoration of 1868. His decorations—colorful and intricate yet richly harmonious in their total effect—were new in spirit: they accorded well with the taste of the time and were prized under names such as "Shōza style" (*Shōza-fū*) and "colored *kinran*" (*saishiki-kinran*). Enameled porcelain of this kind also became popular abroad and laid the foundations for the major role that Kutani was to play in the export of ceramics at the end of the nineteenth century.

Shōza's other contributions included the discovery of a type of manganese known as Noto *gosu* and of a source of high-quality clay; both were to become essential raw materials for Kutani ware. The many younger potters whom he trained also did valuable work in the development of Kutani ware. Shōza died in 1883 at the age of sixty-seven.[35]

Post-Restoration Kutani

At the time of the Meiji Restoration of 1868, all the kilns were in something of a decline. Nevertheless, the characteristic styles developed by earlier generations were still ready to hand, together with a number of able potters, who were soon able to embark on a fresh spate of activity inspired by the new age. In 1869 a kiln for firing overglaze-decorated porcelain was established in Kanazawa. Ceramics firms and porcelain-painting workshops sprang up in rapid succession, attracting many of the most skilled workers of the day, and various technical advances were made, including adoption of Western-style pigments and increasing specialization, the making of the bodies and the overglaze decorations being carried out in different places.

Most of the porcelain turned out showed great technical accomplishment: elaborately worked multicolor (*saishiki*) *kinran*, sumptuous pieces including shading and silver, and pieces with designs of poetry inscribed in minute Chinese characters. This color style suited the taste of the early Meiji era, and had a strong novelty appeal in other countries too. Kutani started exporting energetically at an early stage, and by the 1890s, thanks in part to the style just described, Kutani porcelain had become a major item in Japan's ceramic exports, its name increasingly widely known abroad.

The Kutani style of polychrome decoration became widely popular within Japan too; many potters came to study the techniques at firsthand, and a large number of them became known in their time as outstanding craftsmen. The style of this technically dazzling period became inseparably associated with the name Kutani, and its influence is still strongly apparent in the commercial Kutani ware of today.

172. Large dish with design of dragon in overglaze colors with added gold (*kinrande*), by Eiraku Wazen. H. 9 cm., d. 39.7 cm. Tokyo National Museum.

Following the abandoning of the Miyamotoya kiln, the bureau of industry of the Daishōji fief invited the well-known Kyoto potter Eiraku Wazen to Yamashiro in order to establish a kiln that would get the industry on its feet again. Wazen commanded a whole variety of techniques, including the late Ming Chinese manners of decorating with red enamel (*aka-e*) or with underglaze cobalt, but he was especially skilled at polychrome decoration with gold (*kinrande*), and continued to produce excellent examples of this type during his stay in Yamashiro. The dish shown here—inspired by similar gold-decorated ware produced in China during the Chia-ching era (1522–66) of the Ming dynasty—is one of the finest of Wazen's essays in this style, with well-balanced design, delicate brushwork and vivid coloring. The base bears an inscription which reads in part, "Made by Eiraku at Kutani; outstanding specimen of imitation of old *aka-e* with gold. . . . Eleventh month, first year of the Keiō era [1865]."

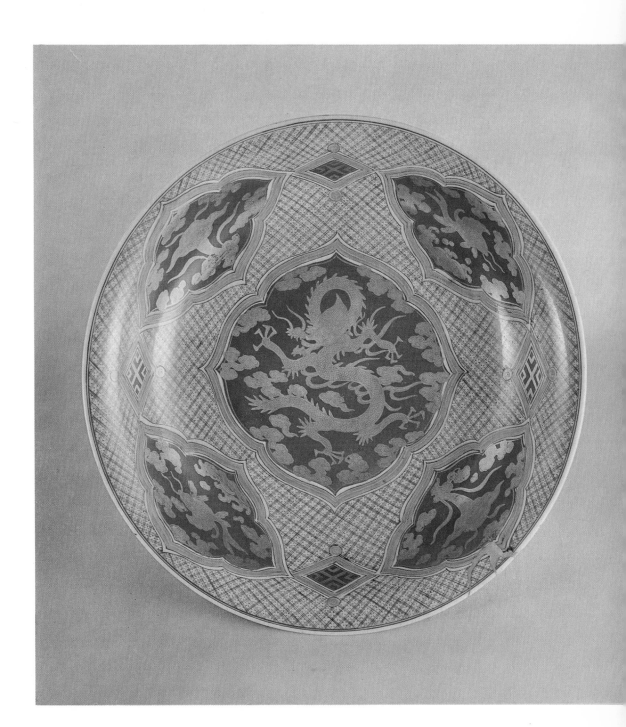

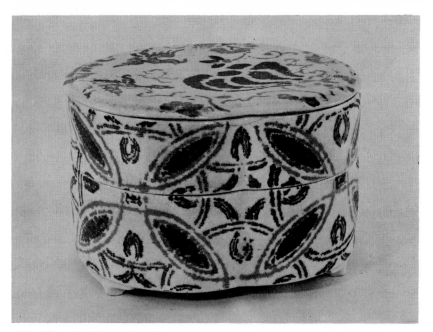

173. Two-tiered box with polychrome overglaze "court textile" (*yūsoku*) pattern, by Eiraku Wazen. Longest d. 20 cm., shortest d. 16.5 cm., h. 13.5 cm. Ishikawa Prefecture Art Museum.

A *yūsoku* pattern—of the kind found on ancient fabrics—is executed in various colors with gold and silver through a piece of coarse cloth placed over the surface. This type of decoration, known as *orimonde* (woven-pattern style) and originated by Eiraku Wazen, is a unique feature of this work. Here a classical design is skillfully employed in a manner both colorful and tasteful. It has been suggested that the work dates from Eiraku's Kyoto period.

175. Lidded bowl with polychrome underglaze design of twin dragons, by Eiraku Wazen. H. 10 cm., d. 21.5 cm. Ishikawa Prefecture Art Museum.

Wazen commanded a wide range of techniques: besides red-and-gold enamel ware (*kinrande*), he produced pieces in the manner of late Ming Chinese wares decorated with red enamel (*aka-e*) or with underglaze cobalt, *gosu aka-e* (Chinese enameled ware predominantly in red and green with occasional use of underglaze blue), and Ninsei, and he continued experimenting during his stay in Yamashiro. Although the work shown here is inspired by the red ware of the Wan-li era (1573–1620) of Ming-dynasty China, the lightness with which the colors are applied and the skillful disposition of the gold raises the piece above the level of mere imitation.

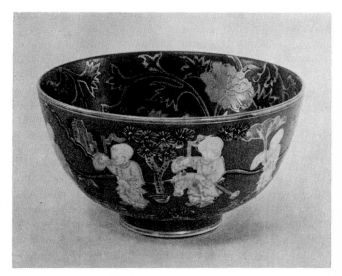

174. Bowl with design of Chinese children at play in overglaze colors and gold, by Eiraku Wazen. H. 8.5 cm., d. 16.2 cm. Ishikawa Prefecture Art Museum.

The inner surface has a design of flowering plants, while the Chinese figures encircle the outside of the bowl, gold being applied to these figures in places. Although the piece falls within the red-and-gold enamel (*kinrande*) style in which Wazen specialized, the care devoted to the use of the gold creates a restrained effect as a whole.

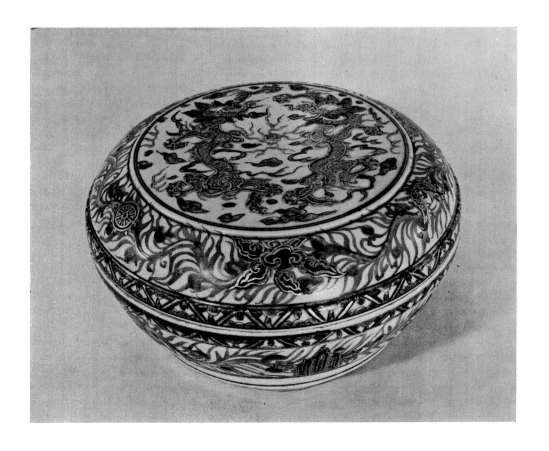

176. Large incense burner with polychrome overglaze bird-and-flower design, by Kutani Shōza. H. 32.5 cm., d. of body 44 cm. Ishikawa Prefecture Art Museum.

Shōza, who played an important role in the development of the Kutani ceramics industry, was the son of a farmer in Terai. He started studying at an early age and was associated with various kilns, eventually evolving a sumptuous style of overglaze decoration employing many colors together with gold and silver. His works are the ultimate in delicacy and brilliance, combining the decorative manners of the various Kutani kilns and even employing the Western pigments imported after the opening of the Meiji era in 1868. The incense burner shown here, a product of his last years, displays these characteristics at their finest. The underside has the inscription "Made by Kutani Shōza at the age of 63, Meiji 11 [1878]."

KUTANI WARE

OVERGLAZE ENAMEL DECORATION OF PORCELAIN

It may help in the appreciation of polychrome decoration to give a brief account, in relation to some of the most outstanding Japanese wares, of the colors used.

First, a few remarks concerning the nature of the colored enamel glazes, also referred to as overglazes. Polychrome decoration is created by applying these glazes to a white pottery or porcelain body that has been coated with clear glaze and fired once, then fired a second time. In some cases, cobalt is also applied in places under the glaze before the first firing. Where there is no underglaze blue and the dominant color is red, the result is known as *aka-e* ("red picture").

Almost all nonmodern works are decorated with some or all the basic enamel colors: red, yellow, green, blue, purple, and black. In all cases except red, the enamel glazes form a slightly raised layer on the surface, and are more or less transparent. They are made by adding a variety of metallic oxides to a colorless, vitreous base, as follows:

Yellow: Produced by the addition of ferric oxide, the color deeping to orange depending on the quantity used. During the K'ang-hsi era (1662–1722) in China, a method was devised using antimony; when mixed with lead-fluxed base, the antimony yielded a brilliant yellow which could be changed to deep orange or various other shades by adding varying amounts of iron.

Indigo—purple: Produced by the addition of cobalt oxide or *gosu* (natural cobalt).

Purple: Produced by adding manganese.

Green—blue: Produced by adding *rokushō* (verdigris produced by the oxidization of copper); the result is green when silicic acid and lead predominate in the basic glaze, and blue when an alkaline flux is used instead of lead.

Red: Ferric oxide is reduced to a very fine powder and mixed with a little glass having a low melting point, then fixed on the surface by firing at a low temperature. The finer the powder, the brighter the red; coarse powder results in dingy red. Unlike other overglazes, red is merely fixed on the surface by the firing, so it tends to flake easily.

Black: A fine powder of manganese or *gosu* (natural cobalt) is used in the same way as ferric oxide is used to produce red. The result flakes easily in the same way, and a further thin layer of some other vitreous glaze is usually applied as protection.

After the design has been applied in overglaze colors, the piece is fired in a kiln at a temperature of 750–850°C. The kiln used, known as a *kingama* ("brocade kiln"; the same characters are also read *nishikigama*), has two small, cylindrical chambers, one inside the other. The decorated piece is placed in the inner chamber, then fuel is put in the space between the two chambers and lit. In the past, pine and other woods were used as fuel, but in recent years these have been replaced almost entirely by electricity.

Pieces whose decoration includes gold or silver usually employ gold or silver dust mixed with glue and fired onto the surface; in the case of gold or silver foil, it is cut into small pieces and stuck on to form the pattern, then fired at around 100°C.

NOTES TO TEXT

Page 16
1. 楢崎彰一・真田幸成 「九谷古窯址の位置と環境」「窯体の構造」「物原の状態」『九谷古窯第1次調査概報』 [Narasaki, Shōichi, and Sanada, Kōsei. "The Location and Surroundings of the Kutani Old Kiln Sites," "The Structure of the Kilns," and "Findings at the Dumps," in *Preliminary Findings of the First Series of Excavations at the Kutani Old Sites*]. See Bibliography, "Japanese Sources," for full information.

Page 18
2. 鷹巣豊治 「古九谷」(『陶説』13) 昭和29年 [Takasu, Toyoharu. "Old Kutani." *Tōsetsu*, no. 13, 1954].

Page 19
3. 黒川真頼 『工芸志料』明治11年 [Kurokawa, Saneyori. *Notes on the Applied Arts*. 1878]; 今泉雄作 『本邦陶説』明治24年 [Imaizumi, Yūsaku. *Description of Japanese Ceramics*. 1891]; 大西林五郎 『日本陶器全書』大正2年 [Ōnishi Ringorō. *A Compendium of Japanese Ceramics*. 1913].

Page 19
4. 飛鳥井清 『九谷陶窯沿革誌』明治10頃 [Asukai, Kiyoshi. *A History of the Kutani Kilns. Ca.* 1877]; 塩田 真 『府県陶器沿革陶工芸』明治19年 [Shioda, Makoto. *The Ceramic Applied Arts: A History of Ceramics in the Various Prefectures*. 1886]; 古賀静修 『陶器小志』明治23年 [Koga, Seishū. *Notes on Ceramics*. 1890]; 横井時冬 『工芸鏡』明治27年 [Yokoi, Tokifuyu. *A Mirror of the Applied Arts*. 1894].

Page 19
5. 三上次男 「まとめ」『九谷古窯第1次調査概報』 [Mikami, Tsugio. "Conclusions," in *Preliminary Findings of the First Series of Excavations at the Kutani Old Sites*]. See Bibliography, "Japanese Sources," for full information.

Page 19
6. 川井直人・広岡公夫・安川克巳・中島正志 「九谷古窯址における考古磁気について」『九谷古窯第1次調査概報』 [Kawai, Naoto; Hirooka, Kimio; Yasukawa, Katsumi; and Nakajima, Masashi. "Archeomagnetism at the Kutani Old Kiln Sites," in *Preliminary Findings of the First Series of Excavations at the Kutani Old Sites*]. See Bibliography, "Japanese Sources," for full information.

Page 22
7. 磯野風船子 「古九谷」(『陶説』20) 昭和29年 [Isono, Fūsenshi. "Old Kutani." *Tōsetsu*, no. 20, 1954].

Page 24
8. 宮本謙吾 『九谷焼研究』 [Miyamoto, Kengo. *A Study of Kutani Ware*]. See Bibliography, "Japanese Sources," for full information.

Page 24
9. 辻本直男 「後藤才次郎と右兵衛吉次」（『陶説』13）昭和29年 [Tsujimoto, Tadao. "Gotō Saijirō and Uhyōei Yoshiji." *Tōsetsu*, no. 13, 1954].

Page 24
10. See above, note 7.

Page 25
11. See above, note 8.

Page 25
12. 斎藤菊太郎 『古九谷新論』70頁 [Saitō, Kikutarō. *A New View of Old Kutani*, p. 70]. See Bibliography, "Japanese Sources," for full information.

Page 26
13. 大河内正敏 『古九谷』 [Ōkōchi, Masatoshi. *Old Kutani*]. See Bibliography, "Japanese Sources," for full information. 鷹巣豊治 「古九谷」（『陶説』13）昭和29年 [Takasu, Toyoharu. "Old Kutani." *Tōsetsu*, no. 13, 1954].

Page 39
14. 楢崎彰一 「出土陶磁類」『九谷古窯第1次調査概報』および『第2次調査概報』 [Narasaki, Shōichi. "Ceramic Finds," in *Preliminary Findings of the First Series of Excavations at the Kutani Old Sites* and *Preliminary Findings of the Second Series of Excavations at the Kutani Old Sites*]. See Bibliography, "Japanese Sources," for full information.

Page 40
15. 三上次男 「出土陶磁類 "有文陶磁器類"」『九谷古窯第1次調査概報』 [Mikami, Tsugio. "Ceramic Finds: Patterned Wares," in *Preliminary Findings of the First Series of Excavations at the Kutani Old Sites*]. See Bibliography, "Japanese Sources," for full information.

Page 40
16. 楢崎彰一 「出土陶磁類」『九谷古窯第2次調査概報』 [Narasaki, Shōichi. "Ceramic Finds," in *Preliminary Findings of the Second Series of Excavations at the Kutani Old Sites*]. See Bibliography, "Japanese Sources," for full information.

Page 42
17. 三上次男 「まとめ」『九谷古窯第2次調査概報』 [Mikami, Tsugio. "Conclusions," in *Preliminary Findings of the Second Series of Excavations at the Kutani Old Sites*]. See Bibliography, "Japanese Sources," for full information.

Page 42
18. 楢崎彰一・真田幸成 「古九谷窯址の位置と環境」『九谷古窯第1次調査概報』 [Narasaki, Shōichi, and Sanada Kōsei. "The Location and Surroundings of the Kutani Old Kiln Sites," in *Preliminary Findings of the First Series of Excavations at the Kutani Old Sites*]. See Bibliography, "Japanese Sources," for full information.

Page 47
19. 斎藤菊太郎 『古九谷新論』53頁 [Saitō, Kikutarō. *A New View of Old Kutani*, p. 53]. See

Bibliography, "Japanese Sources," for full information.

Page 54
20. 田中喜作 「相説筆四季草花図に就いて」(『美術研究』25) 昭和 9 年 [Tanaka, Kisaku. "The *Flowers and Plants of the Four Seasons* Folding Screens by Sōsetsu." *Bijutsu kenkyū*, no. 25, 1934].

Page 54
21. 田中一松 「宗雪の二作品」 (『仏教芸術』14) 昭和 26 年 [Tanaka, Ichimatsu. "Two Works by Sōsetsu." *Bukkyō geijutsu*, no. 14, 1951].

Page 54
22. See above, note 20.

Page 58
23. 斎藤菊太郎 「古九谷の山水図」「古九谷の花鳥図」『古九谷新論』 [Saitō, Kikutarō. "Landscape Designs on Old Kutani" and "Bird-and-flower Designs on Old Kutani," in *A New View of Old Kutani*]. See Bibliography, "Japanese Sources," for full information.

Page 96
24. 斎藤菊太郎 「緑・黄二釉と交趾三彩」『古九谷新論』 [Saitō, Kikutarō. "The Yellow and Green Glazes and *Kōchi* Three-color Ware," in *A New View of Old Kutani*]. See Bibliography, "Japanese Sources," for full information.

Page 97
25. 三上次男 「有文陶磁器類」『九谷古窯第 1 次調査概報』 [Mikami, Tsugio. "Patterned Wares," in *Preliminary Findings of the First Series of Excavations at the Kutani Old Sites*]; 楢崎彰一 「出土陶磁類」，真田幸成・楢崎彰一 「朱田の状態」『九谷古窯第 2 次調査概報』 [Narasaki, Shōichi. "Ceramic Finds"; Sanada, Kōsei, and Narasaki, Shōichi. "Findings at Shuda," both in *Preliminary Findings of the Second Series of Excavations at the Kutani Old Sites*]. See Bibliography, "Japanese Sources," for full information.

Page 97
26. 山下朔郎 『古伊万里と古九谷』 [Yamashita, Sakurō. *Old Imari and Old Kutani*]. See Bibliography, "Japanese Sources," for full information.

Page 100
27. 斎藤菊太郎 「銘款から見た古九谷」『古九谷新論』 [Saitō, Kikutarō. "Old Kutani Considered in Terms of Its Inscriptions," in *A New View of Old Kutani*]. See Bibliography, "Japanese Sources," for full information.

Page 100
28. See above, note 26.

Page 101
29. 楢崎彰一 「在銘陶片類」『九谷古窯第 1 次調査概報』 および 『第 2 次調査概報』 [Narasaki, Shōichi. "Shards with Inscriptions," in *Preliminary Findings of the First Series of Excavations at the Kutani Old Sites* and *Preliminary Findings of the Second Series of Excavations at the Kutani Old Sites*]. See Bibliography, "Japanese Sources," for full information.

Page 101

30. ソーム・ジェニンス 「日本の磁器」(『陶説』40–41) 昭和31年 [Jenyns, Soame. "Japanese Porcelain." *Tōsetsu*, nos. 40–41, 1956].

Page 101

31. See 斎藤菊太郎『古九谷新論』および『古九谷』 [Saitō, Kikutarō. *A New View of Old Kutani* and *Old Kutani*]. See Bibliography, "Japanese Sources," for full information.

Page 102

32. 三上次男「まとめ」『九谷古窯第1次調査概報』および『第2次調査概報』[Mikami, Tsugio. "Conclusions," in *Preliminary Findings of the First Series of Excavations at the Kutani Old Sites* and *Preliminary Findings of the Second Series of Excavations at the Kutani Old Sites*]. See Bibliography, "Japanese Sources," for full information.

Page 105

33. The author is particularly indebted in the ensuing discussion to the following works: 加藤恒『加賀越中陶磁考草』明治28年 [Katō, Kō. *A Brief Study of the Ceramics of Kaga and Etchū Provinces*, 1895]; 松本佐太郎『定本九谷』 [Matsumoto, Satarō. *Authentic Kutani*. See Bibliography, "Japanese Sources," for full information]; 宮本謙吾『九谷焼研究』[Miyamoto, Kengo. *A Study of Kutani Ware*. See Bibliography, "Japanese Sources," for full information]; 脇本十九郎『平安名陶伝』大正10年『日本近世窯業史』[Wakimoto, Jūkurō. *A History of Celebrated Kyoto Wares*, 1921, and *A History of the Ceramics Industry in Edo-Period Japan*]; 石川県美術館編『九谷名陶図録』昭和35年頃 [Ishikawa Prefecture Art Museum, ed. *Catalogue of Famous Pieces of Kutani Ware, ca.* 1960]; 高橋勇『九谷』金沢市　北国出版社　昭和45年 [Takahashi, Isamu. *Kutani*. Kanazawa City: Kitaguni Shuppansha, 1970]; as well as papers published by experts in various magazines.

Page 132

34. 真田幸成「吉田屋窯跡"窯体の構造"」，檜崎彰一「吉田屋窯跡"出土陶磁類"」，三上次男「まとめ」以上，『九谷古窯第2次調査概報』[Sanada, Kōsei, "The Yoshidaya Kiln Site: The Structure of the Kiln"; Narasaki, Shōichi, "The Yoshidaya Kiln Site: Ceramic Finds"; and Mikami, Tsugio, "Conclusions," all in *Preliminary Findings of the Second Series of Excavations at the Kutani Old Sites*]. See Bibliography, "Japanese Sources," for full information.

Page 143

35. 高橋　勇　『九谷』金沢市　北国出版社　昭和45年 [Takahashi, Isamu. *Kutani*. Kanazawa City: Kitaguni Shuppansha, 1970].

LIST OF ILLUSTRATIONS IN JAPANESE

GLOSSARY

aka-e (赤絵; "red picture"): red overglaze enamel designs. Unlike other Kutani enamel colors which are transparent, glasslike, and applied in thick layers, *aka-e* is done in a thin, matt wash. While any design predominantly red in tone can be called *aka-e,* this term specifically refers to simple, bold designs, while *nishikide* (錦手; "brocade style") describes more complicated designs of many colors, including red.

While evidence shows that techniques for producing extremely high quality *aka-e* were developed in China in the late sixteenth century, monochrome red decor declined in popularity and was superceded in the late seventeenth century by five-colored (五彩; *gosai*) and *nishikide* wares in which red was one element but did not dominate the designs. *Aka-e* is said to have been first produced in Japan by Kakiemon in Arita in 1644–49, although nearly simultaneously similar designs were being used on Old Kutani ware and by Ninsei in Kyoto. The use of red enamel gradually spread to other kilns throughout Japan.

Old Kutani red-enamel designs frequently include gold and silver, and are older than two- and three-colored Old Kutani. In the Meiji Period (1868–1912), imported Western pigments were used for *aka-e,* which gained further prominence over Green-style Old Kutani (see *aode*), virtually abandoned by that time.

Gosu aka-e (呉須赤絵), also called *aka-e gosu,* refers to the same bold red designs, combined with underglaze blue decoration. This so-called Swatow ware was first produced in South China in Fukien and Kwantung provinces from the late Ming (1368–*ca.* 1644) to the early Ch'ing dynasties (*ca.* 1644–1912), but detailed information about kiln sites is not known. Such export wares can still be found in Japan, where they were prized by tea devotees. In Kutani, *gosu aka-e* designs are found more commonly on large objects than smaller ones. See plate 146.

aode ko-Kutani (青手古九谷; "green-style Old Kutani"): a type of Old Kutani ware produced before the Meiji period (1868–1912) with two-colored (green and yellow) and three-colored (green, yellow, and purple) enamel decoration applied over designs sketched in black. Because of a similarity in color schemes, *aode* wares are also sometimes referred to as *kōchi* Old Kutani or, because of a similarity in production techniques, as Persian Old Kutani.

This term should not be confused with *ao-Kutani* (青九谷; "Green Kutani"), which identifies a type of Kutani ware made after the Meiji Restoration of 1868. At that time, most Kutani ware was being decorated with red and gold designs using imported Western pigments. Matsuya Kikusaburō, after intensive research using native Old Kutani pigments, began producing five-colored wares which were then named *ao-Kutani.* The latter term is also sometimes used mistakenly to describe Yoshidaya-kiln products or Kutani *sometsuke,* which refers to Kutani ware decorated with cobalt under the glaze, the so-called blue-and-white ware or underglaze blue decor.

archeomagnetic dating (考古地磁気測定法; *kōkochijiki sokuteihō*): one of the methods used to determine the approximate age of Kutani ware. When clay (or any material containing adequate amounts of iron or other potentially magnetic matter) is fired

above 600° C., it develops magnetic properties with fixed poles. This orientation and its strength are determined by when and where the object was fired, but, once established, are permanent. Meanwhile, the orientation of the earth's poles is always changing, having moved over a 40° range in the last two thousand years. Navigational records indicate this fairly accurately from the seventeenth century to the present. Hence, by comparing the magnetic orientation of excavated ceramic objects to that of the earth, one can estimate their age. However, detailed records prior to the seventeenth century are not available. Thus, precise, absolute determinations cannot be made, but relative estimates within a margin of error are possible. Even so, if the pot has been moved from its point of origin, no reliable information can be gained. Until more data from different locations are available for cross-checking, this will remain only one factor in determining the age of excavated ceramics.

Arita ware (有田焼; *Arita-yaki*): porcelain ware made at or near the town of Arita in what used to be Hizen province (now Saga Prefecture). Because the first porcelain deposits in Japan were found in this area and the first native porcelain wares fired here, Arita served as the fountainhead of porcelain technology for the rest of Japan.

In 1616 a Korean potter named Ri Sampei (Japanese reading; naturalized name, Kanegae Sambei), brought to Japan by Hideyoshi's troops, found porcelain clay sources and began to make blue-and-white wares similar to the Korean prototype. It was not until the middle of the seventeenth century that the motifs became truly Japanese.

These wares were widely exported by the Dutch East India Company through the nearby port of Imari (present-day Imari City, Saga Prefecture). As a result they are sometimes referred to as Imari ware (伊万里焼; *Imari-yaki*). Kakiemon wares (q.v.) and Nabeshima wares (q.v.) are also sometimes included in the term Arita ware. Production in both modern and traditional forms continues today.

Overglaze enamel techniques developed in the Arita area are thought to have appeared almost simultaneously in Kutani and many controversies remain concerning the relationship between these kilns. Not only are many designs similar, but there are also identical inscriptions. More problems arise as kiln ruins are excavated, revealing shards which do not agree with what has traditionally been called Old Kutani or Old Imari. Arita-style shapes and designs may have been merely imitated in Kutani, or Old Kutani may have been fired in Arita for Dutch orders.

Bakkei kibun (茇憩紀聞): the most reliable and frequently quoted document with detailed information about Old Kutani ware, although the most recent of the old documents. It was originally published in 1803 as an account of famous scenic spots and historical sites seen by Tsukatani Sawaemon, district magistrate of Daishōji fief, during an inspection tour of clan territories. Containing a wealth of concrete information, it covers such topics as the locale of workshops, kiln ruins, and the dumps; a comparison of Old Kutani and Kutani ware; a description of kiln firing equipment; and an analysis of the clay and cinnabar ore (impure ferrous oxide) used in Old Kutani ware. Tsukatani also discusses the roles of Gotō Saijirō and Tamura Gonzaemon in the founding of the Kutani kilns. Despite the many mysteries surrounding the early history of Old Kutani ware and its excavated kilns, the *Bakkei kibun* remains a major source of information.

bishamon pattern (毘沙門亀甲文; *bishamon kikkō-mon*): one of perhaps three hundred geometric patterns used to decorate Old Kutani ware. It refers to Bishamon-ten (Vaiśravaṇa), one of the Four Guardian

159

Kings and Protector of the North, on whose armor this motif traditionally appeared in an interlocking pattern. It came to be a symbol of strength and manliness and was subsequently used in fabric designs as well as to decorate ceramics. It is referred to as a tortoise-shell motif (*kikkō-mon*) because one unit is composed of a rhomboid resembling the pattern on the shell of a tortoise. See plate 18.

Ching-te-chen kilns (景徳鎮窯; Japanese, *Keitokuchin-yō*): kilns in Kiangsi province in China which formed the center of the Chinese porcelain industry beginning in the Sung dynasty (960–1279). The famous Chinese celadons, blue-and-white, and five-colored wares were all made here. The porcelain clay body, a combination of kaolin and feldspar, was almost pure white with very little iron. A variety of forms were mass-produced here during the Northern Sung dynasty (960–1126) and exported all over the Far East and Southeast Asia. Following a decline and a subsequent revival, the Ching-te-chen potters began to decorate their wares with cobalt, copper oxide, and colored enamels, embarking on the course that the Chinese porcelain industry was to follow from that time on, and setting the standard for the rest of the world.

Porcelain wares decorated with underglaze blue and overglaze polychrome enamels from Ching-te-chen were ordered in specific styles by tea connoisseurs in Japan beginning in the early seventeenth century. Their immense popularity led them to be imitated at Arita and Kutani, and the fact that they were eventually produced in Japan can partially be attributed to cessation of the large shipments from China.

chōshi. See *tokuri*.

cobalt blue. See *gosu*.

daibachi. See *hachi*.

daimyō. See *shōgun*.

Daishōji fief: a small subfief in the western part of the huge Kaga fief held by the Maeda family under the Tokugawa shogunate. Maeda Toshiharu, the first lord of this fief, was born in Kanazawa in 1618, the third son of a daughter of the Tokugawa shogun Hidetada and the third daimyo of the Kaga fief, Maeda Toshitsune. Toshiharu was given the Daishōji fief in 1639. Connections with the Tokugawa family and the backing of the powerful Kaga fief (q.v) compensated for the fact that the revenue of the Daishōji fief was only 70,000 *koku* (one *koku* equals approx. 180 liters) of rice per year. The discovery of porcelain clay in a fief gold mine and Toshiharu's natural flair for business are said to have sparked his decision to establish a porcelain kiln. See map.

daki-myōga motif (抱茗荷): the stylized depiction of two "embracing" stalks of a perennial grasslike plant (*Zingiber mioga*), a type of ginger. Because it is a homonym for the Japanese words meaning "divine protection," it has an auspicious meaning and was frequently included in family crests. This motif often appears on Old Kutani ware inside four-lobed medallions. See plates 13–14.

domburi. See *hachi*.

Edo period: the period from 1600 to 1867 ruled by the Tokugawa shoguns in Edo (present-day Tokyo). This period is often characterized as one of rigidity, conformity, and introspection. Contact with foreigners was limited to Nagasaki port after 1637. On the other hand, it was 250 years of peace during which attention could be diverted to building a national network of roads and waterways and establishing regional industries within each fief. These resources plus the increasing economic power of the urban population led to a greater demand for consumer goods, including ceramics, and a fad for decorated porcelain ware, the technology for which was rapidly being improved. It was in this atmosphere that Old Kutani ware was produced. The creativity and stimulating flavor of the early Edo period unfortunate-

ly settled into a feudal overemphasis on forms and formalism, beauty in stereotypes only, and small-scale triviality by the late Edo period, when production of Kutani ware was revived using highly refined, but empty, technology.

"eight [sacred] treasures" motif (八宝文; *happō-mon*): a type of "scattered treasures" design motif (q.v.), in this case a stylized depiction of eight elements including a banana leaf, a book, a jewel, money, the horn of an animal, and a type of medicine. However, since the characters used to write *happō* have changed over the centuries, the original meaning of the word cannot be taken literally to be "eight treasures." There are two versions of this motif, this one being chosen for auspicious occasions. It appears on the rim and underside of Old Kutani shallow bowls and dishes, and is thought to be an imitation of designs on seventeenth-century Chinese porcelains (*fuyōde*; q.v.) from the Ching-te-chen porcelain center. See plates 7–9, 105–6.

enamel decoration (色絵; *iro-e*, "color picture"): decoration in a very viscous, low-fired glaze composed of a pigment, flux, and binder applied over a glazed surface. Firing to a low temperature just sufficient to fuse the enamel to the glaze allows the colors to be produced without altering the high-fired clay body or glaze. Such decoration may also be covered with another lower temperature glaze or used in combination with designs of underglaze cobalt or iron.

Polychrome overglaze wares are thought to have been produced first in China at the Ching-te-chen kilns in Kiangsi province during the Yüan dynasty (*ca.* 1280–1368). Greatly valued by tea connoisseurs, they were imported into Japan from the Muromachi period (1392–1572) on and distributed from the port of Nagasaki to Kaga province, where there was considerable demand for Chinese late Ming and early Ch'ing (*ca.* 1644–1912) ceramics.

Enamel decorated wares were eventually produced in Japan. One theory holds that a ceramics dealer in Imari, Higashijima Tokuemon, learned the techniques from a Chinese potter, Chou Ch'en-kuan, and passed them on to Sakaida Kakiemon in Arita, who overcame the considerable technical obstacles to reproducing them. Other theories claim that Kyoto potters were the first to perfect these techniques.

Enamels were probably not used in Kutani until the Manji era (1658–61). They were typically subdued, but the effect of massing one thick layer of transparent, glassy enamel on another was quite rich. Green and yellow appeared first, then red was added sparingly, and purple and then dark blue followed, using pigments imported by the Dutch East India Company. Compared to the other enamel wares, the Kutani green is more bluish, clearer, and heavier; the purple and yellow are paler, more transparent and subdued, and the blues range from pale to sooty, while the red is thinner. See plates 45–46, 47–48, 51–52.

fuyōde (芙蓉手): a type of blue-and-white ware produced at the Chinese porcelain center Ching-te-chen in Kiangsi province in the late Ming period (1368–*ca.* 1644) or early Ch'ing period (*ca.* 1644–1912). These were imported to Japan in large quantities beginning in the early Edo period (1600–1867). The design composition of this ware was said to resemble a *fuyō* flower (*Hibiscus mutabilis*; a type of rose mallow), hence the name. Both the shapes and design motifs—especially the "eight treasures" motif—of these wares were imitated in Kutani. See plates 66–67, 69.

glaze test (色見; *iro-mi*, "color view"): one method to determine the approximate temperature and atmosphere in the kiln, degree of fusion of the clay, and maturity of the glaze. Glaze tests, commonly known as draw rings, pull rings, or draw trials, are usually made as either a small pot with a hole through the wall or a simple ring of

161

clay, formed of the same materials as the ware being fired, and placed in the kiln near a peep hole. When the color of the kiln interior indicates that temperature has nearly been reached, the potter sticks an iron rod through a glaze test and draws it out. While the sudden cooling prevents them from exactly foretelling the finished glaze, they show the maturity of the glaze and protect against overfiring. Glaze tests are one of the earliest, simplest, and most universal means of kiln control. They are also essential today to gauge glaze accumulation in firings incorporating salt or natural-ash glazing. Glaze tests have been excavated in Kutani. See plate 132.

gosu (呉須): impure cobalt found primarily in creek beds and containing high percentages of cobalt, manganese, and iron. When fired in oxidation, it turns black, but with reduction, a soft gray-blue results. The intensity and quality of this color are determined by the nature of the clay and glaze, the firing atmosphere, and the purity of the *gosu*. Unlike overglaze enamels, which are applied over already high-fired glazes, *gosu* is dissolved in water and brushed on under the glaze but does not run during the firing. Because natural *gosu* is rare in Japan, imported, processed cobalt oxide is often substituted today but produces a less desirable, harsh blue.

Eventually the term *gosu* came to refer to a specific type of ware and decorative style. It is also used in a very general sense to mean all underglaze decoration. Alternate terms include *gosude* (呉須手), *sometsuke* (染付), *ao-e* (青絵), and, in English, cobalt blue, blue-and-white, and underglaze blue.

Gosu wares imported from China were imitated in Kutani from the early Edo period (1600–1867) on, and the use of cobalt decor ranged from a few lines circling the underside of a dish, to an integral part of the design, to inscriptions. See plates 64–65.

162 *gosu-aka-e*. See *aka-e*.

gosude. See *gosu*.

hachi (鉢): a deep dish or bowllike form in a wide range of sizes and proportions primarily used to hold food; translated as "bowl" in this book. The term was originally applied to temple utensils, the word *hachi* being an abbreviation of a Sanskrit term. Vessels for daily food were made in imitation of these ceremonial utensils until, eventually, that function became predominant. Today *hachi* are used for planters, wash bowls, and decoration as well. They can also be made of metal or lacquer ware, but ceramic ones are most common. See plates 58–59.

Daibachi (台鉢) are literally *hachi* raised on a "platform," or tall, footed *hachi*. See plates 49–50.

Domburi (丼) are small, deep, thickwalled, ceramic *hachi* used to serve food. *Domburi* originally were not lidded but now sometimes are. This term appeared in the Edo period (1600–1867) and is thought to be a corruption of a Korean word.

Hachirō ware. See *kinrande*.

happō-mon. *See* "eight treasures" motif.

hei (瓶): a vase, flask, or storage vessel. Among the many terms for storage vessels, this refers to the smallest sizes. *Hei* were originally used as water dippers or cooking pots and were made of metal. Later on, after they came to be made of high quality porcelain, their shape changed, with the mouth getting smaller and the belly bigger, and they were used to store liquids. Some Kutani *hei* even had spouts. See plates 140, 148.

Heishi (瓶子) is an old word for *tokuri* (q.v.). The form is distinctive, with the shoulder swollen out, then severely curved in, ending in a wide, flat base. Metal and lacquer *heishi* were made in addition to the ceramic ones which were most common. They were used to pour sake into drinking cups before *tokuri*, which have a completely different form, came into use. See plate 135.

heishi. See *hei*.

Hiyō zasshū (秘要雑集): a document published in 1784 which relates one version of the founding of the Kutani kilns, slightly contradicting the two other important documents, *Jūshū Kaetsunō tairo suikei* (q.v.) and *Bakkei kibun* (q.v.). It was written for the temple Daishō-ji but its author is unknown. The *Hiyō zasshū* recounts the anecdote about Gotō Saijirō being sent to Karatsu in Hizen province (present-day Saga Prefecture) to learn about porcelain production, and how, when he had mastered the art, he abandoned his family there and returned to Kutani. Unlike the above documents, the *Hiyō zasshū* claims that Saijirō was sent by Maeda Toshiaki, the second lord of the Daishōji fief, who became head of the fief in 1660, and that production began some years subsequent to that, instead of claiming that Maeda Toshiharu, first lord of the fief, commenced production between 1655 and 1658.

Hizen province. *See* Arita ware.

Imari ware. *See* Arita ware.

inkstone (硯; *suzuri*): a slab made of stone or ceramics with a sloped depression having a well at the lower end, used for grinding an inkstick with water into thick, smooth ink. Inkstones, found in kiln excavations, were made in Kutani as novelty items.

Ishikawa Prefecture: the present-day name for Kaga and Noto provinces. Old Kutani ware was produced here in the early and middle Edo period (1600–1867) and Kutani ware from near the end of the Edo period to the present. The name was changed to Ishikawa Prefecture in 1871 as part of the Meiji-period (1868–1912) reforms. See map.

Jūshū Kaetsunō tairo suikei (重修 加越能大路水径; A Revised Geology of Kaetsunō): the oldest document describing Old Kutani wares and kilns. Published in 1736 and based on the earlier *Kaetsunō sansen-ki* (The Mountains and Rivers of Kaetsunō; 1713) by Tsuchiya Matasaburō, it was compiled by Ōsawa Kunzan as a geological survey of the Kaetsunō area (the three provinces of Kaga, Echizen, and Noto). While the exact meaning of its references is not always clear, it provides one valuable source of information about the founding of the Kutani kilns, stating that in the Meireki era (1655–58), Maeda Toshiharu, first lord of Daishōji fief, commanded Gotō Saijirō to start producing pottery similar to Nanking ware (q.v.). It also specifies that at one stage production was prohibited, and that by the time the account was being written, the kilns were no longer in use.

Kaga fief: also called the Kanazawa or Maeda fief. Lying in the three provinces of Kaga, Noto, and Etchū, Kaga fief was the site of Old Kutani ware production in the early and middle Edo period (1600–1867), and Kutani ware from near the end of the Edo period to the present. The daimyo of the Kaga fief, a position hereditarily filled by the head of the Maeda family, was designated a *tozama* in the Edo period, one of those daimyo with no hereditary ties to the shogunate, and was thus subject to especially close surveillance for signs of disloyalty to the Tokugawa shogunate. One of the 295 fiefs of the early Edo period, Kaga had a yearly revenue equivalent to some 1,025,000 *koku* (one *koku* equals approx. 180 liters) of rice per year (one hundred times that of the smallest fief and one-seventh of the shogun's personal domainal yield), making it the richest fief in the country. This wealth supported a staff of ten thousand at the Maeda villas in Edo and also helped to promote the development of Old Kutani ware. See map.

Kakiemon (柿右衛門): a type of decorated porcelain ware made in the town of Arita in present-day Saga Prefecture (formerly in Hizen province). Characterized by large areas of white ground, clear strong colors, and delicate patterning of overglaze enamels with natural cobalt (*gosu*), this ware is named for the potter Sakaida Kakiemon. He is traditionally designated

163

as the first to have perfected the process for producing bright, orange-red (*kaki* or persimmon-colored) overglaze enamel decoration, called *aka-e* (q.v.), in the middle of the seventeenth century, although some say that such decoration appeared earlier in Kyoto and almost simultaneously in Kutani.

While at first Chinese decorating styles were followed, by the early eighteenth century purely Japanese (*yamato-e*) decorations were added. Kakiemon wares were shipped all over Japan as well as being exported by the Dutch East India Company. However, while Kakiemon and Kutani wares were inspired by many of the same sources, coloration and typical designs became quite distinct. Kakiemon ware continues to be made today by Kakiemon XIII.

Kanazawa: the castle town of historic Kaga fief and the capital of present-day Ishikawa Prefecture. Kanazawa was a first-rank, urban castle-town with a population of 100,000 people in the eighteenth century, and continued to prosper into the modern period. See maps.

Karatsu ware (唐津焼; *Karatsu-yaki*): glazed, high-fired, and sometimes decorated ceramics made in the vicinity of Karatsu City, Saga Prefecture (formerly Hizen province), Kyushu. Production was begun in the first half of the seventeenth century by Korean potters brought back with Hideyoshi's troops after their two invasions of Korea, using Yi-dynasty (1392–1910) technology new to Japan, including the "split bamboo" climbing kiln (see *rembō-shiki noborigama*). Both tea and utilitarian wares were made, using a sandy, iron-bearing clay, glazed with an opaque white glaze (feldspar based), a transparent yellow-green glaze (wood-ash based), or a dark brown, *temmoku*-like glaze. Some were decorated with iron oxide. These technological developments in glazing and firing eventually spread throughout Japan, blending with the native ceramic tradition.

kilns. See *rembō-shiki noborigama*.

kinrande (金襴手; "gold-brocade style"): designs formed by applied gold-leaf cutouts or gold powder mixed with water and brushed on top of enamel colors. The gold must be fired to a high enough temperature to bind it to the enamels, but if fired too high, its weight will make it sink, or the other colors run. *Kinrande* is thought to have been first produced in China during the Sung dynasty (960–1279) and several such tea bowls with gold-leaf designs on the inside are extant. A similar effect is found on Korean wares.

From the end of the Yüan dynasty (*ca.* 1280–1368) to the Ming dynasty (1368–*ca.* 1644), this style became more elaborate, including combinations with red and other enamel decoration, called *saishiki* ("colored") *kinran* (彩色金襴). In the early sixteenth century these were exported on a tremendous scale. Successful imitations were eventually made in Imari, Kyoto, Kutani, and elsewhere, although these were usually called *nishikide* (錦手; "brocade style"). Similar wares were produced in Kutani in the early nineteenth century, then in the late nineteenth century by Kutani Shōza, who used Western pigments in a style later called the Shōza style (庄三風; *Shōza-fū*).

A related ware, called *Hachirōde* (八郎手) was produced at the Kasugayama kiln by Iidaya Hachirōemon, combining red-enameled (*aka-e*) techniques with minutely executed designs in fine gold lines. Classical Chinese subjects were favored, resulting in a luxurious ware which became a hallmark of later Kutani ware.

See plate 172.

Kiyomizu ware. *See* Kyoto ware.

kōchi sansai (交趾三彩; three-colored *kōchi* ware): a Japanese term for Chinese "Chio-chih" ware reported to have been produced at coastal kilns, but perhaps in Canton, and then exported to Japan. Three-colored *kōchi* was a low-fired ware

decorated in low relief on the outside, with blotches of thick, colored glazes, especially green, yellow, dark blue, and purple, applied directly onto the bisque-fired clay surface. Red could not be used because it would not fuse to an unglazed surface. While the pigments were not really overglaze enamels, mastery of these techniques laid the foundation for the later development of polychrome overglaze enamel decoration.

Early *raku* ware is sometimes said to have been inspired by *kōchi sansai*, and the typical Old Kutani color scheme of purple, dark blue, green, and yellow is also frequently attributed to this source.

kuchibeni (口紅; "mouth rouge"): a narrow line of iron glaze bordering the rim of Kutani bowls and plates. The color, determined by the interaction of the clay body, glaze, and firing atmosphere with the iron, may vary from yellowish-brown, to red, to purple. *Kuchibeni* as a design element appeared widely in Old Kutani ware of the 1670s and 1680s. See plates 72–74.

Kutani Shōza. See *kinrande*.

Kyoto wares (京焼; *Kyō-yaki*): a wide variety of wares made in and around Kyoto (*Kyō*) from the Momoyama period (1573–99) on. The Meiji Restoration in 1868, when the capital was moved from Kyoto to Tokyo, is often arbitrarily chosen to mark the end of production of the so-called *Kyō-yaki* and the beginning of what is then termed *Kiyomizu-yaki* (Kiyomizu ware), accompanied by changes in stylistic trends and a decline in quality.

The former encompasses both pottery and porcelain, covered with monochrome glazes and underglaze cobalt and iron designs, but is remembered as the first Japanese nonporcelain ware to be decorated with overglaze enamels. It is limited only by a certain "Kyoto taste," described as having classical proportions, refined quality, original decoration, subtle tones (bright overglaze enamels are not possible as on porcelain), and technical perfection. Pieces are typically glazed on one side with solid green or deep blue, offset by a complexly decorated portion, or with a low-relief effect of thick enamel floral designs, and sometimes imitate the shapes and textures of wood and other media. Potters who achieved prominence within this aesthetically and technically demanding tradition include Ninsei in the mid-seventeenth century and Kenzan (1663–1743).

Kiyomizu ware, porcelain exclusively, began to be made near Kiyomizu Temple in Kyoto in the Meiji period (1868–1912). Although born of Kyoto-ware roots and still actively produced today, it is not generally thought to have equalled the high standards of Kyoto ware.

Some of the design patterns found on Kutani ware which are not typical of Old Kutani or Arita wares reflect this Kyoto taste and may have found their inspiration there.

linked chamber climbing kiln. See *rembō-shiki noborigama*.

Meiji Restoration: On January 3, 1868, a proclamation of imperial restoration officially declared that the emperor was the source of all legitimate authority in Japan, ending 250 years of rule by the Tokugawa shoguns and beginning the Meiji period, which lasted until 1912. The aesthetic confusion of the declining Edo period (1600–1867) was still unresolved at the onset of the social turmoil engendered by the Meiji reforms of the economy, land ownership, military conscription, and class system, ending feudalism and nurturing democracy. Most of the existing kilns in Japan were hard-pressed when they lost the aesthetic guidance and support of their patrons, their stipends, regular orders, and organizational basis. Furthermore, the Meiji period was a time of general rejection of all traditional Japanese crafts in favor of Western machine technology. Consequently, many kilns closed down.

In contrast, in Kutani, which had been

165

in a state of decline, elaborate designs in gaudy colors using Western pigments were developed, and overglaze decoration kilns, porcelain painting workshops, and ceramic factories all sprang up. The resulting porcelain ware may have been less aesthetically pleasing to some, but it was a great technical achievement and well suited to the tastes of the age. Kutani ware was popular in Japan and one of its major export ceramics from the 1890s on.

mokkō shape (木瓜形; *mokkō-gata*): a four-lobed medallion design motif, sometimes enclosing other designs, used to decorate Old Kutani ware. Its shape is derived from a stylization of the leaf of the saxifragaceae plant (strawberry geranium). See plates 83–84.

Nabeshima ware (鍋島焼; *Nabeshima-yaki*): decorated porcelain ware made at or near the town of Arita in present-day Saga Prefecture (formerly Hizen province). The Nabeshima kiln is distinguished from other porcelain kilns in that it was established in the early eighteenth century by the Nabeshima clan to produce wares exclusively for clan use. The product was a noncommercial, official ware made with exact precision to be elegant, refined, and flawless. This sacrificing of all else to meet an absolute standard is often said to have resulted in a ware lacking vigor and humor.

The kilns were established in the vicinity of their current location in 1675, although plain porcelain, underglaze blue, and celadon wares had been made at a previous location. They were staffed by Korean potters, with the Imaizumi family serving as decorators, and were strictly controlled by the Nabeshima clan. At first only blue-and-white wares were produced, but about fifty years after Kakiemon perfected the use of overglaze enamels, blood red, transparent green, and yellow were applied, often over outlines in underglaze cobalt, which was not typical of Kakiemon or Arita wares. The pictorial decoration was inspired by fabric designs. After the Genroku era (1688–1704) commenced, orders were accepted from other aristocracy, but not until after the Meiji Restoration of 1868 was Nabeshima ware exported from Japan. The thirteenth-generation Imaizumi is working today.

Nanking ware (南京焼; *Nankin-yaki*): a term with many meanings, one of which is porcelain ware in general. Before porcelain was produced in Japan, it had to be imported from the Ching-te-chen kilns near Nanking in China, hence the appelation Nanking ware. Even after porcelain ware was produced in Japan, the term was still commonly used until the Meiji period (1868–1912).

Among the many export wares produced at the Ching-te-chen kilns were the Nanking red-enameled (*aka-e*) wares. These were nonofficial wares for popular, everyday use and included *aka-e* and five-colored wares, with landscapes, people, or bird-and-flower designs, with or without *kuchibeni* (a line of iron glaze bordering the rim), and others covered with a light yellow glaze. The exact dates of production are not clear but fall between 1662 and 1722. An ambiguous, early reference to Kutani in the *Jūshū Kaetsunō tairo suikei* states that something similar to this Nanking ware was being produced there.

Ninsei (仁清): a master potter and designer who became one of Japan's first ceramists renowned as an individual artist. His enamel decoration of pottery, which appeared soon after Kakiemon (q.v.) successfully applied red overglaze enamel decoration (*aka-e*) to porcelain, is of a level of refinement and technical skill that astounds even the modern viewer. Ninsei was born Nonomura Seiemon (date unknown) to a Tamba pottery family and served an apprenticeship in Seto. In about 1647 he established a kiln in the Omuro district of Kyoto near the temple of Ninna-ji, under whose patronage he produced Omuro ware (御室焼; *Omuro-yaki*)—deco-

rated tableware, tea ceremony utensils, and ornamental objects. He began using the name Ninsei after 1657, and concentrated on storage jars, incense burners, and water jars. The complex tonal harmonies, wide range of colors, and the arrangement of the designs in both the native Japanese *yama-to-e* and the Chinese-based Kanō styles show a rare balance of decoration and form. Much imitated, identifying authentic Ninsei works is a vexing problem.

nishikide. See *kinrande.*

noborigama. See *rembō-shiki noborigama.*

okimono (置物): decorative ceramic objects sculpted in the shapes of gods, animals, or legendary heroes, and usually placed in the *tokonoma* (an alcove in which a hanging scroll, a vase with flowers, or an *okimono* can be displayed). Many bird-shaped *okimono* were made in Kutani.

Omuro ware. *See* Ninsei.

overglaze enamel decoration. *See* enamel decoration.

polychrome overglaze decoration. *See* enamel decoration.

raku ware (楽焼; *raku-yaki*): light-bodied ceramics, often tea bowls, covered with a soft glaze that has been rapidly fired and cooled. The ranking of "First *raku*, second Hagi, and third Karatsu" for the tea ceremony indicates the prominent position of *raku* ware. It was first made in Kyoto by Chōjirō (1516–89) under the direction of the tea master Sen no Rikyū (1522–91). The name Raku was awarded to Chōjirō's son, Jōkei, by the general Hideyoshi, and his son, Dō'nyū or Nonkō, established the tradition of *raku* ware as we know it today. This includes use of a high-temperature, iron-bearing, light-colored clay mixed with a large amount of grog to ease the thermal shock the pottery undergoes during firing. It is usually shaped by hand without use of the wheel, imparting a rugged, individual quality to each piece. This is enhanced by the fact that the pieces are traditionally covered with a red, black, or white lead-based glaze, rapidly fired one by one to a temperature lower than the bisqued clay body, then allowed to cool in the open air. This produces a characteristic crackle in the glaze that was appreciated by tea masters because it softened the rasping sound the whisk made against the tea bowl as tea was being prepared.

Raku ware is produced today by the fourteenth generation of the Raku family in Kyoto. Green, yellow, and blue glazes have been added to the family repertoire. Wares of similar design and technique, but quite different in end result, are produced by potters outside the Raku family as well as by Western potters in many countries.

rembō-shiki noborigama (連房式登窯; "linked-chamber climbing kiln"): an oblong-shaped kiln of between three and twenty connected chambers, each built on a level step rising above the one before it, over a total slope of approximately 20°. Because each chamber buttresses the next, no external support is needed. Each chamber has a separately contructed arched roof and is divided from those above and beneath it by walls which have a row of flue holes at their base, allowing heat and flames to flow up through the kiln and out the last chamber, drawn up the steep slope by the cold air in the upper chambers. Clay mortar serves as the only insulation. Baffle walls are also unnecessary as the front row of wares or saggars serves this purpose. Each chamber has one or two doors for loading and one or more stoking holes. The kiln is fired from the bottom up: as each chamber reaches temperature, it is sealed off and the firing moves up to the next chamber, which requires less time, having been preheated by the exhaust heat from the previous chamber.

This kiln was introduced to the Hizen area from Korea at the end of the sixteenth century, and spread throughout Japan. Previously, tunnel kilns (窖窯; *anagama*) and "split bamboo" kilns (割竹式窯; *waridake-shiki kama*) were in use. *Anagama*, introduced in the fifth century, were simply

167

long, narrow, underground tunnels with an opening in the front for the wares to be stacked and the fire stoked, and at the back for the smoke to escape. The strong draft allowed high temperatures to be reached for the first time, but control was difficult as the interior could barely be seen. In some areas the transition to linked-chamber climbing kilns was direct, while in others the "split bamboo" kiln, appearing in the fifteenth century in Japan, intervened. The latter were half above and half under ground and, like the tunnel kilns, were built on a continuous slope so that the pots had to be leveled with pads of clay to be stacked. However, the "split bamboo" kilns were much larger and partitioned into long, narrow chambers, making control easier. The linked-chamber climbing kiln allowed still more precise control of the fire, easier access to the chambers, and fewer losses, necessary for the complicated and expensive production of porcelain. See plate 160.

saishiki kinran. See *kinrande*.

"scattered treasures" motif (宝尽; *takara-zukushi*): a design motif depicting a collection of figures symbolizing health, worth, comfort, sweetness, richness, and so forth, appearing in underglaze cobalt or overglaze enamel on Old Kutani ware. This general term includes the "eight treasures" and "seven jewel" motifs (q.v.).

Seto ware (瀬戸焼; *Seto-yaki*): ceramics produced in the vicinity of Seto City in Aichi Prefecture. Favored with a large supply of superior clay, production began in Seto as early as the Nara period (645–781). In the late Kamakura period (1185–1332) Seto began producing high-fired, glazed ceramics, then became the center of porcelain manufacturing in the early 1800s, making it one of the most active ceramic centers.

One tradition holds that the kilns were founded after a potter known as Tōshirō (Katō Shirōzaemon Kagemasa) accompanied the Zen monk Dōgen to China in 1223 to study with Sung celadon potters, then returned to the Owari area of Seto in 1242, eventually succeeding in producing glazed ceramics. The highly plastic Seto clay was formed by both coil and wheel methods, then covered with ash glazes high in iron content. When fired in reduction, amber or brown glazes resulted, in oxidation, yellow and greenish glazes. A wide variety of forms and surface treatments were developed. During the Muromachi period (1392–1572) *temmoku* tea bowls from Seto were shipped all over Japan as a substitute for the Chinese ceramics which had been imported.

After a decline in the late Muromachi period, the center of production shifted from the Owari area to eastern Mino province. There different clay bodies and glazes were used, producing what was called Yellow Seto (黄瀬戸; *kizeto*) and Black Seto (瀬戸黒; *Seto-guro*). Pictorial decoration appeared on Seto wares in the late sixteenth century and overglaze enamels in the early nineteenth century after porcelain clay was discovered. Seto then played a major role in the porcelain fever that swept Japan.

"seven jewel" motif (七宝繋; *shippō-tsunagi*): a type of "scattered treasures" design motif (q.v.) and one of perhaps three hundred geometric patterns used to decorate Old Kutani ware. It is a lattice design composed of diagonally interlaced circles with "jewel" motifs in the spaces between the circles. The fact that it expands in all directions without beginning or end was considered especially auspicious. The present name has been used since the Edo period (1600–1867) and may have come from Shippō village in Owari province (present-day Gifu Prefecture) where the motif was commonly used. However, since the same design was also called by other names, the term "seven jewels" cannot be taken too literally. It also appeared on early enameled Nabeshima ware. See plates 66–67.

shippō-tsunagi. *See* "seven jewel" motif.

shōgun: literally, the "barbarian quelling generalissimo." The title was awarded by the emperor to his military authority from the late eighth century on, but did not become hereditary until 1192, with Minamoto no Yoritomo. These men controlled Japan for the next seven centuries, receiving their legitimacy from the emperor who had no real power.

The Tokugawa shogunate was founded in 1603. Strictly controlling their retainers, the Tokugawas brought prestige to the emperor, protected the peace, and established the supremacy of their own family by turning the rough warriors into an elite bureaucracy of civil servants. However, this was also to bring their downfall. There were too many hereditary warriors, and the expenditures required of them by the shogun exceeded the value of their rice-based salaries, forcing them to borrow from the increasingly wealthy merchant class. The result was corruption, currency debasement, and the eventual end of the Tokugawa shogunate with the Meiji Restoration of 1868.

Daimyō, literally "great names," were the territorial lords who served as intermediaries between the shogun and his "warriors." Their realms emerged early in the fourteenth century but changed many times as power shifted. Originally warriors themselves, they became administrators under the Tokugawa shoguns. While they were autonomous rulers of their own realms, they received protection and rice stipends, and paid taxes and labor levies to the shogun. They were also forced to spend alternate years of residence in Edo at great expense. The Maeda family were the daimyo of Kaga (q.v.) and its subfief Daishōji (q.v.).

shonzui (祥瑞): blue-and-white porcelain teaware produced at the Ching-te-chen kilns near the end of the Ming dynasty (1368–*ca*. 1644). The term also refers to the designs found on this ware, consisting of spirals, swirls, and circular medallions enclosing various geometric patterns. The name of the ware is derived from an inscription—"Gorōdayū Go Shonzui *fecit*" (五良大甫　呉祥瑞造)—found on the base of some *shonzui* ware, but the meaning of this inscription is subject to considerable debate. Furthermore, while the high quality indicates that the workmanship was not Japanese, the design reflects Japanese tastes. As a result, some theories hold that Gorōdayū Go Shonzui was a Japanese potter sent to Ching-te-chen to study porcelain production techniques, or that Gorōdayū was a Japanese and Go Shonzui a Chinese, or that this is a fictitious name chosen by Japanese tea connoisseur Kobori Enshū, who ordered tea ware made at Ching-te-chen to his own specifications.

Old Kutani ware imitated blue-and-white *shonzui* design in its polychrome enamel decoration. See plates 72-74.

Shōza-fū or Shōza style. See *kinrande*.

sometsuke. See *gosu*.

suisaka ware (吸坂焼; *suisaka-yaki*): precursor of Old Kutani ware, made in Kaga province (present-day Kaga City, Ishikawa Prefecture). Among the many theories about the founding of this kiln, one states that Maeda Toshitsune, third daimyo of the Kaga fief, engaged potters from Seto to make tea wares in Suisaka village. They made technically advanced Seto-style dark-glazed wares, Bizen-like unglazed wares, as well as thinly glazed reddish-black works with cobalt decoration, subtle brown-glazed ones, those with lapis lazuli colored glazes, and wares in the style of iron-decorated Korean ware. Production ended at this kiln slightly before, or at approximately the same time as, Old Kutani.

One style of Old Kutani ware is called Suisaka Old Kutani. It was decorated in a a variety of complex ways: completely covered with a Nanking-style *kaki* (persimmon) glaze, except for one circle which

169

was left unglazed but decorated with polychrome enamel designs or red alone; glazed on one side with the *kaki* glaze and decorated on the other with cobalt; covered half with the *kaki* glaze and half with lapis lazuli; or decorated with cobalt or polychrome enamel designs on the plain ground.

Swatow dishes. See *aka-e*.

temmoku (天目): the name of conical-shaped tea bowls originally made in Fukien and Honan provinces in China during the Sung dynasty (960–1279) which were very popular with early tea ceremony connoisseurs in Japan. The name was probably derived from Tien-mu Shan, a mountain in Chekiang province where Buddhist temples of the Ch'an (Zen) sect were located. Buddhist priests from Japan who visited there saw these tea bowls in use and, admiring them, brought them back to Japan. These were made of a dark stoneware body covered with a glaze ranging in color from purple-black when thick, to reddish-brown when thin, and characteristically collecting in a thick roll where the glaze and the raw clay of the foot met.

Imitations were soon attempted in Japan. Shards of copies have been found in Seto kiln ruins from as early as the Kamakura period (1185–1332). The term *temmoku* today connotes one of the most popular glaze effects in Japan.

three-colored *kōchi* ware. See *kōchi sansai*.

tokuri (徳利): a ceramic vaselike vessel with a long, narrow, constricted neck and bulging base, used to store and serve sake; sake bottle. The evolution of the size, shape, material, and use of *tokuri* is complex. The word itself is said variously to have come from the sound of sake being poured, or to be a corruption of the Korean word for storage vessels. Originally these bottles were made of metal and used only to heat, not serve, the sake. Metal *chōshi* (spouted sake servers which resemble small Western tea pots in shape) and lacquer cups were then used for the actual serving and drinking. Eventually, blue-and-white decorated porcelain *chōshi* became popular as did ceramic sake cups, because they preserved the flavor and freshness of the sake without burning the hands and lips of the drinker. From then on, it was considered proper to drink sake from ceramic vessels. Gradually, people began to serve sake directly from heated *tokuri*, bypassing *chōshi*, or perhaps using the latter for only one or two ceremonial drinks then shifting to a ceramic *tokuri*, which, with its larger mouth, was easier to pour. To a certain degree, the clear distinction between *chōshi* and *tokuri* has blurred, and the former term is often used to refer to the latter. See plates 18, 19.

underglaze blue. See *gosu*.

wan (碗): small ceramic bowls in a variety of shapes and sizes from which food can be eaten or drunk. However, when written as 椀, the word refers to lacquer bowls. Whereas in Korea ceramic *wan* were the norm, with metal ones more rare, in Japan lacquer and metal *wan* were common and ceramic ones unusual until the Heian period (782–1184) when ceramic *wan* became common. Today, ceramic *wan* dominate tableware, but while they used to be deep and narrow, they are now generally wide and shallow. Korean rice bowls with their distinctive tall, flaring feet served as the inspiration for many Japanese *chawan* (tea bowls).

Although not without exception, the main differences between *hachi* (q.v.; translated as "bowl" in the text) and ceramic *wan* concerns size (*hachi* are usually bigger), shape (*hachi* tend to be deeper), function (*hachi* are used to serve food but, except for *domburi* [q.v.], are not usually eaten out of directly), and use (*wan* can be drunk from as well as eaten out of). Four types of *wan* have been identified in Kutani ruins. See plates 31–34.

(Glossary compiled by Jeanne Carreau)

BIBLIOGRAPHY

JAPANESE SOURCES
(updated and annotated by Carla Zainie)

大聖寺藩史編纂会編『大聖寺藩史』（昭和13年）複製版　加賀市　江沼地方史研究会　昭和50年　[Editorial Committee for the History of Daishōji Fief, ed. *The History of Daishōji Fief.* 1938. Reprint. Kaga City: Research Committee for the History of the Enuma Region, 1975].

深田久彌・北出塔次郎　『九谷』（日本のやきもの 10）　京都　淡交新社　昭和39年　[Fukada, Hisaya, and Kitade, Tōjirō. *Kutani.* Japanese Ceramics, vol. 10. Kyoto: Tankōshinsha, 1964].
General survey of Old Kutani and Kutani wares and research problems. Black-and-white illustrations.

藤岡了一　『色絵磁器』　東京　小学館　昭和48年　[Fujioka, Ryōichi. *Enameled Porcelain.* Tokyo: Shōgakkan, 1973].
Includes a general treatment of Kutani along with a discussion of other enameled porcelains.

林屋晴三　『古九谷』（原色愛蔵版日本の陶磁 11）　東京　中央公論社　昭和50年　[Hayashiya, Seizō. *Old Kutani.* Japanese Ceramics: Deluxe Edition in Color, vol. 11. Tokyo: Chūō Kōronsha, 1975].
Lavishly illustrated volume of major masterpieces of Old Kutani ware; captions and list of plates in English.

今泉元佑　『初期有田と古九谷』　東京　雄山閣　昭和49年　[Imaizumi, Motosuke. *Early Arita and Old Kutani.* Tokyo: Yūzankaku, 1974].

石川県美術館編　『古九谷名品展図録』　金沢市　石川県美術館　昭和48年　[Ishikawa Prefecture Art Museum, ed. *Catalogue of the Exhibition of Famous Pieces of Old Kutani Ware.* Kanazawa City: Ishikawa Prefecture Art Museum, 1973].
Short essay concludes with a useful chronological chart of Kutani-related activities from 1616 to 1883.

磯野風船子　「古九谷」（『陶説』20）　昭和29年　[Isono, Fūsenshi. "Old Kutani." *Tōsetsu,* no. 20, 1954].
General survey, concentrating on the chronological development of the ware. English summary.

小松市立博物館編　『若杉窯名陶展目録』　小松市　小松市立博物館　昭和47年　[Komatsu Municipal Museum, ed. *Catalogue of the Exhibition of Famous Ceramics from the Wakasugi Kilns.* Komatsu City: Komatsu Municipal Museum, 1972].

小山富士夫他編　『世界陶磁全集6』（江戸篇下）　東京　河出書房　昭和30年　[Koyama, Fujio *et al.*, eds. *The Edo Period*, part 2. Collected World Ceramics, vol. 6. Tokyo: Kawade Shobō, 1955].
This volume contains several short essays by various authors on aspects of research on Kutani ware.

171

九谷古窯調査委員会編 『九谷古窯第 1 次調査概報』 金沢市 九谷古窯調査委員会 昭和 46 年 [Kutani Old Sites Research Committee, ed. *Preliminary Findings of the First Series of Excavations at the Kutani Old Sites.* Kanazawa City: Kutani Old Sites Research Committee, 1971].

九谷古窯調査委員会編 『九谷古窯第 2 次調査概報』 金沢市 九谷古窯調査委員会 昭和 47 年 [Kutani Old Sites Research Committee, ed. *Preliminary Findings of the Second Series of Excavations at the Kutani Old Sites.* Kanazawa City: Kutani Old Sites Research Committee, 1972].
This report, and that in the preceding entry, summarize the results of excavations carried out in 1970–71 at Kutani kiln sites nos. 1 and 2, their dumps, and the Yoshidaya kiln. Invaluable sources for the study of Old Kutani ware, they raise many intriguing questions as to its origins. A further excavation was made in 1974, but a report has yet to be issued.

松本佐太郎 『定本九谷』 宝雲舎 昭和15年 [Matsumoto, Satarō. *Authentic Kutani.* Hōunsha, 1940].
A guide to all known works on Kutani at that time, including annotated bibliography, survey of major research topics, discussion of terms, and illustrations of marks, signatures, and seals.

宮本謙吾 『九谷, 吉田屋窯』 (陶器講座 6) 東京 雄山閣 昭和 10 年 [Miyamoto Kengo. *Kutani and the Yoshidaya Kiln.* Lectures on Ceramics, vol. 6. Tokyo: Yūzankaku, 1935].
A survey of documents concerning the establishment of the Yoshidaya kiln.

——— 『九谷焼研究』 学芸書院 昭和 11 年 [———. *A Study of Kutani Ware.* Gakugei Shoin, 1936].
A complete treatment of all aspects of Kutani-ware scholarship as of that date. A standard work.

——— 『九谷焼』 (陶器全集 6) 東京 雄山閣 昭和 11 年 [———. *Kutani Ware.* Collected Ceramics, vol. 6. Tokyo: Yūzankaku, 1936].

中川千咲 『古九谷』 (陶器全集 8) 東京 平凡社 昭和 33 年 [Nakagawa, Sensaku. *Old Kutani.* Collected Ceramics, vol. 8. Tokyo: Heibonsha, 1958].
A short essay on the origin and development of Old Kutani, plus numerous illustrations.

——— 『陶器講座 11』 (江戸前期 2) 東京 雄山閣 昭和 47 年 [———. *The Early Edo Period,* part 2. Lectures on Ceramics, vol. 11. Tokyo: Yūzankaku, 1972].
A short discussion of Kutani types and sources, plus a report of kiln site excavations; well illustrated.

西田宏子 『九谷』 (陶磁大系 22) 東京 平凡社 昭和 53 年 [Nishida, Hiroko. *Kutani.* Outline of Ceramics, vol. 22. Tokyo: Heibonsha, 1978].
The most up-to-date survey of Old Kutani; well illustrated.

大河内正敏 『古九谷』 宝雲舎 昭和 22 年 [Ōkōchi, Masatoshi. *Old Kutani.* Hōunsha, 1947].
A general survey of Old Kutani.

奥田誠一 『古九谷の再検討』 (彩壺会講演録) 彩壺会 昭和 11 年 [Okuda, Seiichi. *A Reexamination of Old Kutani.* Collection of Lectures Sponsored by Saikokai. Saikokai, 1936].

斎藤菊太郎 『古九谷新論』 東京 三彩社 昭和 46 年 [Saitō Kikutarō. *A New View of Old Kutani.* Tokyo: Sansaisha, 1971].
Classifies Kutani pieces by decoration, then suggests sources for decor in Chinese woodblock prints, lacquer, Near Eastern ceramics, etc.

─── 『古九谷』 東京 集英社 昭和46年 [───. *Old Kutani*. Tokyo: Shūeisha, 1971].
Large and richly illustrated volume of plates accompanied by a volume of text discussing decor, excavations, and research problems; illustrations of most patterns and marks found on Old Kutani.

嶋崎 丞 『九谷』 (日本のやきもの 18) 東京 講談社 昭和50年 [Shimazaki, Susumu. *Kutani*. Japanese Ceramics, vol. 18. Tokyo: Kōdansha, 1975].
A well-illustrated survey containing nineteenth- and twentieth-century Kutani as well as older pieces.

─── 『古九谷』 (日本陶磁全集 26) 東京 中央公論社 昭和51年 [───. *Old Kutani*. Collected Japanese Ceramics, vol. 26. Tokyo: Chūō Kōronsha, 1976].
A survey of recent research, strongly supporting the theory of Arita undecorated porcelain being brought to Kutani for enamel decoration.

ソーム・ジェニンス 「日本の磁器」 (『陶説』 40–41) 昭和31年 [Jenyns, Soame. "Japanese Porcelain." *Tōsetsu*, nos. 40–41, 1956].
The Japanese translation of Soame Jenyns's article "Japanese Porcelain" that appeared in the catalogue *Exhibition of Japanese Porcelain* (London: Oriental Ceramic Society, 1956).

寺前為一 「九谷窯跡発掘抄」 (『陶説』 79) 昭和34年 [Teramae, Tameichi. "Summary of the Excavations of the Kutani Kiln Remains." *Tōsetsu*, no. 79, 1959].
A report on the excavation carried out in 1959 by the Yamanaka-machi Cultural Properties Protection Committee.

土岡究渓 『古九谷図説』 高岡市 高岡市立美術館 昭和49年 [Tsuchioka, Kyūkei. *Old Kutani Illustrated and Explained*. Takaoka City: Takaoka Municipal Museum, 1974].
Contains largest number of illustrations (over 700) and widest variety of Kutani pieces of any work. Some are controversial as Kutani.

山下朔郎 『古伊万里と古九谷』 東京 雄山閣 昭和43年 [Yamashita, Sakurō. *Old Imari and Old Kutani*. Tokyo: Yūzankaku, 1968].
Presents in detail the theory that the majority of so-called Old Kutani polychrome overglaze ware are in fact early Imari (Arita) ware.

FURTHER READING
(selected and annotated by Jeanne Carreau)

Benrido. *The Ceramic Art of Kitaoji Rosanjin: Three American Collections*. Tokyo: Benrido, 1964.
A small book illustrating the life and work of a calligrapher, gourmet, potter, and major aesthetic force in modern Japan. His interpretations of Kutani overglaze enamels and underglaze blue are illustrated. In Japanese and English.

Cleveland, Richard. *200 Years of Japanese Porcelain*. Kansas City: City Art Museum of St. Louis and Nelson Gallery–Atkins Museum, 1970.
Catalogue of an exhibition of mid-seventeenth-century and early nineteenth-century Japanese porcelain made for both domestic and export use. The introductory note by John Pope unravels the legends surrounding the beginnings of porcelain production in Japan,

while Richard Cleveland ties economic and societal features of the Edo period to European demand for decorated porcelain ware following the termination of the China trade. He makes clear, consistent distinctions between Old Kutani, Kutani-style Arita ware, and Green Kutani. Notes analyze aesthetic and technical quality, design balance and subject matter, and problems of dating and provenance.

Fujioka, Ryōichi, with Masaki Nakano, Hirokazu Arakawa, and Seizō Hayashiya. *Tea Ceremony Utensils*. Translated by Louise Allison Cort. Arts of Japan, vol. 3. Tokyo and New York: Weatherhill and Shibundo, 1973.

A great variety of tea ceremony utensils examined and illustrated. Brief discussion is given to the vast change that occurred in the selection of ceramics for everyday and *kaiseki* (tea ceremony) meals with the introduction of decorated porcelain wares.

Jenyns, Soame. *Japanese Porcelain*. London: Faber and Faber, 1965.

Although written before the recent excavations revealed new information about Old Kutani ware, this is still one of the most extensive treatments of the subject in English. Kutani ware is placed among the other Japanese porcelain ware; its history, controversies, kiln sites, and types explained; and the bodies, glazes, enamels, designs, marks, documented pieces, and literary evidence examined. Included is a list of names, pseudonyms, and dates of Kutani as well as a map of kiln sites.

———. *Japanese Pottery*. London: Faber and Faber, 1971.

A comprehensive survey of the most well-known pottery kilns, with quotations from primary sources to emphasize histories and visual descriptions. There are no direct references to Kutani ware, but a section on dating and attribution points out the pitfalls in identifying kilns, wares, and potters; the distinction made between copying and forging is also useful.

Koyama, Fujio. *The Heritage of Japanese Ceramics*. Translated by John Figgess. Tokyo and New York: Weatherhill, 1973.

As the title suggests, this book focuses on the traditions and the interrelationships of the various wares that form the heritage of Japanese ceramics. A brief history and visual description of Kutani ware and a list of kiln sites are given, but it is the large, sensitive photographs of pots, potters, tools, kilns, and landscapes that highlight this book.

———, ed. *Japanese Ceramics from Ancient to Modern Times: A Commemorative Catalogue for the Exhibition Held at the Oakland Art Museum*. Oakland, Calif.: Oakland Art Museum, 1961. Covers Japanese ceramics from the very earliest to modern times, with chronological chart and map. Kutani ware is briefly discussed.

Mikami, Tsugio. *The Art of Japanese Ceramics*. Translated by Ann Herring. Heibonsha Survey of Japanese Art, vol. 29. Tokyo and New York: Weatherhill and Heibonsha, 1973.

A general study of the history of Japanese ceramics stressing the continuous tradition of the many wares produced for popular use. Kutani is discussed as a basically plebian ware, with the 1970–71 excavations of old kiln sites taken into account. Generously illustrated.

Muraoka, Kageo, and Okamura, Kichiemon. *Folk Arts and Crafts of Japan*. Translated by Daphne Stegmaier. Heibonsha Survey of Japanese Art, vol. 26. Tokyo and New York: Weatherhill and Heibonsha, 1973.

A thoughtful book that combines a theory and history of folk crafts, a perceptive discussion of their beauty and importance to modern man, and a no-nonsense analysis of

the state of folk crafts today. The reader is reminded that Kutani ware played a part in the daily lives of the people.

Sanders, Herbert H., with Kenkichi Tomimoto. *The World of Japanese Ceramics*. Tokyo and New York: Kodansha International, 1967.

With introductory notes by Shoji Hamada and Bernard Leach, this book is based on interviews with potters, visits to kilns, and research at the Kyoto Municipal College of Fine Arts. The materials, equipment, and techniques of historical and contemporary ceramics are described in accurate and satisfying detail, with a number of references to Kutani ware. Formulas for typical Japanese porcelain bodies and for the Kutani red overglaze enamel are given in the technical appendices.

Seattle Art Museum. *Ceramic Art of Japan: One Hundred Masterpieces from Japanese Collections*. Seattle: Seattle Art Museum, 1972.

A catalogue of the first major exhibition of Japanese ceramics to leave Japan, held by the Seattle Art Museum in 1972. It includes a brief history of Old Kutani and a description of its motifs and glazes, together with a number of illustrations.

————. *International Symposium on Japanese Ceramics*. Seattle: Seattle Art Museum. 1973.

The transcript of the 1972 symposium that accompanied the exhibition referred to in the preceding entry. Lectures and question-and-answer sessions reveal much of current scholarly thought about Kutani ware and other Japanese ceramics. In "Ko-Kutani in the Light of Recent Research," Tsugio Mikami evaluates, from the viewpoint of a participant, information yielded by the 1970–71 excavations of the sites of Old Kutani kilns nos. 1 & 2 and the Yoshidaya kiln. In "The Problem of Ko-Kutani and the Ao ["Green"] Kutani Enameled Ware," Soame Jenyns presents a straightforward description of the major uncertainties surrounding Old Kutani ware, his own theories, and possible criteria for distinguishing between Kutani, Artia, and imported wares.

Tsuji, Kaichi. *Kaiseki: Zen Tastes in Japanese Cooking*. Adapted by Akiko Sugawara. Tokyo and New York: Kodansha International, 1972.

Discusses the relationship of the *kaiseki* (tea ceremony) meals to the tea ceremony and the seasons, as well as the selection of appropriate utensils and courses and the preparation and serving of the meal itself. Beautiful color illustrations show Kutani and other wares in use.

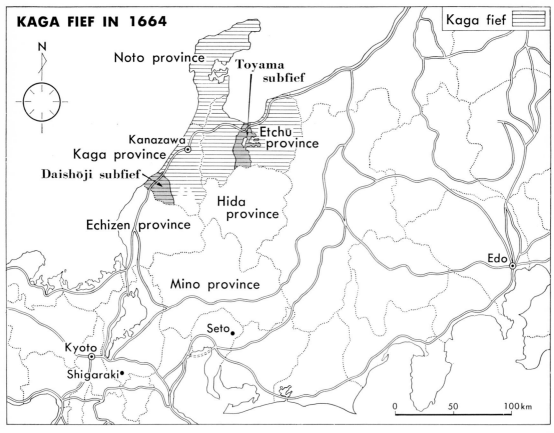

KAGA FIEF IN 1664

Kaga fief

N

Noto province

Toyama subfief

Kanazawa

Kaga province

Etchū province

Daishōji subfief

Echizen province

Hida province

Mino province

Seto

Kyoto

Shigaraki

Edo

0 50 100km

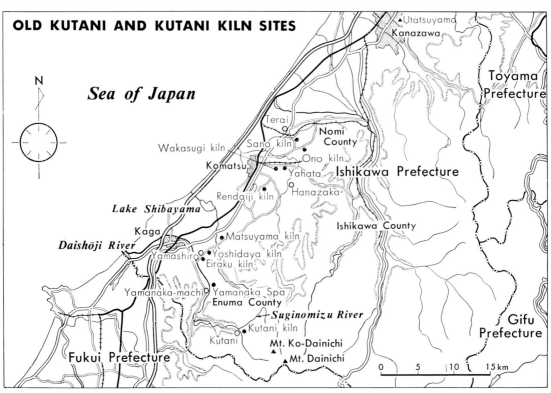

OLD KUTANI AND KUTANI KILN SITES

N

Utatsuyama

Kanazawa

Sea of Japan

Toyama Prefecture

Terai

Nomi County

Wakasugi kiln

Sano kiln

Ono kiln

Komatsu

Yahata

Ishikawa Prefecture

Hanazaka

Rendaiji kiln

Lake Shibayama

Ishikawa County

Kaga

Matsuyama kiln

Daishōji River

Yamashiro

Yoshidaya kiln

Eiraku kiln

Yamanaka-machi

Yamanaka Spa

Enuma County

Suginomizu River

Gifu Prefecture

Kutani kiln

Kutani

Mt. Ko-Dainichi

Fukui Prefecture

Mt. Dainichi

0 5 10 15 km

INDEX

Japanese Arts Library

In 1966 the Shibundo publishing company in Tokyo began an unprecedented series of monthly publications on Japanese art entitled *Nihon no bijutsu* (Arts of Japan). Prepared with the cooperation and editorial supervision of the Agency for Cultural Affairs and the three great national museums in Kyoto, Nara, and Tokyo, the series is written by leading Japanese scholars for a general audience, each issue devoted to a single aspect of Japanese art. Now totaling over 150 issues, this monumental series presents a comprehensive, detailed picture of Japanese art unequaled in Japanese publishing history—and now available to the English-reading public. Entitled the Japanese Arts Library, the English edition is being translated by scholars of Japanese art under the overall editorial direction of John Rosenfield of Harvard University. Abundantly illustrated and adapted for the Western reader, the Japanese Arts Library is an outstanding event in English-language publication.

Published titles
1. *Shino and Oribe Ceramics*
2. *Japanese Portrait Sculpture*
3. *Kanō Eitoku*
4. *Pure Land Buddhist Painting*
5. *Bugaku Masks*
6. *Nagasaki Prints and Early Copperplates*
7. *Kutani Ware*

In preparation
Japanese Ink Painting: Early Zen Masterpieces
Early Temple Architecture
Tempyō Sculpture
Hasegawa Tōhaku
Shoin-style Architecture
Shintō Architecture
Japanese Swords
Blue-and-white Wares
Folkcrafts of Japan
Jōgan Sculpture
Portrait Painting